INFINITE WORLDS

Infinite Worlds

AN ILLUSTRATED VOYAGE TO PLANETS BEYOND OUR SUN

Ray Villard and Lynette R. Cook

WITH A FOREWORD BY Geoffrey W. Marcy AND AN AFTERWORD BY Frank Drake

University of California Press · BERKELEY LOS ANGELES LONDON

University of California Press
Berkeley and Los Angeles, California

University of California Press, Ltd.
London, England

Library of Congress Cataloging-in-Publication Data

Villard, Ray.
 Infinite worlds : an illustrated voyage to planets beyond
our sun / Ray Villard and Lynette R. Cook ; with a foreword
by Geoffrey W. Marcy and an afterword by Frank Drake.
 p. cm.
 Includes index.
 ISBN 0-520-23710-2 (alk. paper)
 1. Extrasolar planets. 2. Life on other planets.
I. Cook, Lynette. II. Title.

QB820.V595 2005
523.21'4—dc22 2004016540

Manufactured in Italy

14 13 12 11 10 09 08 07 06 05
10 9 8 7 6 5 4 3 2 1

The paper used in this publication meets the minimum
requirements of ANSI/NISO Z39.48–1992 (R 1997)
(*Permanence of Paper*).

To my loving family, who shares my cosmic adventure: my wife, Paulette; my children, Christopher, Renee, and Eric. And to my parents, Helen and George, who nurtured my love of astronomy. —*Ray Villard*

To my grandmother Edith Christensen, who has brightened my universe with her love, gentle spirit, and strength of character. —*Lynette R. Cook*

Contents

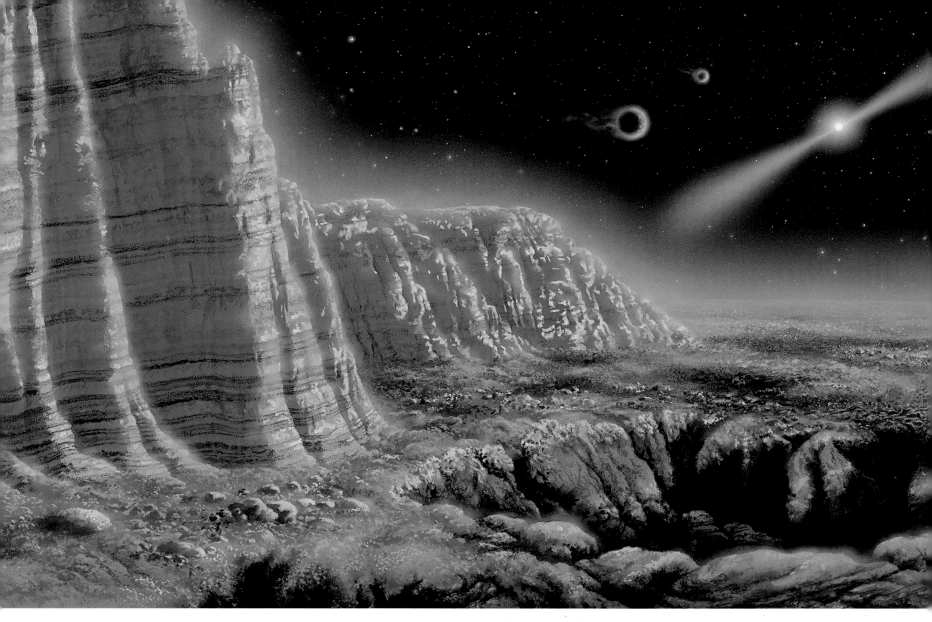

PULSAR PLANETS II *Planets elsewhere in the Galaxy will present a wide diversity of landscapes. One of the most exotic imaginable is the surface of a planet orbiting a dead and crushed star, called a neutron star. A fire hose of deadly radiation from a rotating neutron star (also called a pulsar) is causing materials on the landscape to fluoresce in a bright blue glow, just as minerals glow under black light. The intense stellar wind from the pulsar creates a tail of electrically charged particles behind the planets.*

Foreword

An avalanche of recent discoveries in astronomy has transformed our understanding of the expanding universe and our origins within it. The ultimate destiny of the cosmos has also come into focus for the first time in history. We can barely keep pace with the new revelations.

Three remarkable discoveries are particularly revealing. First, astronomers have found that the universe is expanding at an ever-increasing rate, driven by a mysterious "dark energy." If you were feeling small before, you're shrinking even faster now, compared to the cosmos. Second, planets abound in our universe, with over 140 discovered and more found regularly. The plenitude of planets displays a surprising diversity of sizes, chemistry, and orbits never imagined and offers billions of chances for biospheres to take a crack at survival and evolution. And third, back on Earth, scientists have learned that microbes don't just dominate the biology budget but flourish in the most hideous environments.

Sprinkled here and there throughout the cosmic darkness are glowing oases called galaxies. There are spiral galaxies and elliptical galaxies, both types composed of roughly 100 billion stars each. Our home galaxy, the Milky Way, contains some 200 billion stars and spans 100,000 light-years across. Viewed away from city lights, it stretches across the sky as a thin veil of stars: the disk of our home galaxy seen from within.

The Milky Way's beauty transcends the visual. All of the laws of physics—gravity, electricity, and magnetism, as well as quantum mechanics—remain absolutely constant everywhere in the Galaxy. So do the laws of chemistry. Water molecules or amino acids on Earth are indistinguishable from any located across the entire Milky Way.

But the laws of biology remain unknown. Does life everywhere depend on liquid water? Is DNA the only replicating molecule that can carry the blueprint of life? Does evolution lead inexorably to species endowed with intelligence, dexterity, and a proclivity for speech, the necessities of human technology? Perhaps *Homo sapiens* occupies just one tiny twig, lucky to have sprouted, on a complex tree of life. Alternatively, the advent of intelligence on a habitable planet may be common.

The universe possesses the ingredients necessary for life, as well as places beyond Earth where life may have evolved. Planets discovered around other stars, ranging from the size of Jupiter and Saturn to that of Neptune, are bizarre in many respects. Some orbit so close to their star that they complete a "year" in three days. Many move around their star not in neat, near-circular paths, but in generally elongated orbits. Still other planets have masses and orbits that resemble those of the gas giants around the Sun. In the next few years we may find exact analogs of Jupiter and Saturn, serving as signposts of other "solar systems" like ours.

Why are extrasolar planets so bizarre? No astronomer knows. Perhaps during the early era of planet formation they scattered off each other like billiard balls. They may sling-shot themselves into wild orbits, using gravity as the sling, some with superheated surfaces as they orbit close to their star, some destined to wander in dark, frigid, solitary confinement.

Sadly, we don't know what the extrasolar planets actually look like or what they are made of. We are left to use the universal laws of physics and chemistry to guess at their composition and appearance. Our own planets provide us with some insight, but it's risky to project beyond what we know from our Solar System. Scientists can't speculate beyond the data, lest we be chastised as planetary palm readers.

Undaunted, Ray Villard and Lynette Cook, with scientific integrity clutched in one hand and an artist's license in the other, have produced this extraordinarily accurate and unique book. Villard conveys the truth about our universe with vivid precision. Cook's art offers a glimpse of the possible landscapes and atmospheres that almost cer-

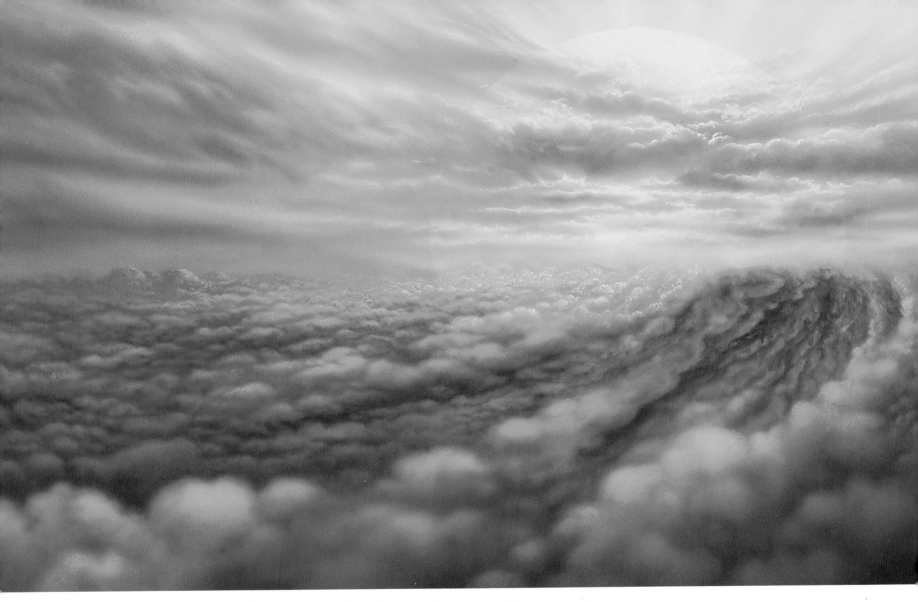

HOT JUPITER SUNRISE *Dawn illuminates the cloud tops of a Jupiter-sized planet orbiting pre-cariously close to its parent star. Some of the very first extrasolar planets discovered were Jupiter-sized monsters, with their atmospheres heated to over 2,000°F. This sunrise is probably a common sight throughout the Galaxy. However, such spectacular dawns occur on presumably lifeless worlds, so no being is there to witness such splendor.*

tainly adorn alien worlds. Her logical, imaginative renderings show us worlds yet to be seen and yet to be visited. I have no doubt, however, that many of the scenes in this book are exceedingly close replicas of real alien worlds. How wonderful to have a book that combines the best explanations of modern astrophysics with the best artistic extrapolations.

Half of all stars probably harbor rocky planets like Earth and Mars. All remain undetected so far. But observations of planet-forming regions, along with sound theory, tell us that rocky worlds probably number in the billions. Many will have temperate and tropical climates warmed by the glow of their star. Planets can serve as stable platforms for life for billions of years. The chemical building blocks of life exist everywhere too. Carbon, nitrogen, oxygen, hydrogen, phosphorus, and iron are distributed throughout the Milky Way Galaxy, often combining into rich organic molecules observed by radio telescopes. And water is one of the most common molecules in the Milky Way. Moreover life needs energy, and there is plenty of it in the form of starlight, geothermal heat, and tidal energy. Who can doubt that primitive life, and even multicellular life, flourishes on millions of planets in our Galaxy?

The trick question remains. Are there other technological creatures in the Milky Way Galaxy? If only a small percentage of stars in our Galaxy harbor intelligence, then aliens are everywhere. If so, many of them have been developing more and more advanced technologies for billions of years. After all, our Galaxy was making stars and planets five billion years before Earth was even born. What a head start some aliens must have on us! Imagine a Milky Way filled with thousands of civilizations, most more advanced than ours.

If science fiction writers are right, some of these older civilizations would have sent out spaceships. Traveling at just 1 percent of the speed of light (never mind warp drive), technologically advanced aliens could cross the Galaxy in only 10 million years.

But something is wrong with this picture. Where is everybody, and why haven't they visited or colonized our beautiful Solar System? We have no evidence of past colonies

on Mars or the Moon, no evidence of past spacecraft, no obelisks, beacons, or trans-mitters. The extraterrestrial hordes nightly have eluded professional telescopes around the world.

Maybe science fiction novels have it wrong. Maybe we are alone, or nearly so. The only way to solve this greatest of scientific mysteries is to venture forth. We must travel to Mars, to the moons of Jupiter and Saturn, and to the stars. We must seek out and study other Earth-sized planets. And we must continue to scan the heavens for signals from intelligent species, using all the wavelengths of light and all our powers of inge-nuity.

GEOFFREY W. MARCY
Director, Center for Integrative Planetary Science
University of California, Berkeley

Preface

A project such as this book comes about via the input and influence of many people—too many to name individually. However, a few deserve specific mention.

Lynette's stunning, colorful, and evocative art was the inspiration for this book. I was truly mesmerized by it when I saw Geoffrey Marcy give a talk on extrasolar planets at a meeting of the Astronomy Society of the Pacific in 1998. I was expecting to see a bunch of squiggly graphs. But instead Geoff showed compelling and imaginative paintings of one planet after another. In the darkened auditorium I felt transported to these worlds. I admired Geoff for being visionary enough to team up with an outstanding space artist and engage in speculation. After his talk I had the delight of meeting Lynette for the first time. I immediately felt that a collaboration on just such a book was inevitable. This exciting era of extrasolar planet discovery needed to be captured for the lay reader. Lynette was the artist to do it. As the book developed, it was Lynette's perseverance, patience, and focus that really kept us on track. I am deeply indebted to her for that.

I also must acknowledge the seminal work of science writer Willy Ley and the legendary space artist Chesley Bonestell as the fundamental inspiration for this book. Before *Sputnik* was ever launched, Bonestell accurately depicted the upcoming age of space exploration. Before NASA was ever created, Ley described the blueprint for exploring the Solar System. Elements of his vision are still being implemented by NASA today. In 1964 Bonestell and Ley teamed up to publish the book *Beyond the Solar System.* The authors did not hesitate to show hypothetical extrasolar planets and even interstellar probes. Through their imagination readers visited these worlds nearly 40

years before the first extrasolar planet was discovered. In that spirit, it is our fondest wish that *Infinite Worlds* will inspire a new generation of dreamers who will actually take us to the stars.

As ideas for the book developed, I received encouragement from numerous science communication colleagues: Dana Berry, Eric Chaisson, Terry Dickinson, Timothy Ferris, Andrew Fraknoi, Ann Jenkins, Barbara McConnell, Dennis Meredith, Ron Miller, and Adolf Schaller. Over the course of researching this book a number of astronomers in addition to Geoff's team were extremely helpful in reviews and discussions: Fritz Benedict, Howard Bond, Alan Boss, David Charbonneau, Don Feiger, Andrew Fruchter, Ron Gilliland, Mario Livio, Jonathan Lunine, Jon Morse, Keith Noll, Jim Pringle, Harvey Richer, Kailash Sahu, Glenn Schneider, Al Schultz, Steinn Sigurdsson, and Karl Stapelfeldt.

I want to thank my parents, George and Helen, for encouraging my interest in the universe at a young age. I fondly remember standing on the front lawn with my father to watch *Sputnik* pass overhead. In my teenage years my mother bought me a movie camera with which I made award-winning student films, one about human flight to Mars. All of this developed a passion for science communication and ultimately catapulted my life into dedication and service to NASA's space science program.

RAY VILLARD

As an astronomical illustrator I translate scientific facts into a visual medium. This can be a challenging endeavor for several reasons, such as the vast differences in mass and scale between bodies that need to be shown within the same picture plane and made clearly identifiable. Yet it is a worthwhile challenge.

Astronomers, when writing papers and discussing their observations, must stick to the data; there is little room for speculation. Fine artists have the freedom to do anything they wish, but their results often aren't scientifically rigorous enough to pass

muster in a research setting. But I have the best of both worlds! In my art I show the science and what is known to exist about my subjects, but I am also free to express what plausibly *may* exist as well. In the case of an extrasolar planet, for instance, many specifics are known: the type of star around which the planet orbits, the distance of the planet from its star, and the mass of the planet. These basic facts offer many possibilities as to what the planets may look like—the type of terrain, the existence of water, the potential for moons, the chance that a gaseous planet may have rings, and so on. As an artist I can explore these possibilities in a unique way.

The extrasolar worlds are too far away to be photographed directly at this time. Even if images of just a few pixels in diameter become available in the near future, we remain decades away from photographing these planets in high resolution. The only way to visit them up close is through the eyes of an astronomical artist.

As we look around our Earth, we see that the natural world is full of color and variation. The views we have had of places beyond our home world—via our spacecraft and telescopes such as Hubble—confirm that the cosmos is equally amazing. As we learn even more, I have no doubt that we will find an abundance of worlds so unusual that they could have been created by an artist's hand. In anticipation of those discoveries, I bring you my own vision of the universe's infinite worlds.

My thanks first go to Ray for asking if I'd be interested in collaborating on a book; this question launched *Infinite Worlds*. I have very much appreciated Ray's enthusiasm, good nature, and perseverance in seeing this project through. In spite of the obvious challenges of adding one more thing to a busy life with a full-time job, teaching commitments, and a family, he got the job done, and done well. It has been a real pleasure to work with him.

Prior to Ray's inquiry, and over the course of many years, the foundation for this book was laid through the input of two very remarkable people, Frank Drake and Geoff Marcy. They have been open to working with me and have provided many excellent ideas for my artwork, in addition to constructive criticism and scientific guidance. Cer-

tainly *Infinite Worlds* could not have come into being without their long-term and ongoing input, not to mention their own personal research and contributions to the fields of SETI and extrasolar planet discoveries. Thanks of the same nature also go to California and Carnegie Planet Search team members Paul Butler, Debra Fischer, and Steve Vogt. I am honored to have been able to illustrate so many of their amazing worlds and play a role in sharing these discoveries with the world.

During the past few years I have had the opportunity to interact with other planet hunters, discoverers, and researchers in related fields as well; several of the resulting illustrations are included in this book. I thank them all for their input to my art; collectively they too have assisted in laying the groundwork for *Infinite Worlds*. Specific mention goes to Laurance Doyle, Michael Endl, George Gatewood, Garik Israelian, Jack Lissauer, Michel Mayor, Stephane Udry, and Alex Wolszczan.

A big thank-you also goes to Alice Houston and Adam Levison for their invaluable input at beginning stages of working on the book; Research Corporation, which provided welcome assistance for the creation of several of the earlier extrasolar planet illustrations included in this book; my parents, Charlotte and Marchal, sister Kitty, and friend Nathan, who have all helped in a huge way to make my home and studio a wonderful place in which to work on a project so involved as this one. I also thank my mother for never once suggesting I should have found a "real job" instead. Additionally, I greatly appreciate the scientific input and artistic feedback from Bob Arnold, Bruce Balick, Malcolm Currie, Walter Denn, Greg Laughlin, and Robert Naeye as the book developed and new art took shape.

LYNETTE R. COOK

The authors are also grateful to UC Press at large for its interest in publishing this book, as well as to the individual staff whose hard work and commitment enabled the book to develop and take tangible form. Acquisitions editor Blake Edgar and editorial assis-

tant Jenny Wapner were there from the beginning to provide guidance and feedback and to answer questions. Particular appreciation goes to Blake for his leadership and patience throughout. At the production stage others took the project under wing and helped it come alive: project editor Rose Vekony, copyeditor David Anderson, designer Sandy Drooker, and production coordinator Janet Villanueva. A big thank-you goes to them all. The input and expertise of all these people have truly made this project a successful team endeavor.

1 Cosmic Evolution

SETTING THE STAGE FOR PLANETS

WE ARE THE FIRST "EXTRATERRESTRIALS." This means we are the first civilization to leave planet Earth and explore the universe with spacecraft and powerful spaceborne observatories. We have sent humans to the Moon and plan to return by the year 2020. Space probes have journeyed to every major planet in the Solar System. Telescopes with electronic eyes billions of times more powerful than ours have seen out to the far horizons of the universe.

Merely a century ago scientists thought that our Galaxy was the only "island universe." It was about 30 million years old and contained about a million stars. Now we know the universe is 13.7 billion years old with at least 100 billion galaxies, each containing about 100 billion stars. To date more than 140 planets have been found orbiting nearby stars. Some astronomers speculate that, based on this very preliminary survey, there might be at least a billion, or even 10 billion, rocky planets the size of Earth. But what fraction are habitable? Today that is anybody's guess. Within a few decades, however, the answers may at last be within our grasp.

Today the world's largest telescopes unveil this vast universe as a restless diversity of color, shape, and dynamics. These celestial panoramas reach across an immense gulf of time and space. Images of iridescent nebulae, stately spiral galaxies, gaseous pillars, and jewel box clusters of shimmering stars are inspirational. But they are also a reminder of our cosmic isolation and loneliness. Is all this celestial real estate barren and sterile? Are we the only entities in the universe that behold the wonder and awe of cosmic creation?

Powerful telescopes such as the Hubble Space Telescope, the twin W. M. Keck telescopes in Hawaii, and the Very Large Telescope array in Chile are allowing astronomers

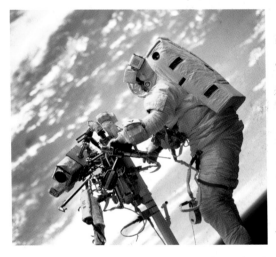

AN "EXTRATERRESTRIAL" VISITOR *Space Shuttle astronaut Steven L. Smith looks like an alien visitor perusing the vista around the small blue globe of Earth behind him. Smith is retrieving a power tool while servicing the Hubble, one of several space telescopes that extend and sharpen our view of the vast universe to which we can't yet travel. Not only are we the first humans to venture beyond our tiny blue planet, but our robot emissaries have visited all the major planets and moons in the Solar System. We are indeed the "extraterrestrials." But are we the only life forms in the universe that have ever ventured into space? (Courtesy NASA)*

HELIX NEBULA *This image of iridescent gases around a dying star embodies the splendor of rebirth and renewal in the universe. It also captures the raw forces that govern the lives and deaths of stars. In this picture of the Helix Nebula we are looking down the edge of a trillion-mile-long tube of iridescent gases ejected from a burned-out Sunlike star. The eerie tentacles formed when a hot "stellar wind" of gas plowed into colder shells of dust and gas ejected previously by the doomed star. The radiant tie-dye colors correspond to glowing oxygen (blue) and hydrogen and nitrogen (red), elements that will be used to make successive generations of stars in our Galaxy. These colorful, heavier elements might also be used to forge planets and life. (Courtesy NASA, NOAO, AURA, NSF, M. Meixner, and T. A. Rector)*

to look far enough back into time to see how the universe has evolved. This is possible because the light from the earliest objects in the universe is just now arriving, like a postcard from a friend in a faraway country. We are the first generation to realize our cosmic origins. We are the first to understand that our planet Earth and its many forms of life are a result of energetic events unfolding over billions of years. We are just beginning to confront unexpected new complexity and diversity as to how planets around other stars form and evolve.

We may also become the first generation to discover we are not alone in the universe. If this ever happens, it will be one of the most defining moments imaginable in the history of our species. Daniel Defoe describes such a moment in his classic story *Robinson Crusoe,* when the castaway realizes he is not alone on a seemingly deserted island. One day he finds a footprint on the beach, which forever changes Crusoe's sense of reality about his life on the island: "I stood like one thunderstruck, or as if I had

seen an apparition. . . . Nor is it possible to describe . . . how many wild ideas were found every moment in my fancy, and what strange, unaccountable whimsies came into my thoughts by the way."

Our cosmic loneliness was felt long before telescopes were ever invented. Simply looking into the starry nighttime sky invites a humbling sense of isolation beneath a beckoning but stone-silent stellar tapestry. Nearly 25 centuries ago the Greek philosopher Metrodorus wrote that considering Earth the only populated world in the starry universe was "as absurd as to assert that in an entire field sown with millet only one grain will grow." In the thirteenth century Thomas Aquinas thought that Earth was so unique it would be pointless for God, who cannot act in vain, to create other inhabited worlds. His contemporary Roger Bacon took exactly the opposite view. He held that no reason could be found to justify the creation of a limited number of worlds; an infinity of inhabited worlds had to be assumed by us.

Three centuries ago the science writer Bernard Le Bovier de Fontenelle was a bit more tongue-in-cheek in his popular 1686 book *Conversations on the Plurality of Worlds*, in which he explains the universe to a beautiful and intelligent lady friend: "There's no indication that we're the only foolish species in the universe. Ignorance is quite naturally a widespread thing." Fontenelle's contemporary Christiaan Huygens held that God's wisdom and providence were clearest in the creation of life and that Earth held no privileged position in the heavens. Since the same natural laws operated everywhere, life had to be universal, and it could not differ much from life on Earth. Contemporary astronomer Ben Zuckerman of UCLA best echoed our cosmic loneliness in the preface to his 1981 book, *Extraterrestrials: Where Are They?*: "To astronomers who work with giant optical and radio telescopes the universe appears to be a gigantic wilderness area untouched by the hand of intelligence."

Astronomers have just started down the road to finding out how common or rare habitable planets may be. We now know that Jupiter-sized planets are common. They continue to be discovered at a steady rate. Smaller, Earthlike planets should be out there

too. Within not too many years we should know what fraction of stars have Earthlike planets in Earthlike orbits. Then the deeper and more profound research will follow: What kinds of atmospheres do they have? How did they give rise to life? What kinds of life do they harbor? If we ever do contact extraterrestrial civilizations, it's a safe bet they will be even more diverse than aliens dreamt up in numerous science fiction stories.

"You have to be made of wood not to be a little interested," said the astronomer Carl Sagan in a 1993 televised interview. "Are humans all there is? Or are there other beings on other worlds? Older? Smarter? Wiser?" But if Earths are rare, we may never find one, much less intelligent beings. The thought that our world is the only place for life in the universe is sobering and has far-reaching cultural, philosophical, and religious implications. If Earths are abundant, the ramifications are equally spellbinding. Then we will see that the stage is set for life to play out in an unimaginable symphony of complexity and variation.

Either way, solving this question will truly define us as a species. It will answer whether we are a rare concoction of physics and chemistry, or a natural outcome of 13 billion years of cosmic evolution. Until we can answer this question we can never truly understand the role of life in the evolving universe. The great nineteenth-century essayist Thomas Carlyle summarized the paradox confronting us: "If [the universe] be inhabited, what a scope for misery and folly. If . . . not inhabited, what a waste of space." Astrophysicist Sir Roger Penrose comes to a similar conclusion by asking why the universe is so inconceivably vast if Earth is the only place where everything was "just right" for life to appear. Nature would be incredibly extravagant. The universe could have been a lot smaller and simpler today.

The story of how the universe evolved to form planets and life is understood in a broad-brush fashion. There are many gaps to fill in, as well as eerie underlying riddles and puzzles that still might overturn conventional wisdom. But every day our largest telescopes are reading the 13-billion-year-old history book of the universe. The text is

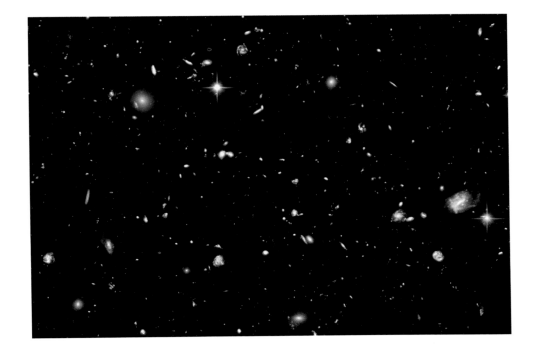

THE HUBBLE ULTRA DEEP FIELD *This farthest-ever view of the universe, called the Hubble Ultra Deep Field, is a core sample of the universe, cutting across billions of years back to almost the beginning of time. The snapshot includes galaxies of various ages, sizes, shapes, and colors. The smallest, reddest galaxies, numbering about 100, may be among the most distant known, existing when the universe was just 800 million years old. The nearest galaxies—the larger, brighter, well-defined spirals and ellipticals—thrived about one billion years ago, when the cosmos was 13 billion years old. In vibrant contrast to the rich harvest of classic spiral and elliptical galaxies, a zoo of oddball galaxies litter the field. Some look like toothpicks, others like links on a bracelet. A few appear to be interacting. These oddball galaxies chronicle a period when the universe was younger and more chaotic, and order and structure were just beginning to emerge. (Courtesy M. Stavelli, STScI, and NASA)*

written in the precise message of starlight, and decodable by any technological intelligence in the universe. Today we confront the paradox that the universe is indifferent to our fate, yet is fine-tuned to allow for our very existence. Despite what might have been incredible odds, life on Earth has managed to reshape our planet for 3.5 billion years. In essence, we may live in a universe that "won the lottery." Out of infinite other possibilities we live in a universe just right for us.

Cosmic Dawn

Based largely on conjecture and logic, the Greek philosophers imagined infinite worlds. But the unreachable Moon might just as well have been made of green cheese. The

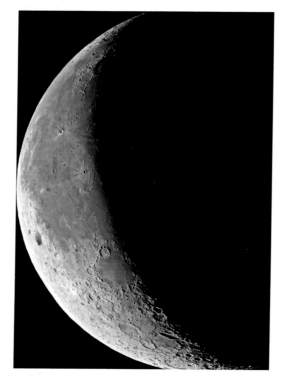

THE CRAGGY MOON *This eight-meter mirror of the Very Large Telescope provides a view of the Moon that is sharper than that seen though Galileo's small refractor. Yet Galileo could easily see topographic relief along the Moon's terminator (the boundary between day and night sides) where shadows from mountains and crater walls are easily discernible. The Moon became the first celestial body to truly resemble another physical world in space. Galileo could compare what he saw to Earth's surface. It was a dramatic leap of imagination in the early 1600s to believe there were other places in space like Earth. (Courtesy ESO/VLT)*

Greeks knew that the stars were farther away than the Moon, but no one back then could have imagined how much farther. The Greek astronomer Aristarchus proposed a Sun-centered universe, but the notion was little credited at the time. For almost 1,500 years western civilization embraced the Alexandrian astronomer Ptolemy's model of the Sun and planets whirling around Earth. Then, in the sixteenth century, the mathematician Nicholas Copernicus asserted that Earth rotated on its axis and completed a revolution around the Sun yearly. In one fell swoop Copernicus rearranged the Solar System: Earth was no longer at the center.

Copernicus demoted Earth to being just one of six known bodies subservient to the Sun, which sat as ruler at the center of the Solar System. His views challenged the literal interpretation of scripture and even common sense. Copernicus brought such a crucial change in thinking that scientists today invoke the Copernican Principle in assessing new theories. A scientific theory is regarded as wrong if it requires that the observer occupy a special place in time or space. This is dismissed as anti-Copernican. Scientists ever since have reaffirmed the Copernican Principle in all successful theories about the fundamental workings of nature. In fact, the history of astronomy has been a step-by-step process of dethroning Earth from being the center of anything: we do not lie in the center of the Galaxy; the Galaxy does not occupy the center of the universe. The eventual realization that Earth and intelligent life might not be unique will be the final big step in the Copernican revolution.

Only 70 years after Copernicus's death the great Italian scientist Galileo Galilei used the newly invented telescope to unveil a host of new surprises and clues about the universe. Galileo saw mountains and valleys on the Moon. He compared the shadow play of the Sun rising over a terrestrial valley to the illumination of a crater on the Moon. This led Galileo to speculate openly that the Moon was like Earth, and not some ethereal body. This was a dramatic leap for astronomy. The Moon and planets became other places that could be examined with the senses and the mind. They would never again be mere pinpoints of light moving mysteriously amidst the zodiacal constellations.

Fellow astronomer Johannes Kepler was inspired by Galileo's observations. Kepler believed the Moon was inhabited because Galileo found that it looked Earthlike. However, Galileo rejected the idea that the Moon, or any other planet, could contain animals and people as Earth does. Speculation like Kepler's may have been suppressed by clerical warnings. A chilling example comes from the Jesuit rector of the Collège de Dijon, in a letter urging the French philosopher and scientist Pierre Gassendi to consider the likely repercussions of his work. Once people accepted the idea of a Sun-centered universe, they would reason that "if there is no doubt that Earth is one of the planets, just as it has its inhabitants, it is right to believe that the others have them too, and that the fixed stars are not uninhabited either, that they are even superior to us." This, he wrote, would lead them to question Genesis, and ultimately the Christian faith, which held that "all the stars were produced by God the creator, not for other people and other creatures to live on, but solely to give light and fertility to the Earth with their rays. So you see how dangerous it is for these ideas to be spread about publicly."

Kepler was the first scientist to accurately deduce the planets' orbital behavior. In doing so he developed the laws that describe the motions of celestial bodies, though he did not understand the underlying force at work. Several decades later the English scientist Isaac Newton identified this force as gravity. He made the bold assertion that the laws of gravity are the same across the universe. With his *Principia*, scientists had an elegantly simple set of equations to do everything from measuring the masses of the planets in the Solar System to deducing the masses of distant stars orbiting one another. These same laws would be used in our own time to measure the masses of planets orbiting other stars.

This universality of matter and energy was bolstered in the mid-1800s by the emerging science of spectroscopy. Spectroscopy allowed astronomers to figure out the elemental composition of the Sun and stars. Scientists found that by dissecting starlight into its component colors, they could find the embedded spectral lines or "fingerprints" that precisely corresponded to all matter on Earth. Scientists realized that the universe

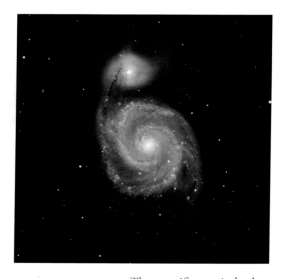

SPIRAL GALAXY M51 *The magnificent spiral galaxy M51 (the "Whirlpool Galaxy") is one of the most famous members of the so-called realm of the spiral nebulae. Before the distances to the spirals could be reliably measured, astronomers debated whether these objects were nearby whirlpools of star-forming gas or, more outlandishly, some other "island universes" far away. One fact was certain by 1920: the spiral nebulae were rushing away from us into inky black space. (Courtesy NOAO, AURA, and NSF)*

is made of the same elements found on Earth. The underpinnings of how atoms produce colors of light would not be understood until the early twentieth century. Spectroscopy eventually will be used to measure the atmospheres of other Earthlike planets and identify unusual atmospheres that are modified by biological processes on the surface. Someday this may provide the first evidence for life on those worlds.

The beginning of the twentieth century saw a remarkable new synthesis of physics, which would lay the groundwork for the fantastic discoveries in the new century. Albert Einstein's theory of General Relativity described how gravity warps the universe. His theory of Special Relativity described the behavior of space and time throughout the universe. One spin-off from his theories of relativity is an explanation of how stars shine through the conversion of matter to energy. At the infinitely small frontier of nature, nuclear physics and quantum physics came to describe the structure of the atom.

The inventions of the early twentieth century laid the groundwork for the tools needed to test some of these theories and explore the universe ever deeper—the development of electricity, radio communication, flight, and rocketry, just to name a few. Much later in the century esoteric ideas from quantum physics would lead to the development of transistors and then microcomputers.

The stirrings of a new astronomical revolution began when Vesto Slipher, director of the Lowell Observatory in Arizona, noted that a mysterious class of objects collectively called spiral nebulae were all speeding away from Earth. He measured that their light was "stretched" or reddened by their apparent motion away from us. The nature of the spiral nebulae was a hot topic of debate in 1920, squaring off top observational astronomers against each other. One camp held that they were actually galaxies, independent islands of stars tens of thousands of light-years across, and therefore located very far beyond our own Milky Way. The other camp believed they were much nearer, smaller disks of dust and gas encircling newborn stars. One popular astronomy book of the period estimated these nebulae to be only a few light-years across. This text somewhat condescendingly dismissed the idea that they could be other galaxies as an "effort of great imagination."

But by 1920 astronomers at last had a giant telescope, the 100-inch Hooker telescope on Mount Wilson in Pasadena, California, to show these spiral nebulae in new detail. Astronomer Edwin Hubble used the Hooker telescope to measure the distances to them by using a special class of "milepost marker" stars (also often named "standard candles") called Cepheid variables. The oscillation rate of these stars gives a direct readout of their intrinsic brightness. This value can be used to calibrate the star's true distance by simply measuring how much the star's light dims traveling across space, which happens at a mathematically predictable rate.

Edwin Hubble soon realized that the spiral nebulae are so far away they are actually galaxies—independent islands of stars—very far beyond our own Milky Way Galaxy. This discovery won over scientists who had believed that the Milky Way was the entire universe. Hubble then made the momentous discovery that the farther away a galaxy is, the faster it is receding from us. This led him to realize that galaxies are apparently moving away because space itself is expanding uniformly in all directions.

This finding was at odds with Einstein's theory of General Relativity. Einstein realized the universe should collapse under the gravitational pull between stars, so he invented the cosmological constant, a repulsive form of gravity, to keep the universe in balance. Stars weren't falling together or flying apart. This satisfied the naked-eye view of a seemingly static and eternal cosmos. But Einstein quickly abandoned the cosmological constant. By the end of the century, however, the reality of this repulsive gravity would be proven to the amazement of astronomers, who had largely locked it away as a skeleton in the closet of embarrassingly wrong theories. Einstein himself had dismissed it as his "biggest blunder."

Hubble realized that if he could measure the universe's speed of expansion, he could easily calculate its true age. Assuming that the universe's expansion rate hasn't changed much over time, Hubble calculated an age of about two billion years. Astronomers who followed him wrestled with refining the universe's age for 60 years. Precise expansion measurements using Hubble Space Telescope observations converged on an age of approximately 13 to 14 billion years. In 2001 the Hubble telescope uncovered the dimmest

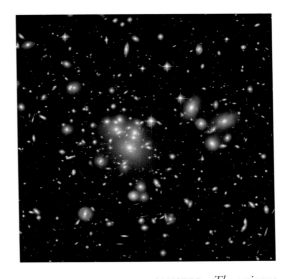

GIANT GRAVITATIONAL CLUSTER *The universe is rich in layers upon layers of galaxies and their underlying bedrock, dark matter. This is vividly illustrated in a Hubble Space Telescope view of the massive galaxy cluster Abel 1686. This dense grouping of yellowish galaxies looks caught in a red and blue spider's web of eerie, distorted background galaxies. The gravity of the cluster's trillion stars, plus dark matter, acts as a two-million-light-year-wide lens in space. This "gravitational lens" bends and magnifies the light of galaxies far behind it. Some of the faintest objects in the picture are over 13 billion light-years away. The picture is an exquisite demonstration of Einstein's prediction that gravity warps space and so distorts beams of light. The amount of warping can be used to decode fundamental parameters of the universe. (Courtesy H. Ford, Johns Hopkins University, and NASA)*

and oldest white dwarf stars in our Galaxy. These burned-out remnants of normal stars, estimated to be 12.6 billion years old, provide a beautiful, independent confirmation of the previous estimates.

Cosmic Evolution

The idea of an expanding universe was unsettling enough. Astronomers also had to consider the idea that it must be evolving too. The Belgian mathematician and priest Georges Lemaître theorized in 1927 that the universe sprang from a hot and dense "cosmic egg," or more exactly an object he called the "primeval atom," that existed for eternity until it miraculously exploded. The idea established by Lemaître likened the present universe to a fading fireworks show, where now all that remains is smoke and ash from a blazing beginning.

By the middle of the century a trio of leading British cosmologists, Hermann Bondi, Thomas Gold, and Sir Fred Hoyle, derided the cosmic expansion theory. They nurtured a competing model called the steady-state universe, whereby the universe is eternal and matter is always spontaneously created in space. This holds the universe in equilibrium as ongoing star formation forever fuels the universe's growth. In true Copernican thinking, the steady-state theory meant that we do not live in a special time. The universe would always look the same for countless generations in the past and future.

The idea of cosmic expansion from a beginning point was first dubbed the "Big Bang" by Hoyle on a British radio program in late March 1949. Hoyle didn't necessarily mean to be sarcastic about the competing theory. He was trying to create a word picture for the listening audience. The phrase Big Bang was succinct and colorful. Hoyle could have said something like "spontaneous phase transition of the Lemaître protonucleus," but it just would not have had the same ring with the radio audience. The term Big Bang did not make it into scientific literature until a decade later.

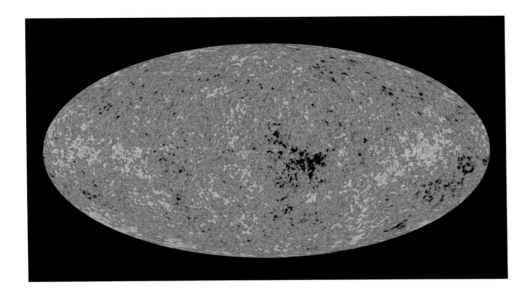

But the steady-state model was fraught with paradoxes. Why is the sky black at night if there is an infinity of stars? If the universe is infinitely old, life should no longer be evolving. Anything that could have happened would have happened by now. And the universe would have had time to reach the same temperature everywhere; there would no longer be hot stars in the sky.

The brilliant and eccentric Russian theorist George Gamov predicted that if the universe was formed in a cataclysmic explosion, there ought to be radiation left over from that explosion. This radiation should be detectable, and it should be uniform throughout the universe. In 1964 two Bell Labs scientists, Arno Penzias and Robert Wilson, stumbled upon the relics of the once hot and dense universe as predicted by Gamov. While calibrating a communications satellite antenna they were puzzled to discover that the entire sky has a background hiss in microwave energy. No matter where they aimed the antenna, the hiss persisted. At first they thought it was a malfunction, or a thermal source as innocuous as pigeon droppings inside the antenna's feed horn. The

microwave glow did not come from any stars, clusters, galaxies, or any other particular location in space. It also represented a lot more energy than all the stars and galaxies combined. The sky glow was as perplexing as walking into a windowless room and finding that the walls, ceiling, and floor all glowed with an eerie luminescence—but in the absence of a light source!

This background glow was widely embraced as the "smoking gun" for Lemaître's initial hot and dense universe—one without stars, planets, or life. This was a seething crucible out of which the universe today must have been forged—and must have evolved. Observations by NASA's Cosmic Background Explorer (COBE) satellite and much higher-resolution views by the Wilkinson Microwave Anisotropy Probe (WMAP) found structure in the cosmic microwave background. Encoded in this fossil-like imprint is the simple blueprint on which cosmic expansion, the density of matter, and other fundamental parameters of the universe left their marks forever.

"It's a lot like matching fingerprints," says David Spergel of Princeton University. "We ran computer simulations based on many different values for all of the numbers, generated patterns for each, and found the one that best matched what we actually saw." The recipe for the universe: 4 percent ordinary atoms; 23 percent "dark matter," an unknown type of matter that pervades space; and 73 percent "dark energy," a form of the repulsive gravity first predicted by Einstein that is expanding space at an ever-faster rate.

Cosmologists surmised that the early galaxies that emerged from this crucible must have been fundamentally different from the universe around us today. Astronomers had to wait for the sensitivity and clarity of the Hubble Space Telescope to peer far enough back in time to truly see how galaxies change over time. In 1996 and again in 1998, former Space Telescope Science Institute director Robert Williams used his own precious discretionary observing time to use the Hubble telescope to peer for 10 consecutive days at small and seemingly blank patches of the sky near the north and south celestial poles above Earth. The long exposure trawled thousands of galaxies scattered

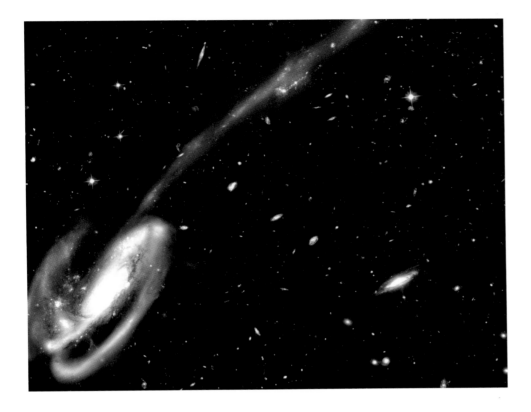

THE TADPOLE GALAXY *Beyond the uniformity of the naked-eye universe lies an "other" universe full of discordant objects and cataclysmic disturbances. This is a view of the early universe; the light from that long-lost era is just now arriving at Earth. Galaxies devour each other; stars form in infernos of gas and dust and light. This photograph of the universe taken with the Hubble Space Telescope reveals the vibrancy of energy and matter in space. In this view a foreground spiral galaxy resembles a runaway skyrocket. Dubbed the "Tadpole Galaxy," it has a tail of stars that was tidally formed in a close encounter with another galaxy. (Courtesy H. Ford and NASA)*

down a "time tunnel" 12 billion light-years long. In 2003 William's successor, Steven Beckwith, used his own director's time to boldly go even further with the Hubble Ultra Deep Field exposure. This view carries astronomers all the way back to the end of the so-called dark ages, the relative brief period after the Big Bang when the universe was cool but devoid of galaxies. Astronomers aimed Hubble's sister NASA observatories, the Chandra X-ray Space Telescope and the infrared Spitzer Space Telescope, at the same small patch of sky that Hubble scrutinized. The comparative view of galaxies in high energies, visible starlight, and warmed dust offered for the first time a holistic and far-reaching view of galaxy evolution. This was bolstered and complemented by wider, though not as deep, surveys from giant ground-based telescopes.

These surveys, collectively, took astronomers beyond the uniformity of the naked-eye universe into a "lost in time" universe—a universe teeming with discordant objects and cataclysmic disturbances. Galaxies devour each other. Stars form in infernos of gas, dust, and light. Truly a core sample of the universe, the superdeep exposures unveiled dim red fragments of galaxies near the horizon of the universe, blue "building blocks" of galaxies, and fully mature galaxies.

The Book of the Universe

The evolution of the universe from chaos to order is a narrative of epic proportion. It interleaves the parallel ideas of geological, biological, and stellar evolution. Current Big Bang cosmology predicts that the universe arose initially from a volume less than one-trillionth the size of a proton. When the universe was one-billion-billionth the diameter of an atom, it contained huge amounts of compact energy.

The early universe went through a rapid series of profound changes. The universe sprang into existence under the unimaginable birthing push of a repulsive force, which may still exist today between the galaxies. This rapid period of inflation lasted only from 10^{-35} to 10^{-34} of a second, yet it imprinted on the universe all the characteristics that would predetermine its evolution for possibly an eternity.

The universe cooled rapidly as it bubbled up from a singularity, an infinitely small and dense "seed" universe. As it did, various forces and particles condensed out. Inflation—a brief but incredibly rapid expansion of the universe—happened because this freezing out of matter and energy was not continuous but rather cascaded, like water stair-stepping down a cliff. If you hold a ball in the air, it has potential gravitational energy that will be released if you drop it. Now imagine that the ball falls onto a table. Some energy will be released, but that process will pause until the ball rolls off the table and suddenly drops further, abruptly releasing more kinetic energy.

Cosmologists believe that the expanding universe "paused" at 10^{-35} second and then explosively sprang up to expand incredibly larger in an unbelievably brief amount of time. This rapid inflation smoothed out the universe so that it would be the same initial temperature everywhere. During inflation the universe sloshed like water in a tub, and these acoustic ripples imprinted structure onto the universe. It's like sound waves hitting a window and causing microscopic ripples in the glass. Once the universe was cool enough, this pattern of slightly high- and low-density gas regions served as a template for building up stars, and then galaxies.

At creation plus one minute the universe was still much hotter than the inside of the Sun. This was hot enough to make protons. Free-floating neutrons also existed but decayed in 10 minutes unless captured by protons to make helium nuclei. A trace amount of lithium was also produced. After three minutes, no longer than the time it takes to cook an egg, the universe had cooled so much that subatomic particles could no longer travel fast enough to overcome repulsive nuclear forces, and they stuck together.

Dark after the Dawn

The brilliant universe dimmed and cooled as hydrogen and helium nuclei captured free-flying electrons. The universe was now spacious enough that its firestorm of photon "bullets" could not frequently collide with emerging hydrogen atoms and dislodge electrons. It was no longer dense plasma like the glowing gases inside a fluorescent tube.

About 360,000 years after the Big Bang, the young universe would have looked like a very gloomy place. It was pitch black—the fire and fury and glory of its first few hundred thousand years forever gone. It would have resembled the quiet after the fireworks finale as described by Lemaître—just smoke and ash. But even during the "dark ages" the universe would have continued reinventing itself through birth and renewal, and increasing complexity. If atoms had been scattered evenly throughout the universe like

DARK MATTER UNIVERSE *Supercomputer simulations like this picture are used to understand the emergence of structure in the universe. The bulk of the universe's mass, dark matter, is the backbone of this structure. In the first few billion years, chains of galaxies formed along great filaments of dark matter. Galaxy clusters formed where chains intersected. In reality, luminous "normal" matter in the universe is like the white foam on top of huge underlying waves. (Courtesy F. Summers and STScI)*

a perfectly smooth bedsheet, the universe might have remained an eternally black sea of thinly distributed matter. But imperfections were imprinted on the universe, making it more like a wrinkled sheet.

During these early epochs the universe was far more than a sea of hydrogen, helium, and lithium atoms. A distant cousin was "dark matter." It is dark because it does not emit any kind of light or other electromagnetic radiation. As noted earlier, normal matter makes up only a few percent of the composition of the universe.

The relentless tug of gravity from dark matter asserted itself on the free-floating hydrogen. The universe was cool enough that hydrogen could no longer resist gravity's pull. Without the pressure of photons colliding with atoms, matter, both dark and normal, began to coagulate. Dark matter got lumpy sooner than normal matter did, along the "wrinkles" in the bedsheet. This built a ghostly backbone structure to the

universe, over time coming to resemble the filamentary structure of a sponge. The gravity of the clumps of dark matter pulled on "normal" matter, and the normal matter collected in little "puddles" of dark matter. Hydrogen fell together to form dense clouds.

STELLAR ALCHEMY

In Greek mythology a race of giants first ruled Earth, the Titans. Astronomers presupposed that the first stars were Titans too, weighing in at hundreds of times the mass of the Sun. While in the present-day universe heavier elements inside stars being born help cool the contracting cloud of gas so that it can reach critical density for fusion, in the young universe the first stars were made purely of hydrogen and helium because other elements didn't yet exist. This meant that only the biggest stars had enough gravity to collapse and overcome the resistive gas pressure trying to blow them apart. But if they had been too massive, beyond about 300 solar masses (that is, 300 times the size of the Sun), they would have immediately collapsed into black holes. The universe would have been scattered with midsized black holes and no stars, planets, or life as we know it.

It is nearly impossible to imagine the opulence of these first stars. They must have shone fiercely and defiantly as lords over the darkness, like lighthouse beacons across an inky black ocean night. They opened a new chapter for the universe—the Stelliferous Era (meaning "filled with stars"), when stars would rule the darkness for perhaps 100 trillion years to come. These first stars burned so furiously that they must have been very short-lived. They died in stupendous supernova explosions, the biggest explosions since the Big Bang itself. These supernovae were 100 times more powerful and brighter than those seen in the nearby universe in recent centuries. They gave the formative universe a "kick-start" by providing shockwaves that collapsed the surrounding clouds of condensed hydrogen to initiate the process of forming more stars. The heavier

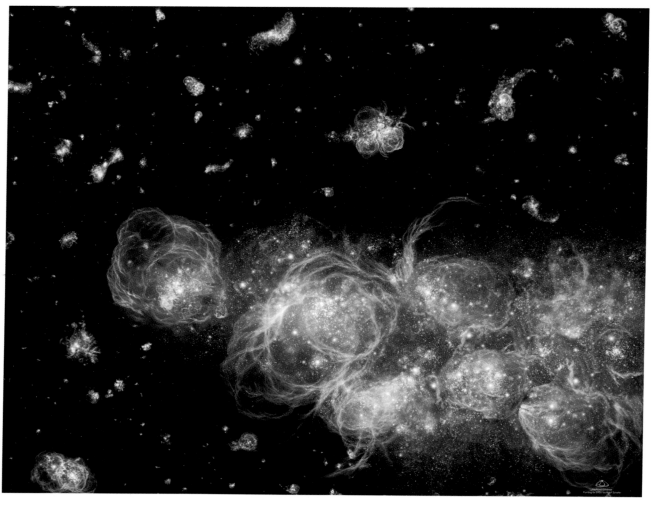

STAR FORMATION IN THE EARLY UNIVERSE *This artist's impression shows the very early universe (less than one billion years old). It went through a voracious onset of star formation, converting primordial hydrogen into myriad stars at an unprecedented rate. Back then the sky blazed with primeval starburst galaxies; giant elliptical and spiral galaxies had yet to form. Within the starburst galaxies, bright knots of hot blue stars came and went like exploding fireworks. Regions of new star birth glowed intensely red under a torrent of ultraviolet radiation. Unlike today, there was very little dust in these galaxies because the heavier elements had not yet been cooked up through nucleosynthesis in stars. (Courtesy A. Schaller and NASA)*

elements—like carbon, oxygen, lead, iron—were widely scattered to populate the small, expanding universe with heavier elements. In so doing, this sowed the elemental seeds for planets and life.

That the first-generation stars began the process of fabricating the more complex atoms in the universe was realized following the birth of nuclear physics in the early twentieth century. Einstein had shown that matter was essentially frozen energy. Under the right conditions some of the tremendous energy locked up in the nucleus of the hydrogen atom could be released. This requires temperatures over 10 million degrees, where hydrogen nuclei are traveling so fast that they can overcome repulsive forces and combine to make helium. At even higher temperatures helium fuses into carbon, carbon into nitrogen, and on up to iron. The raw violence of supernovae reaches even higher temperatures and so makes even heavier elements.

Nuclear fusion allowed nature to juggle more and more electrons in shells to make bigger atoms. But this had to wait for stellar furnaces to come online. This is a truly miraculous vision, a universe fabricating the stuff of planets and people in the most unlikely places, the seething interiors of the earliest stars.

The "star stuff" was then spewed back into space for future generations of stars. The universe was getting sooty—quite literally with carbon. Other common elements included oxygen and nitrogen atoms. When combined with hydrogen, these basic elements formed molecules of ammonia, carbon dioxide, and methane. These common elements and molecules were the building blocks for constructing planetary environments, fired in solar kilns for the emergence of life in the youthful, effervescent universe.

Blaze of Glory

The early universe was a rambunctious place. Most of the stars that would ever exist came into being in the first few billion years. Stars quickly assembled themselves into

STAR BIRTH IN THE MILKY WAY *The early construction of the Milky Way Galaxy 12 billion years ago saw a firestorm of stellar birth reminiscent of Van Gogh's painting* Starry Night. *The Galaxy was ablaze with bright blue stars that were doomed to explode like a string of firecrackers.*

clusters, then superclusters, and then entire galaxies stretching along vast filaments of dark matter. Where filaments crossed, thousands of galaxies grew and then collided with each other. Brilliant quasars were born when supermassive black holes inside these galaxies devoured gas from galaxy collisions. But the Age of Galaxies was playing a game of "beat the clock" against the fabric of space-time itself. About seven billion years ago the universe began expanding at an ever-faster rate, which squelched the formation of galaxy clusters. The great age of galactic construction was at an end.

Just a couple billion years after the Big Bang the Milky Way Galaxy was born 60,000 light-years from the intersection of two great filaments of dark matter that precipitated the birth of thousands of galaxies in what we now call the Virgo Cluster. Our Galaxy formed in a "rural," relatively low-density region of the universe. The Milky Way took billions of years to grow into the majestic pinwheel we see today. Imagining its growth is a bit like watching a city develop from a cluster of little towns merging into a booming metropolis. The latest supercomputer simulations show what can best be described as a cosmic Cuisinart. Smaller galaxies whip crazily around under gravity to merge to build up the halo, bulge, and disks of the larger spiral galaxies.

Inside our corner of the universe 12 billion years ago dozens of blue clusters of stars swarmed together like bees. Shards and tentacles of glowing gas enriched with heavier elements bubbled up from titanic explosions from the clusters' most massive stars. These star clusters formed first in small mergers and later in bigger ones. The mergers can be pictured as many little brooks coming together to form streams, which then converge into a wide river. For the first several billion years the Milky Way's neighborhood was blobby and chaotic, containing hundreds of globular star clusters and dwarf galaxies.

The Milky Way cannibalized many of these star clusters, which built up a halo of stars around our Galaxy and the central bulge. Over a few billion years gas around the Galaxy slowly settled into a disk. Density waves within the disk set up "traffic jam"

MI6 NEBULA *The MI6 Nebula (also called the "Eagle Nebula") is a nearby region of star birth. A bright open cluster of stars lies in the center of a nascent cloud of gas and dust. The surface of the cloud fluoresces different colors under the ultraviolet glow of radiation from the hot young stars. Black stalks of cold gas laced with dust create a fantasy landscape. Our Sun and its planets were likely incubated in such a star factory. (Courtesy NOAO, AURA, and NSF)*

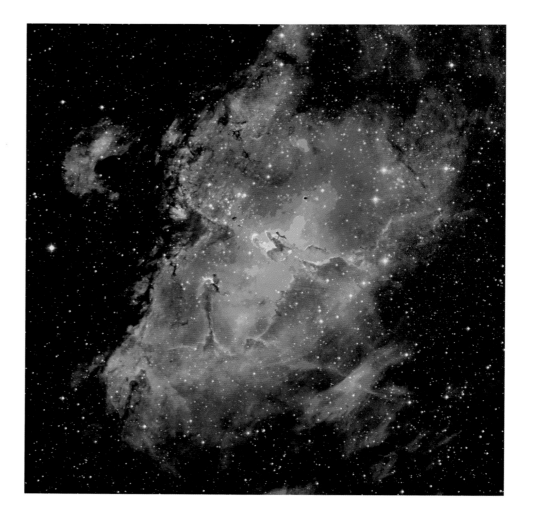

regions where dust and gas piled up like snow in front of a plow. This created majestic spiral arms, the glorious hallmark of a disk galaxy.

About five billion years ago a massive star in the Milky Way's disk came to an abrupt end. Its iron core, unable to sustain nuclear fusion, imploded in the wink of an eye. The rebound sent out a shockwave that tore the star apart, spewing heavy elements into space at one-tenth the speed of light. For a few million years the expanding bub-

ble of supernova debris slammed into surrounding clouds of gas and dust, shocking them into glowing, gaudy neon-strip colors. The blast wave finally plowed into cold, dusty clouds of interstellar hydrogen, lacing them with radioactive shrapnel from the supernova blast. Like snow pushed by a plow, the gas grew denser because of the shock, and the cloud began to collapse under gravity. Over 99 percent of all the gas fell into a central core, and the fires of fusion were ignited. Buoyed by centrifugal force, a thin disk of dust formed around the star. This was not a unique event: it is the standard recipe for star birth throughout the Galaxy.

The young star began to shine steadily. Its radiation warmed eight major bodies that condensed out of a maelstrom of debris swirling around it. These bodies survived an ensuing "demolition derby" with other embryonic debris. Even as they settled into stable orbits, smaller shards pummeled them. A runaway intruder smashed into one of the protoplanetary bodies lying a mere 93 million miles from the star. The collision created a moon in the process. A rain of ice-laden asteroids would later help irrigate the battered planet. It was also zapped with blistering X-ray and ultraviolet light gushing off the madly whirling young star.

The oceans that condensed after the interplanetary barrage ended allowed for a chain of increasingly complex chemistry that eventually gave rise to self-replicating matter. This tenacious new force in the universe survived innumerable cosmic catastrophes that pounded the small blue planet. After another 3.5 billion years, punctuated by further cosmic catastrophes, the self-replicating matter became self-aware. It gazed out onto an infinite sea of galaxy in wonder, awe, and loneliness.

Like a spider plant shooting out seedlings, this consciousness would eventually send robot emissaries into the infinite abyss among the Galaxy's stars. The automobile-sized spaceships, small but eternal monuments to the curiosity, prowess, and perseverance of their creators, would carry a simple note-in-a-bottle message to the stars:

We Are Here . . .

2

Stars

THE GENESIS MACHINES

STARS ARE A PREREQUISITE FOR THE EXISTENCE OF PLANETS AND LIFE IN THE UNIVERSE. Over billions of years they have arranged themselves "brick by brick" into a hierarchy of objects: star clusters, galaxies, and immense clusters of galaxies. They are the universe's factories for forging the heavier elements beyond hydrogen and helium. Most of these stars gently expire and puff off these heavier elements in colorful shells and jets. Others rattle the universe in huge supernova explosions.

If everything in the universe were at exactly the same temperature, order and structure could not emerge. Stars help forestall the universe's inevitable march toward maximum entropy by halting a hydrogen cloud's collapse and flooding space with energy from nuclear fusion. The gravitational whirlpool around a star also brings the necessary order to matter for building planets as potential homes for life.

Stars are the most obvious sources of energy for nurturing life on planet surfaces. The early universe was so hot that it was once the same temperature as stars. If the universe did not expand and cool, the universe could not make hot objects like stars. A star basically is a hot object in a dark, cold sky. Its light offers a low-entropy flow of energy to the surface of a planet. Life on Earth thrives and builds complexity at the expense of robbing "order" from sunlight and returning it to space as more disordered infrared radiation.

Deep sky surveys show that most of the stars in the universe came into being in the first few billion years after the Big Bang. Within the spiral galaxies, and some lagging dwarf irregular galaxies, star birth continues at a rate one-tenth of what it used to be. To an outside observer the disk of a galaxy would look grimy and polluted. Like the

THE LIVING SUN *The Sun is a seething "fusion engine" of raw energy for nurturing life on planets. It is our nearest laboratory for understanding the dynamics of distant stars. These X-ray images of the Sun, taken between 1991 and 1995, provide a dramatic view of an active and changing star. During an 11-year cycle, the magnetic field around the Sun grows increasingly complex as it is tangled by the Sun's rotation. When the Sun is active, flares in its atmosphere glow at millions of degrees because they are compressed by these fields. This releases intense bursts of X-rays. The relatively cooler visible light surface of the Sun glows at 11,000°F. (Courtesy NASA, the National Astronomical Observatory of Japan, and Lockheed-Martin)*

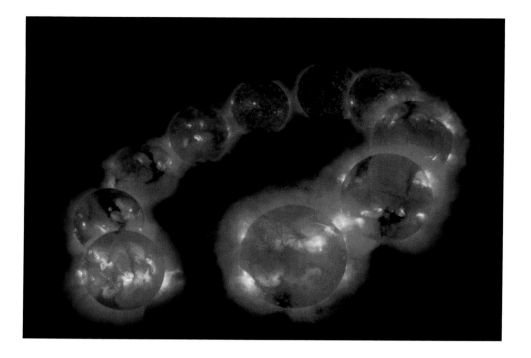

air over a large industrial city, it is dusty and smoggy with gases, filled with all kinds of contaminants. But it really is a galactic "ecosystem" where the elements of first-generation stars are recycled into new generations of stars. The most opulent stars, the blue giants that trace out the spiral density waves in galaxies, help spur new star formation when they explode as supernovae and send out tidal waves of energy. These shock waves compress gas to trigger new generations of stars. This is more than theory. Meteorites contain unusual radioactive elements considered to be the "shrapnel" from a supernova that preceded the birth of our Solar System.

Within the past few centuries it has became commonly accepted that the Solar System's planets are most likely a natural by-product of the Sun's birth 4.5 billion years ago. It is not a unique star, so processes similar to those that gave birth to the Sun and planets should, in principle, be common throughout our Galaxy. The ongoing dis-

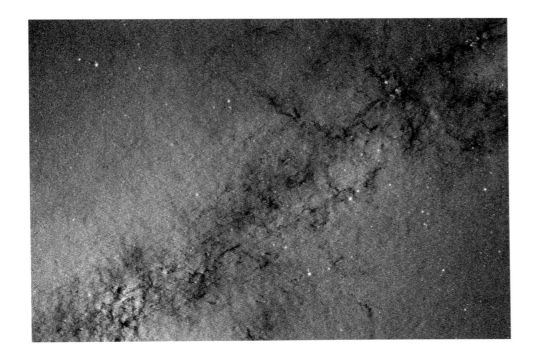

STELLAR TREASURE TROVE *Earth lies about two-thirds of the way out from the center of the Milky Way Galaxy. Most of the view between Earth and the heart of the Galaxy is obscured by dust. Using infrared light, as in this photo, astronomers can see deeper toward the galactic core (the orange region) than they could otherwise. The densest clouds of dust are etched across the galactic plane. How many planets and civilizations may be scattered among these innumerable stars? (Courtesy 2MASS, G. Kopan, R. Hurt)*

coveries of extrasolar planets have solidified this belief. But fully mature planetary systems don't yield clues as to how they formed.

Astronomy textbooks typically present an orderly schematic of the idealized birth of a star and planetary system. The star is born in isolation. A spherical cloud of hydrogen gas laced with dust slowly contracts under gravity. A disk forms around the star. Dust in the disk clumps together to build up the cores of planets. Planets continue to "snowball" in size until they are so massive that they carve out concentric rings in the protostellar disk, like the grooves in a record. Radiation pressure from the newborn star sweeps the disk clean of debris, and voilà! Planets.

But astronomers are realizing that the "devil is in the details," as the picture grows ever more chaotic on close inspection. Increasingly sophisticated supercomputer simulations show that the interplay of gravity, radiation pressure, and stellar magnetic fields

stirs up a complex maelstrom for an embryonic planetary system. Predicting the outcome for planetary systems is like trying to predict the details of the pattern cream will make when it first swirls after being poured into coffee. When it comes to making orderly planetary systems like ours, the success of the endeavor may be as chancy as a roll of the dice. "Star and planet formation is a hazardous process," asserts astronomer John Bally of the University of Colorado. He has found that young stars and nascent planetary systems are zapped by the radiation of nearby bigger siblings. Dynamically there are hazards too. Circumstellar disks, the spawning grounds of planets, are frail and impossibly chaotic. This leads to a game of beat the clock in making planets before the raw materials and dynamics are no longer optimum for growing planets.

SEEDS OF CREATION

It is hard to imagine the ensuing turbulence and chaos of star formation when we look at the prologue to star birth. The raw stuff of stars can be found in the vast ocean of space between individual stars, simply called the interstellar medium (ISM). Matter here is very scarce. The air inside a ping-pong ball contains 10 million trillion atoms. But that same volume in interstellar space would contain just *one* atom. In dense star-forming regions this number could go up to 10,000 atoms per cubic inch—still a near vacuum by physics laboratory standards.

When we look along the Milky Way on a clear night it simply resembles a hazy ribbon of light. Through binoculars it resolves into a gravel path of countless stars. But even to the naked eye, the Milky Way's luminous band breaks up into dark lanes that crisscross it. These were once mistaken for gaps in the Galaxy's disk. Now they are known to be dust clouds lying between us and the central part of the Galaxy.

The Swiss cheese structure of the ISM is invisible to us. The cold hydrogen gas is the "cheese," and the "holes" are hotter gas, heated by supernova explosions that "blow

bubbles" in space. The Sun and Solar System reside near the edge of a hydrogen cloud 60 light-years in diameter. The space outside this local gas cloud is called the "Local Bubble," consisting of very hot gas. A supernova explosion may have created this 300-light-year-wide "hole" in the galactic plane.

In this stellar recycling, elements are drawn into stars, further enriched to make heavier elements, and then blown back into space for future-generation stars. Stars like the Sun contribute a few percent of their mass back into space. Elements such as carbon, nitrogen, sulfur, and oxygen come from earlier-generation solar-type stars. Strontium, zirconium, and barium are made in aging red giant stars. Iron, gold, and uranium are forged in supernovae. The fraction of heavier elements in stars, called the metallicity abundance, increases the later a star forms in the history of the universe. The Sun, as measured by its heavy element content, is a second- or third-generation star.

Stars born in regions of the Galaxy where vigorous star formation is ongoing may have even higher metallicity. This helps planet formation, says Debra Fischer of San Francisco State University: "We now know that stars which are abundant in heavy metals are five times more likely to harbor orbiting planets than are stars deficient in metals. If you look at the metal-rich stars, 20 percent have planets. That's stunning." (The percentage concerns only giant planets detected by current surveys; it would likely be much higher in terms of all planets.)

STAR FACTORIES

Amateur astronomers enjoy perusing the Galaxy for faint glowing clouds—emission nebulae—that are the sites of new star formation. They resemble small nighttime campfires in a forest as seen from far away; they are firestorms of star birth. Star birth is an ongoing feature of the Galaxy. The shadowy silhouetted structures inside these clouds

CRAB NEBULA *Supernovae enrich interstellar space with many of the heavier elements for star and planet construction. This colorful network of filaments in the Crab Nebula is the material from the outer layers of a star that exploded nearly 1,000 years ago. The yellowish-green filaments toward the bottom of the image are closer to us and are expanding at nearly half a million miles per hour. The various colors in the picture arise from different chemical elements created during the evolution and explosion of the star. These include hydrogen (orange), nitrogen (red), sulfur (pink), and oxygen (green). The shades of color represent variations in the temperature and density of the gas, as well as changes in the elemental composition. (Courtesy Hubble Heritage and NASA)*

V838 MONOCEROTIS *This is a rare CAT-scan-like probe of the three-dimensional structure of shells of dust ejected from an aging star. Material processed in the fusion engine in the heart of the star is ejected in this way back into interstellar space. In 2002 the star called V838 Monocerotis put out enough energy in a brief flash to illuminate ordinarily invisible surrounding dust, like a spelunker taking a flash picture of the walls of a pitch-black cavern. In this rare "light echo" event, some of the light from the outburst travels as far as the dust, which reflects it to Earth. Because of this indirect path, the light arrives at Earth months after light coming directly toward Earth from the star itself. Different shells of dust are illuminated as the light continues rebounding off the dust, unveiling different parts of the reflection nebula. (Courtesy H. Bond, STScI, and Hubble Heritage)*

resemble a fantasy landscape. A common shape is a long, slender pillar resembling an afternoon thunderhead, like the iconic Horsehead and Eagle Nebulae.

The glowing clouds that the "elephant trunk" features are embedded in form just the tip of the iceberg. The nebulae, called ionized hydrogen regions or HII regions, are blisters on the edge of dark, giant molecular clouds that store most of the star-forming mass of our Galaxy. They are called giant molecular clouds because their hydrogen is so cold that hydrogen atoms bond together in pairs. Hidden from the destructive influence of hot radiation from young stars, and chilled to nearly absolute zero (−459°F), dust and hydrogen can collect in giant molecular clouds that can be hundreds of light-years across and 100,000 times denser than the ISM.

These dark molecular clouds are turbulent, clumpy, and chaotic, as dramatically shown in hydrodynamic computer simulations. Light-year-wide "pockets" buried deep inside these could fragment and condense many "nuggets" of hydrogen, precipitating a flurry of star formation. About 10,000 solar-type stars are born from each giant molecular cloud. The bubbling energy of newborn stars eats out gaseous caverns inside the clouds like a cosmic "Pacman." One of the nearest and best-known clouds is the Orion Nebula, located 1,500 light-years away. Despite this prolific star formation, molecular clouds like Orion convert only about 10 percent of their gas into stars.

Most of the hydrogen gas buried inside a molecular cloud is laced with trace gases such as oxygen and nitrogen, and with fine dust grains of carbon and silicon that are smaller than smoke particles. These are the raw materials for making planets. These particles also provide the seeds for collecting much-needed volatile chemistry that is easily broken apart by starlight.

Cold clouds shocked by the stellar wind of nearby star formation raise frigid temperatures to about 200°F. This initiates chemical reactions that convert most of the oxygen atoms in the interstellar gas into water. The Orion Nebula is a big chemical factory that generates enough water molecules in a single day to fill Earth's oceans 60 times over! Eventually that warm water vapor will cool and freeze, turning into small,

solid particles of ice. Similar ice particles were presumably present within the gas cloud from which the Solar System originally formed. These ices remained packed away and inert inside comets and asteroids. They are unleashed when these minor bodies slam into planets.

Much of the water in the Solar System was originally produced in giant water vapor factories like Orion. The most exciting property of interstellar ice is that when exposed to light it can flow, even though its temperature is only a few degrees above absolute zero. The similarity of this ice to liquid water allows it to create organic compounds, the building blocks of life as we know it. As much as 10 percent of the volume of interstellar ice grains is composed of simple molecules such as carbon dioxide, carbon monoxide, methane, and ammonia, and 100 other different organic compounds in cold molecular clouds.

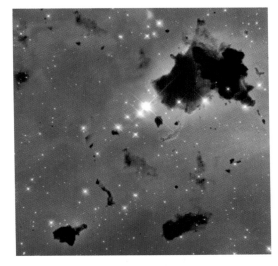

DARK GLOBULES *These dense, opaque dust clouds—known as "globules"—are silhouetted against the red glow of hydrogen gas and bright stars in the busy star-forming region IC 2944. The largest of the globules in this image is actually two separate clouds that overlap along our line of sight. Each cloud is nearly 1.4 light-years along its longest dimension, and collectively they contain enough material to make more than 15 stars like the Sun. (Courtesy Hubble Heritage and NASA)*

A Star Is Born

The earliest stages of star formation inside nebulae remain poorly understood. Something causes these diffuse, quiescent clouds to become gravitationally unstable and begin to collapse, fragmenting into smaller condensations in the process. The dimensions of this collapse are mind-boggling. The gas density rises by a factor of a billion trillion—analogous to something the size of Wisconsin being compressed to the size of a dime.

Even stranger is the fact that gravity fragments the clouds into a predictable proportion of small-, medium-, and high-mass stars. A very small fraction of the cloud becomes blue supergiants, dozens of times more massive than the Sun. Most of the stars that precipitate out, the most numerous stars in our galactic neighborhood, are one-fifth of the Sun's mass. The cloud also precipitates the universe's underachievers, the brown dwarf stars. These objects are only 10 to 80 times the mass of Jupiter, too

cool to sustain nuclear fusion. These low-mass objects scatter through encounters with larger stars. Observations of the Orion Nebula have found numerous brown dwarfs drifting through space.

When a hydrogen cloud is compressed it generates tremendous heat. Anyone who has ever pumped up a bicycle tire has experienced what happens when gas is compressed. A puzzling fact is that unless this heat is removed, the "steam cooker" pressure would push back on gravity and halt the star's collapse. The presence of water, carbon monoxide, and oxygen helps to cool the gas, permitting compression to continue. Even stranger, though, is the fact that these cooling elements did not exist when the very first stars formed. The first stars, made up only of hydrogen and helium, somehow had to bootstrap themselves. This means the first stars must have been extraordinarily massive to overcome pressure.

Fundamental to star birth is the fact that the universe commonly forms disks of gas and dust swirling around a massive central body. Galaxies collapse to form disks, and disks exist around black holes. So a disk around stars coming into being seems natural. As the collapsing cloud shrinks, whether around a black hole, a galaxy core, or a star, its rotation rate increases to conserve angular momentum. This is exactly what happens when a figure skater retracts her arms and "spins up." The disk forms around the star, buoyed by centrifugal force. Though the centrifugal force is at its maximum in the disk (which is exactly at right angles to the star's spin axis), it slows but does not necessarily halt dust and gas accretion onto the star.

The disk then begins to collapse onto the star and is clumpy and turbulent. Material from the "cocoon" of gas and dust around fledgling stars feeds the disk. Depending on the thickness of the disk, this material then spirals onto the star, where it is heated, then fiercely ejected along jets. These billion-mile-long blowtorches herald the birth of a new star. The jets dramatically poke out of molecular clouds like a skyrocket trailing a plume. The in-falling gas is not smooth but lumpy as clumps drop onto the star. This is clearly evident in images of jets that reveal a string-of-pearls appearance.

FORMATION OF THE DISK *Stages in the conventional birth of a planetary system: (1) Young stars form in a giant cloud of gas and dust. (2) As the material settles into a disklike shape around individual stars, jets of hot gas shoot away from a star as the disk dumps material onto it. (3) The disk stops feeding material onto the star, and planets begin to come together.*

Clumpy "cannonballs" of gas fly along the jet flow and often catch up with slower-moving blobs shot out earlier. Today we know that circumstellar disks are big, they are abundant, and they are turbulent.

It wasn't until the 1970s that NASA's Infrared Astronomy Satellite (IRAS) offered the first evidence for the existence of dust disks around stars. The spectrum of energy coming from a young star being formed showed a curious bump in infrared emission. This could not come directly from the star, which obeys a standard "blackbody" spectrum (where a body's brightness follows a predictable distribution of electromagnetic energy depending on its temperature). Instead, it had to come from heated dust around the star that would reradiate infrared light back into interstellar space.

In the 1980s and early 1990s, millimeter-wavelength observations led to the conclusion that disks several billion miles across surround many young stars. Observing at millimeter wavelengths makes the dust particles more visible than in optical light, so it is much easier to detect the faint dust signal near the bright star. One of the most dramatic findings came in the early 1990s, when the Hubble Space Telescope successfully imaged dark, dusty disks in the Orion Nebula. Many were seen in silhouette against the glowing nebula's "walls," looking like little Frisbees.

In 2004 NASA's Spitzer Space Telescope began a survey of thousands of stars to characterize circumstellar disks. Spitzer can't image the disks, but the stellar spectra show the telltale infrared fingerprint of the warm dust in the disks. Spitzer can even tell if a disk has an inner gap that has likely been gravitationally swept out by larger bodies.

PLANETARY DISK II *A young star is a planet-building factory. A vast, embryonic circumstellar disk of gas and dust swaddles the newborn star. Gas condensations in the disk begin to form giant planets like Jupiter. Two small, comet-like objects burn up and disintegrate as they plunge into the giant planet's atmosphere. Several small protoplanets are slowly building up from the agglomeration of dust close to the star. Material near the center of the disk spirals onto the star and is heated and ejected as a narrow jet. Powerful magnetic fields keep the jet long and narrow like a fire hose stream. Stars do not form in isolation. The giant molecular cloud that spawned this star's birth can be seen in the background. Gaseous "pillars of creation" for new stars appear like summer afternoon thunderheads.*

ABLATING PROPLYD IN THE ORION NEBULA *Planet formation is a hazardous process. Proto-planetary disks (or proplyds) around embryonic stars in the Orion Nebula are being "blowtorched" by a blistering flood of ultraviolet radiation from the region's brightest star. Within these disks lie the seeds of planets. The disks start out being wider than the Solar System and reside in the centers of the cocoons of gas, formed from material evaporating off the surface of the disks. Dust grains in the disk are already forming larger particles, which range in size from snowflakes to gravel. But these parti-cles may not have time to grow into full-fledged planets because of the relentless "hurricane" of radi-ation from the nebula's hottest star, Theta 1 Orionis C.*

But the prognosis for stars is iffy. "Significant numbers of stars have lost protoplanetary disks, but there are still a lot of stars that retain disks," says George Rieke of the University of Arizona. "Many stars appear to lose material in the terrestrial zone of their circumstellar disks [i.e., the inner region, where rocky planets can form] too early to make planets. Terrestrial planets are built around other stars in a series of violent collisions for 200 million years, after which the system settles down." This prognosis is better for cooler red stars, which do not pour out enough radiation to sweep the disk clean quickly.

The protoplanetary disks in Orion are typically 10 to 20 billion miles across and carry a bulk mass of 10 percent the mass of our Sun—enough to make nearly 100 Jupiters! But the reassurance that protoplanetary disks actually go on to evolve planets was diluted by Hubble observations that show many of these disks in distress. They look like hapless comets with long tails of gas streaming behind them. These are caused by the intense flood of radiation from Orion's brightest star, Theta 1 Orionis C, which evaporates away much of the disks.

Southwest Research Institute astronomer Henry Throop says, "The dust we're seeing in the Hubble observations is large, completely unlike dust that we've seen in young star-forming regions like this before. We're seeing the very first stages of planetary formation happening before our eyes. We have two things happening in these systems: dust grains are beginning to stick together as a first step toward making planets, but then these bright stars are trying to tear everything apart. Which one wins is really a big question. It's like trying to build a skyscraper in the middle of a tornado."

Though supergiant stars are a small fraction of the nebula's starry population, their gusher of searing ultraviolet (UV) light dominates the cluster. The far UV radiation heats the inner disks that destroys and evaporates molecules from the disk surface. This flow of gas eventually reaches a point where electrons are stripped off the gas atoms in a process called photoionization, which then produces the bright rims and drives off the gas as easily visible things like hydrogen, oxygen, and nitrogen. After the gas is

ORION NEBULA STELLAR NURSERY *At a distance of 1,500 light years, the Orion Nebula is the nearest large region of star formation. It is home to thousands of young stars, dozens of which are known to have disks of dust that may be forming new planets. At its core, a cluster of four massive stars (known as the Trapezium) provides most of the energy that causes this nebula to glow. This energy also may destroy many of the embryonic protoplanetary disks. The visible part of this nebula is just the glowing tip of a much larger cloud of dust and gas extending up and to the left. Known as the Orion A Molecular Cloud, it is a vast storehouse of material for star birth. This infrared-light view makes the obscuring clouds of dust more transparent, revealing otherwise hidden stars. None of the reddest objects in this picture can be seen in visible light. (Courtesy NASA and JPL)*

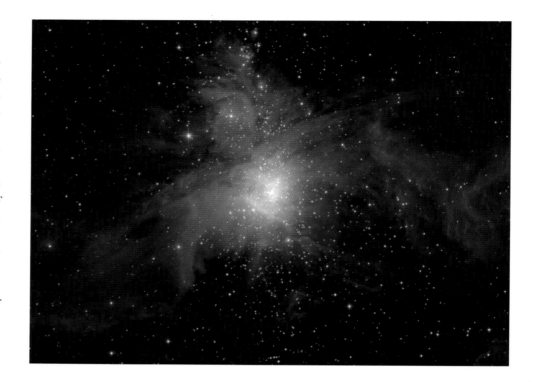

driven off, all that might be left would be dust grains to go into the making of relatively dry terrestrial planets.

The reality is that 90 percent of the stars in our Galaxy are made in Orion-type regions. "We really don't know how long, in general, the exposure to destructive UV radiation will last. However, in the case of Orion, it appears that there is no avoiding destruction. The exception to this would be the case of a really massive protoplanetary disk or one that is very compact, so compact that the UV radiation simply doesn't have time to get into the inner region," says C. Robert O'Dell of Vanderbilt University.

Recently, Carnegie Institution of Washington astronomer Alan Boss has come to the rescue by proposing that planets close to their stars, and embedded deep within a star's gravitational field, may be protected from the intense ultraviolet flux in Orion-like "star factories." It's also not well understood how long stars drifting through the

dust and gas in the billowing nebula would actually be exposed to the radiation from the central star. So this may not be as big a developmental challenge for stars as it seems at first.

DEMOLITION DERBY

It is becoming increasingly clear that planet formation has to happen quickly if it's going to happen at all. Somehow, dust smaller than smoke particles has to clump together to build objects thousands of miles across. This must be accomplished before the young star "turns on" and sweeps away residual dust and gas with a stellar wind of charged particles. The dust disk can dissipate in 100,000 years, and the gas disk might boil away quickly depending on how irradiated the star is by neighboring stars. But no one really knows. Nor do they know where the gas goes. It might blow away, freeze up, or be sucked up by giant planets.

The young disks that have been observed show that they first clear out big holes in their center in as few as 10 million years. "Is this due to planet formation? That's the $10 million question," says Ray Jayawardhana of the University of Toronto. This would make sense because faster orbiting particles near a star would stick together quickly. Astronomers generally agree that the terrestrial planets in the Solar System formed through a bottom-up, agglomeration process. This began with micron-sized dust grains sticking together. When they had sufficient mass, gravity took over to build mile-wide planetesimals that snowballed up to Moon-sized planetary embryos. After less than 100,000 years these Moon-sized bodies came together to build up Earth, Venus, and Mars.

The conventional idea was that Jupiter formed in a similar way, at an optimum distance of 500 million miles from the Sun, beyond the Solar System's "frost line," where volatile materials from the protostellar nebula—water, methane, and ammonia—were not vaporized by the hot Sun. Get too far beyond the frost line, though, and orbits of dust particles are so slow that it takes a very long time for protoplanets to sweep up

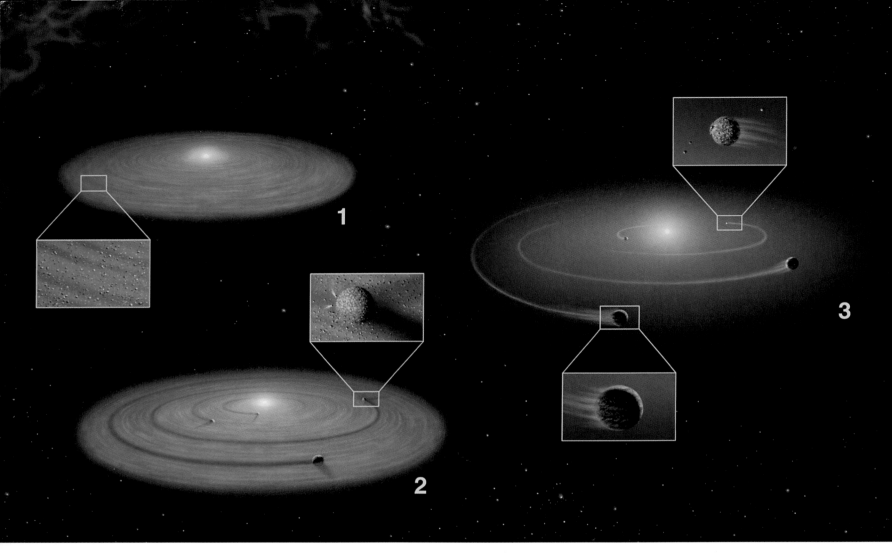

FORMATION OF THE PLANETS *The conventional view of planet formation in a circumstellar disk: (1) The planetary disk is a spinning, flattened disk of gas and dust around a central star but is not completely smooth. (2) The gas and dust begin to clump together, forming ever-larger bodies that clear out gaps along the path of their orbits. (3) These growing objects continue to grow larger and become planets. The solar wind from the newborn star blows away the remaining gas and dust in the disk. Small, rocky planets remain close in to the star, while gas giants orbit in the outer regions. This basic model does not take into account planet migration, which is a new factor based on extra-solar planet discoveries.*

mass gravitationally. The common theory is that Jupiter's rocky core grew so big that its gravity pulled in and held onto hydrogen and helium. But building a big planet this way may take a lot of time, possibly more time than the gas disks would last (which may be only a few million years, according to some theories). Conventional bottom-up planet growth theories predict about 10 million years to make a Jupiter. Newer modeling, however, suggests that the amount of radiation absorbed by dust grains in the disk might cool the disk and force it to contract more quickly, leading to faster accretion of gas to make Jupiters.

Alan Boss has proposed a more controversial "shake and bake" approach to giant planet formation. His models suggest that instabilities in the gas disk can occur within thousands of years, well before the disk dissipates. For this to happen, a clump of gas would somehow have to cool very quickly and contract without needing a "seed core." This top-down theory would help explain the abundance of planets that are a few times the mass of Jupiter in extrasolar systems. In some disks there may be a "tortoise and hare" race between bodies accreting versus those collapsing through disk instabilities. It's a reasonable bet that nature has more than one recipe for building a planet. Whatever the formation processes are, they must be quite robust given the simple fact that so many giant extrasolar planets have been found so far, Boss emphasizes.

A somewhat different formation process around other stars might create "pathological systems." A gas giant planet forms far out in the disk, the swelling giant planet's gravity opening gaps in the disk. After a gap forms, the planet might follow the spiral motion of the disk gas, set up by a spiral density wave commonly seen in disk galaxies as well as in Saturn's rings. The disk contains so much mass that there is dynamical friction with the gas giant planet, putting a viscous drag on the planet.

Hydrodynamic supercomputer models show that if gas giant planets formed quickly, they soon dominated the early planetary system. Giant planets gravitationally scattered small rocky and icy debris. In our Solar System there could have been 10 other Earth-sized planets that were tossed out or assimilated by giant Jupiter-like planets. "There

must be a huge mortality rate," says astronomer Lucianne Walkowicz of the University of Washington. "One wonders how anything survives."

In a close encounter between two worlds one planet will pick up speed and the other will lose speed. Nature needs to "balance the books" so that the total sum of momentum stays the same after the planetary close encounter. While one planet moves inward toward a star, the other migrates outward to a distant orbit. This can continue until a planet gets very close to its star and there are no more minor bodies left for it to toss out.

Close encounters with other bodies in the disk in the early Solar System made the giant planets lose momentum and travel closer in toward the Sun. Other large planets picked up momentum and migrated farther out. If there is more mass far from the star, the giant will migrate outward. Fortunately, Jupiter migrated only about 50 million miles closer to the Sun from its birthplace. Had it come much closer, it would have torn up the inner dust disk needed to make the terrestrial planets. This is certainly the fate of many planetary systems found so far. Uranus and Neptune probably formed between Jupiter and Saturn and then moved outward by a few hundred million miles. Comets were slung out of the Solar System like golf balls shot across a practice range and formed the immense Oort Cloud of comets around our Solar System. This also depleted the two debris fields in the protoplanetary disk: the Asteroid Belt and the Kuiper Belt where Pluto dwells. Today the Asteroid Belt contains a mere 1 percent of its original mass.

The presence of older residual dust disks around nearby stars also reinforces the belief that planet formation is an efficient and common process. The dust in these disks comes from the bumping and grinding of comets and asteroids, so it is indirect evidence for larger bodies that have already accreted. Images of these "secondary" disks offer dramatic circumstantial evidence for planets. An unseen planet's gravity is expected to redistribute dust in the disk, forming beautiful features including swirls, arcs, voids, warps, and clumps. Because the subtle details depend on the planet's mass and orbital characteristics, determining the kind of pattern could reveal information about the planet.

I. Initial Disk

II. Gap Formation

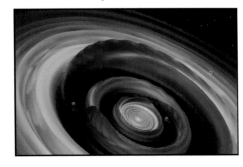

III. Gas Ring Dissipation

IV. Resonant Configuration

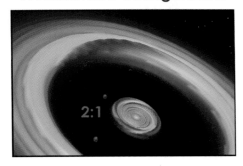

V. Inward Migration

VI. Disk Evaporation

PROTOPLANETS IN DISK SIMULATION　*Computer simulations are used to trace the evolution of a massive planet in a circumstellar disk:*

I. The collapse of an interstellar cloud produces a central protostar surrounded by a protostellar disk. First planetesimals, then planets, form out of this disk.

II. Once planets grow to masses comparable to Jupiter, they open gaps in the disk. In this case two planets are large enough to form gaps.

III. The waves excited by the protoplanets collide with each other in the ring between the planets. The resulting shocks cause the ring to spread out and disappear on a short timescale.

IV. The outer and inner disks try to push the planets together, but they are initially held apart by the gas ring between them. Once the ring dissipates, the planets are forced together until they are locked into a 2:1 resonance.

V. After gap formation, the planets tend to follow the bulk motion of the disk gas. As the gas accretes onto the central star, the planets also spiral inward. Their migration is stopped at small radii, perhaps by direct magnetic interaction with the central protostar.

VI. Eventually the disk clears, leaving behind two short-period planets in 2:1 resonance. This type of system is found around the star Gliese 876.

(Courtesy G. Bryden, JPL)

One of the earliest stars suspected to have a dust ring is the bright summer star Vega. It even inspired Carl Sagan to locate an alien transportation system on Vega in his 1985 novel, later made into a movie, *Contact*. Vega is an optimum target not only because it is nearby but also because the disk is tipped face-on to Earth. This makes it a perfect candidate for more detailed study of features in its dust cloud. High-resolution millimeter-wavelength observations detect two prominent clumps of warm dust, each offset roughly five billion miles on either side of the star. These offset clumps are best explained by the dynamical influence of an unseen planet in an eccentric orbit.

The granddaddy of mature circumstellar disks is the debris field orbiting the star Beta Pictoris. It was here in 1984 that astronomers Brad Smith and Richard Terrile first saw evidence for a nearly perfectly edge-on dust disk. Here too is a fascinating inner gap the size of the Solar System where planets have probably formed. Spectroscopic studies inside the gap show variation in the star's light that could indicate the presence of comet-like bodies whirling around Beta Pictoris. The disk has a complex warp that could be explained by the presence of a Jupiter-like planet at a Jupiter-like distance from the star.

A dust disk 75 billion miles in diameter around the star HD 141569, which lies about 320 light-years away, appears to come in two parts, perhaps due to an unseen "shepherding planet" that carves out a gap in the disk. A bright inner region is separated from a fainter outer region by a dark band. "The most obvious way to form a gap in a disk is with a planet," says Alycia Weinberger of the Carnegie Institution of Washington. "The planet does not have to be in the gap, however. It could either be sweeping up the dust and rocks from the disk as it travels in its orbit around the star, or the gravity of the planet could knock the dust out of one part of the disk."

The disk's structure became even more complicated in pictures with even higher resolution from a new camera aboard the Hubble Space Telescope. The disk turns out to have a tightly wound spiral structure. The outer regions reveal two diffuse spiral arms, one of which appears to be associated with a nearby double star system (HD 141569BC).

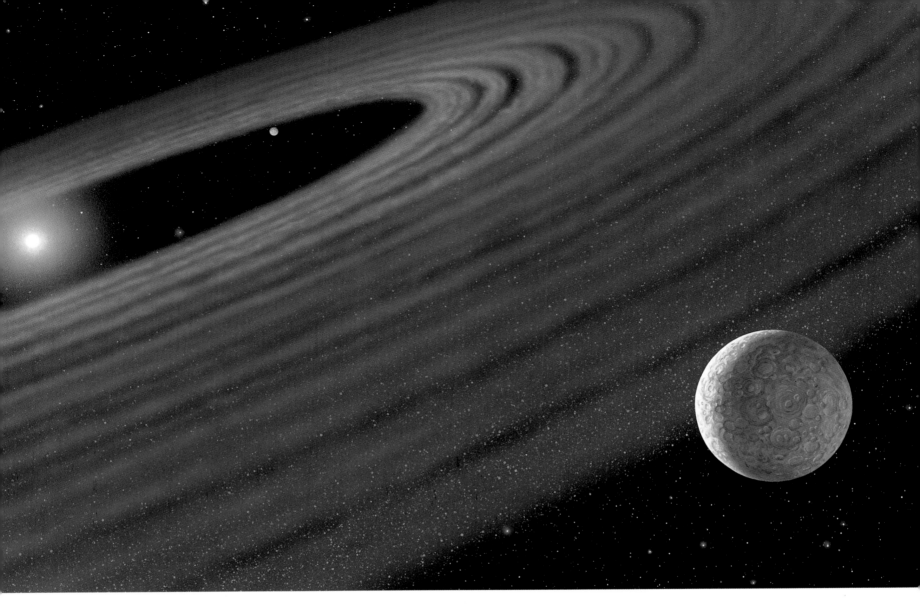

SHEPHERDING PLANET AT HR 4796A *The 13-billion-mile dust ring circling the star HR 4796A*
may be another example of a ring that gets its shape from one or two objects, perhaps large enough
to be planets, that confine the dust to a specific area. This effect makes the star look superficially like
the planet Saturn, though on a much vaster scale.

EPSILON ERIDANI b AND MOONS *Epsilon Eridani, a star only 10.5 light-years away, is thought to have one Jupiter-like planet in a five-year orbit. A frozen lunar landscape on an airless moon shimmers in the foreground, in contrast to the hot volcanic moon closer in toward the planet's rings. In the distance glows the zodiacal light from a secondary dust disk orbiting the star. The outer dust ring encircling Epsilon Eridani forms an arc at the top. Structure in the outer disk suggests another planetary companion. Any inhabitants of this system would scrutinize the Sun and infer the presence of Neptune from possible perturbations in the Kuiper Belt—our equivalent of the disk seen around Epsilon Eridani.*

This apparent connection between the disk and the binary star suggests that an inter-action with the star system may be responsible for some of the structures seen in the disk. Still, the center of the disk is relatively clear of dust within approximately 2.8 billion miles of the binary star. This inner region may have been swept clear by one or more unseen planets.

One of the nearest known stars with planets is the Sunlike star Epsilon Eridani, located a mere 10.5 light-years away in the southern constellation Eridanus the River. It is clearly visible to the naked eye as the third closest star viewable without a telescope. This star piqued astronomers' interest in 1998 when they detected a Kuiper Belt–type disk of icy debris. A planet roughly Jupiter's mass orbits a cozy 300 million miles from Epsilon Eridani. But the fact that the detected planet is in an eccentric orbit also suggests that it has interacted with another unseen, massive body in the planetary system, a planet one-tenth Jupiter's mass and orbiting the star once every 280 years. Because of its elliptical orbit, the as-yet-unseen planet would prevent asteroid debris from growing into Earth-sized bodies. Instead, the result would be more of an asteroid belt in the habitable zone around Epsilon Eridani instead of planets. (See Chapter 5 for more on habitable zones.) Inside the disk there is 1,000 times more dust than is found today in our Solar System. This implies that the Epsilon Eridani system may have about 1,000 times more cometary bodies than ours. Because the star is less than a billion years old, the debris may also represent the final stages of planetary bombardment, like the rain of fire that took place in the Solar System four billion years ago.

A sobering example of at least a partially failed planetary system can be found around the star Zeta Leporis, which is twice our Sun's mass and located 60 light-years away. Instead of rocky terrestrial planets it has a vast asteroid belt, 1,000 times more massive than the one encircling our Sun and several times broader. The dust is so close to the star that it is warmed to 150°F, unlike the frigid dusty disks that encircle other stars at a wider perimeter. If all the matter in the Zeta Leporis disk were compacted, it would form a planet the size of Earth. Assuming a lot of the rocky debris were ejected, the disk started out with enough mass to make dozens of Earths. The vast belt stretches

from the diameter of Mars's orbit to beyond the diameter of Jupiter's. That largely fills in the zone where terrestrial planets might have formed. Given the star's age, the disk shouldn't exist at all; primordial dust should have dissipated. This means there must be colliding asteroids that are replenishing the dust. No outer planets have been detected here, but such a debris field is "smoking gun" evidence that a giant planet over a billion miles from Zeta Leporis must have pumped up the orbits of the planetesimals such that they had destructive collisions and could not have gently coalesced to form planets.

TWILIGHT OF A GOD

Life and death among the stars is just as inevitable as it is for biology on Earth. Even more deterministic than the apparent abundance of planet formation is the fact that planets will be irrevocably changed by the eventual demise of their parent star. This was deduced even before scientists knew how the Sun was powered. It certainly could not shine forever. The lingering death of Earth is envisioned in the closing chapters of H. G. Wells's *The Time Machine,* when Wells's time traveler stops 30 million years in the future (the Sun's predicted life span at that time, based on the notion it was chemically burning, like a piece of coal; the concept of nuclear fusion had not been theorized yet):

> I stopped very gently and sat upon the Time Machine, looking round. The sky was no longer blue. Northeastward it was inky black, . . . and southeastward it grew brighter to a glowing scarlet where, cut by the horizon, lay the huge hull of the sun, red and motionless. . . .
> . . . From the edge of the sea came a ripple and whisper. Beyond these lifeless sounds the world was silent. Silent? It would be hard to convey the stillness of it. All the sounds of man, the bleating of sheep, the cries of birds, the hum of insects, the stir that makes the background of our lives—all that was over.

GREENHOUSE EARTH *Within a billion years Earth will become a "moist greenhouse" with a scald-*
ing surface because the Sun is continuing to brighten as it ages (this is counterintuitive to earlier,
"non-nuclear" solar theories that predicted the Sun would dim over time), and the rising tempera-
tures will cause the oceans to boil away. Most surface life will become extinct. Eventually the only
water will pool at the bottom of the deep-sea trenches, where bacteria will still survive as the last life
forms on Earth. The habitable zone that Earth now occupies will move farther out into the Solar
System.

The Earth is a child of the Sun. However, our parent star is indifferent to our fate. The Sun has nurtured life on Earth for billions of years. But the Sun is a fusion engine that cannot keep the thermostat constantly regulated for our survival. It is presently converting hydrogen into helium through nuclear fusion. Eventually nuclear fusion reactions at the Sun's center will move out to an expanding shell around an inert core of helium "ash." This will make the core gradually heat up, and the Sun's rate of fusion will increase, making it grow steadily brighter.

Roughly a billion years from now the Sun will grow bright enough to evaporate away Earth's oceans. Like an evil genie let out of a bottle, carbon dioxide locked away for eons in ocean sediments will be released back into the atmosphere. Earth will become perpetually cloudy, and surface temperatures and pressures will rise as the carbon dioxide enriches the atmosphere. This will make the atmosphere more efficient at trapping solar radiation through the "greenhouse effect." Earth will become hellish like Venus, and only the hardiest microorganisms may find these conditions livable.

The final stages of the Sun's existence will be punctuated by relatively swift and major changes in size and temperature. The helium ash core will contract, releasing gravitational energy. Some of this energy will heat up the center, while the rest of the heat will cause the Sun's outer layers to expand. As the Sun swells, its outer atmosphere will grow thinner and cooler. The expanding Sun will engulf Mercury, and then Venus. As the Sun continues to balloon to the size of Earth's orbit, our planet's fate will lie in a precarious balance.

Earth will be so close to the Sun's outer atmosphere that it will raise a tidal bulge in the Sun; this will cause the Sun's outer envelope to gradually spin faster. Earth will slow in its orbit and move inward toward the Sun, possibly falling inside the Sun's extended atmosphere. In this case Earth would spiral into the Sun and vaporize. However, Earth's

RED GIANT SUN, FIVE BILLION YEARS OLDER *In about five billion years the Sun will expand into a red giant. Mercury and Venus will be engulfed by the Sun's outer atmosphere. Earth will be baked into a solid waterless rock and may also be swallowed. Mars, perhaps the last surviving terrestrial planet, is seen in the foreground.*

orbital decay will be counterbalanced by the fact that the expanding Sun will lose mass through a continuous stellar wind of gas streaming off it. Earth's orbit thus would widen as the Sun loses mass into space. So our planet may be spared the final indignity of being burned to a cinder.

The red giant Sun will briefly contract until it becomes so hot in its center that it triggers helium fusion at the core, where helium atoms will collide to create carbon and oxygen atoms. The Sun will burn helium for just 100 million years more. Near the end of its life the Sun's surface will pulsate and shudder with seismic energy from changes in the activity of the fusion furnace. With each pulse, which will last about a year, the surface layers will expand and cool. Each time this happens some of the stellar exterior will be flung into space.

The Sun will look deceptively redder as space around the Solar System is filled with dust that scatters blue light. Background stars will disappear behind this stellar pollution "smog." The Sun itself will slowly become embedded in a cocoon of dust of its own making and will grow smaller and hotter as it loses layers that are too hot to condense into dust. As the upper gas layers strip away, the hot stellar core will be slowly exposed. Light from the core will make brilliant "sunbeams" that shine through the mottled clouds of dust around it. Finally, the remnant solar core will shrink and heat up to a fierce blue-white brilliance to become a white dwarf star. A flood of ultraviolet radiation will cause the gases in the surrounding nebula to glow.

Our galaxy is littered with such opulent death shrouds from dying stars. They are called planetary nebulae because, when viewed through a telescope over a century ago, some resembled the disks of planets. But the fact that many planetary nebulae are not spherical but more hourglass shaped may be indirect evidence for extrasolar planets. One of the most striking examples is the planetary nebula M2–9, nicknamed the Siamese Squid or Twin Jet. It appears much like a pair of exhausts from jet engines. The ejected gas is moving at over 200 miles per second. Any surviving planets around this star would be bathed in a glow of ultraviolet light, and the sky would be filled with the eerie wisps of fluorescing gases ejected from the star.

PLANET NEAR THE SIAMESE SQUID NEBULA *This view is from a hypothetical world near the planetary nebula M2–9, dubbed the "Siamese Squid" because of its symmetrical jets. Different minerals in the surface rock fluoresce in pink and green colors, caused by the white dwarf's fierce ultraviolet glow rather than from the nebulosity. The planet is near the star's spin axis, and so the view is almost down the center of one of the twin jets the star is ejecting. It would be unusual to find a planet in an orbit so high above the star's ecliptic plane, but planet discoveries so far have taught us to expect the unexpected.*

PLANET INGESTION IN THE HD 82943 SYSTEM *HD 82943, a solar-type star in the constellation Hydra, has been shown to contain a significant amount of lithium-6, inferring that it swallowed one or more large planets during its history. Two giant planets still orbit this world. When a planet fell into the star it likely formed a comet-like tail. This image shows the view from the vantage point of a moon orbiting a second planet. The outermost planet, with three tiny, hypothetical satellites, is seen in the distance at upper left.*

The strange elongated shapes in many planetary nebulae could come from a large planet or brown dwarf being swallowed by a dying star. Computer simulations by theoretical astrophysicists Mario Livio and Lionel Siess show that a large planet that is engulfed by a red giant star continues to orbit inside the star for thousands of years before it is completely vaporized. "You have to remember that these stars are super-tenuous gas balls with their matter smeared over an absolutely huge volume," says Livio. "Their outer regions are as rarefied as what we would consider a good vacuum on Earth."

Their modeling shows that when a large planet spirals inward it sheds material that stays in the plane of the planet's orbit to form a doughnut-shaped cloud around the star. Later, when the star's hot core is exposed, its radiation drives a fierce stellar wind of matter away from it. The wind blows in all directions, but because the slow-moving gas in the doughnut impedes its expansion, it escapes fastest along the star's rotation axis in opposite directions, forming exquisitely symmetrical double-lobe features. "The doughnut acts like a corset, and the wind blows two bubbles perpendicular to the corset," says Livio.

The gravitational energy dumped by the rapidly orbiting planet as it spirals into the stellar core should also raise the star's spin rate. Also, a large swallowed-up planet would contaminate the star with its heavier elements. Astronomers have observed the predicted effects of stars swallowing a planet or brown dwarf. The stars emit unexpectedly large amounts of infrared radiation from dust, and their light shows the spectral fingerprint of lithium, an element that does not normally survive very long in a star. Its presence may not necessarily indicate planet ingestion, however, since lithium can also be dredged up as a star's churning convection zone deepens into the layer in which lithium was burned. Thus, only a few stars showing the presence of lithium may have actually swallowed planets. About 8 percent of red giant stars are candidates for planet ingestion. Some researchers have used this estimate to predict the ratio of Jupiter-sized planets in close orbits around stars in our galaxy. But the next step in planet hunting requires finding out more about how our own Solar System was put together.

3 Solar System Clues

LONG BEFORE WE COULD GO LOOKING FOR PLANETS AROUND OTHER STARS WE HAD TO DEVELOP AN UNDERSTANDING OF OUR OWN FAMILY OF WORLDS AROUND THE SUN. This awakening realization of the contents, dynamics, evolution, and architecture of the Solar System is a fascinating tale of twists and turns and revelations. A true comprehension of the planets' varied physical environments and their evolution did not begin to come together until the final decades of the twentieth century, when we broke free of Earth's gravitational clutch to roam among the planets at will. These first interplanetary voyages will one day be as legendary as the first expeditions to the New World. Our emissaries were robotic explorers, aptly named *Mariner, Viking, Voyager, Galileo,* and *Pathfinder*—even *Spirit* and *Opportunity*!

Today scientists are working toward a holistic understanding of how the early Solar System created this remarkable diversity of worlds with titanic storms, towering volcanoes, immense chasms, and ancient impacts. Deciphering the early days of the Solar System is crucial to understanding how planets are born and evolve around other stars. Earth's restless surface, driven by plate tectonics, has largely erased this record. But it is preserved on a wide collection of primitive bodies in the Solar System stretching billions of miles from the Sun.

Before the age of planetary exploration, the Solar System seemed to be an eclectic collection of objects that didn't have many ties to each other. Earth's sister planet Venus was shrouded in clouds. Mars was Earthlike but presented odd mysteries, such as seasonal changes in surface markings and planet-wide storms. The distant gas giants Jupiter and Saturn were unique. One had a great red spot, and the other a magnificent ring

SUN AND PLANETS *The planets of the Solar System are shown to scale. Our system is divided between four rocky inner planets and four gas giant outer planets. Pluto may represent a third class of planet, the icy dwarfs. This was once thought to be the standard architecture of a planetary system, but early extrasolar discoveries question whether the Solar System is the rule or the exception.*

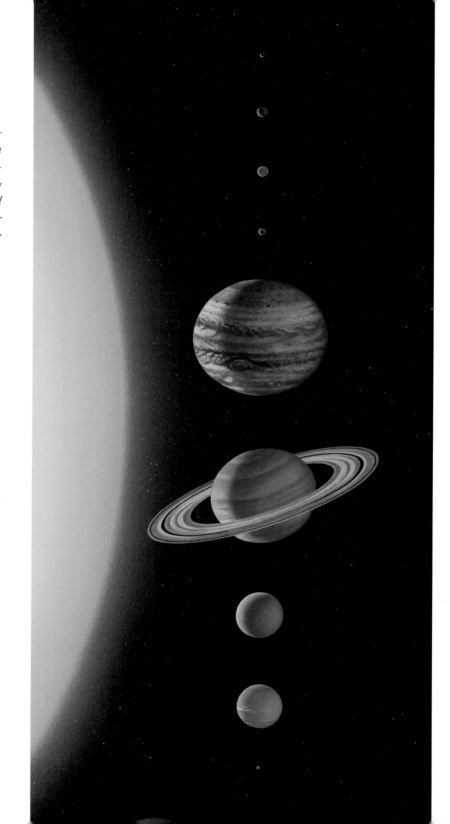

system. Uranus and Neptune seemed like cold, remote, featureless twins. Early clues to the Solar System could be found simply in the fact that the major planets' orbits all lie in nearly the same plane, and move in the same direction. The Solar System is partitioned such that the denser rocky/metallic planets huddle close to the Sun, and the cold and monstrous, but lower density, gas giants sweep out huge orbits far from it.

GENESIS OF THE SOLAR SYSTEM

Early astronomical theories described planets forming through catastrophe, rather than as a common by-product of the normal star-birth process. This implied they were so exceedingly rare that Earth could be the only inhabited planet in the universe. In 1745 French naturalist Georges comte de Buffon proposed that material ripped from the Sun by collision with a comet had condensed into the planets. In 1905 the American geologist Thomas Chamberlin and astronomer Forest Moulton suggested that giant filaments were pulled off the Sun by the gravitational attraction of a passing star. At about the same time English geologist-astronomer Sir Harold Jeffreys and mathematician and physicist Sir James Jeans also theorized that a cigar-shaped gaseous filament was pulled from the Sun by the sideswiping action of a passing star. They reasoned that the middle section condensed into the Jovian planets, and that the ends of the cigar condensed into the smaller planets. This encounter theory accounted for the common direction of the planets' orbital motion, the Sun's rotation, and the fact that the planets are in nearly circular and coplanar orbits.

The theories could not explain how solar matter, whether pulled or ejected, could acquire sufficient angular momentum to stay in orbit. The hot hydrogen and helium could not have condensed into planets. Nor did this theory explain where irons and silicates came from. Moreover, the probability of a near encounter in our region of the Galaxy over the past few billion years is infinitesimally small because the stars are so far apart, making this explanation implausible.

THE SOMBRERO GALAXY *This striking, nearly edge-on galaxy was once thought to be a circumstellar disk around a single star. It was believed to be millions of miles across and within our own galactic metropolis of stars. Instead, it is a 50,000-light-year-wide "city" of at least 100 billion stars. Why such a major misidentification? Before astronomical distances could be accurately measured, astronomers often deduced the nature of an object by its appearance. The disk looked like the hypothesized disk that encircled the newborn Sun. Because the object is at a whopping distance of 50 million light-years, there was no way early astronomers could determine that it was so big it actually contained stars. (Courtesy Hubble Heritage and NASA)*

Eighteenth-century philosopher Immanuel Kant proposed that the planets condensed out of a rotating pancake-like disk of dust that encircled the newborn Sun. The planets' orbits, arranged like concentric grooves in a phonograph record, are essentially fossil remains of this primordial disk. The planets "remember" the rotation and spin in the disk, and so all obediently orbit the Sun in the same direction.

Intriguingly, Kant thought that observational evidence for the circumstellar nebula theory came from John Herschel's reports of seeing "spiral nebulae." Kant believed that an object listed as number 104 (eventually to be called the Sombrero Galaxy) in the catalog of his contemporary Charles Messier was an ideal example of a circumstellar disk. The spiral nebulae were correctly surmised to be disks tilted at different viewing angles. Though this deduction was right, today we know that the spiral nebulae are entire galaxies of stars much bigger and farther away than Herschel could have imagined.

It wasn't until 1781 that a planet was discovered beyond the five planets visible to the naked eye known since antiquity. While systematically searching the sky with his telescope on March 13, 1781, British astronomer William Herschel and his sister Caroline uncovered a curious "green star" that changed position between observations. Unlike stars, it showed a disk when viewed through even a fairly low-powered telescope. The planet, named Uranus after the Greek creation god of the sky (after Herschel's initial proposal to name it after King George III was rejected), turned out to be nearly twice as far away as Saturn. This doubled the size of the known Solar System overnight.

Encouraged by the discovery of Uranus, astronomers went hunting for a suspected missing planet in the huge gap between the orbits of Mars and Jupiter. On January 1, 1801, the Sicilian monk Giuseppe Piazzi, while making routine observations of stars to plot their exact positions, noticed that one of the stars appeared to move slowly against the background stars. Piazzi's observations and the subsequent mathematical work of German mathematician Carl Gauss placed the new object, called Ceres (after the Roman goddess of agriculture), precisely between Mars and Jupiter, at 2.6 times Earth's orbit from the Sun.

Ceres was 1,000 times fainter than Jupiter or Mars, making it the smallest planet observed to date at no more than a few hundred miles across, or merely one-quarter the diameter of Earth's Moon. It was dubbed a "minor planet." Its status shrank even further when in 1802, just a year after Piazzi's discovery, Wilhelm Olbers discovered another "planet," Pallas, at about the same distance. With the discovery of Juno in 1804 and Vesta in 1807, Ceres's planetary status began to fade away. The astronomical community called these "asteroids," for "starlike" or minor bodies. Eventually theoretical work on the origin of the planets explained this Asteroid Belt as a debris field of primordial rubble that never coalesced into a planet due to the gravitational pull of nearby Jupiter, which pumped up asteroid orbits so that encounters were destructive collisions,

RELIC OF A PLANETARY BUILDING BLOCK
A Cassini *spacecraft image of the Saturnian moon* Phoebe *provides the first close-up view of a four-billion-year-old fossil relic of the rock- and ice-laden planetary building blocks that were abundant in the early Solar System.* Phoebe *differs greatly from asteroids that are drier and nearer the Sun. It has a variegated surface with a mixture of carbon dioxide frost, water ice, and simple hydrocarbons, together with water-bearing minerals, possible clays, and primitive organic chemicals. Most other primeval icy bodies like Phoebe were assimilated by the giant planets or tossed out of the Solar System into the Kuiper Belt. But Phoebe was apparently captured by Saturn's powerful gravitational field when it wandered too close to the gas giant. (Courtesy JPL and NASA)*

rather than gentle mergers that would build up a planet. Now we know that such belts exist around other stars.

In 1845 Cambridge mathematician John Couch Adams predicted the existence of an unseen planet to account for the fact that Uranus was being pulled slightly out of position in its orbit. Adams attributed this pull to the gravitational effect of an unknown body and calculated its position. Little might he have guessed that the telltale effects of gravity between seen and unseen bodies would be employed 150 years later in hunting for invisible planets around other stars. French astronomer Urbain Leverrier published a prediction similar to Adams's and enlisted the help of astronomers at the Berlin Observatory, who found the new planet on September 23, 1846. It was named Neptune after the Roman god of the sea.

In 1905 a Boston aristocrat turned astronomer, Percival Lowell, completed his analysis of data on Neptune's orbit. Lowell erroneously concluded that a planet yet farther out was tugging at Neptune. Such a distant world never would have been found at that time if traditional naked-eye observing techniques were still being used. Instead, by the beginning of the twentieth century, photography was significantly changing the way astronomers collected data. Photography allowed for areas of the sky to be permanently recorded and archived for later comparison. Searches could go deeper into the heavens to find much fainter and slower-moving objects.

A search was begun at Lowell's Flagstaff Observatory in 1915, but it continued long after Lowell's death in 1916. On February 18, 1930, Clyde Tombaugh found the elusive planet. Pluto's size was overestimated because the astronomers did not realize until 1978 that Pluto had a moon. The two bodies are so close that they blur together, creating

PLUTO AND CHARON *Pluto and its moon Charon are an example of a binary planet system. They orbit around a common center of gravity between the two worlds. It is not the only binary object system in this region. Unlike the other planets of the Solar System, Pluto dwells in the Kuiper Belt, an icy debris field left over from the Solar System's formation. If Pluto were discovered today, it would not be classified as a planet because it is not unique to the outer Solar System.*

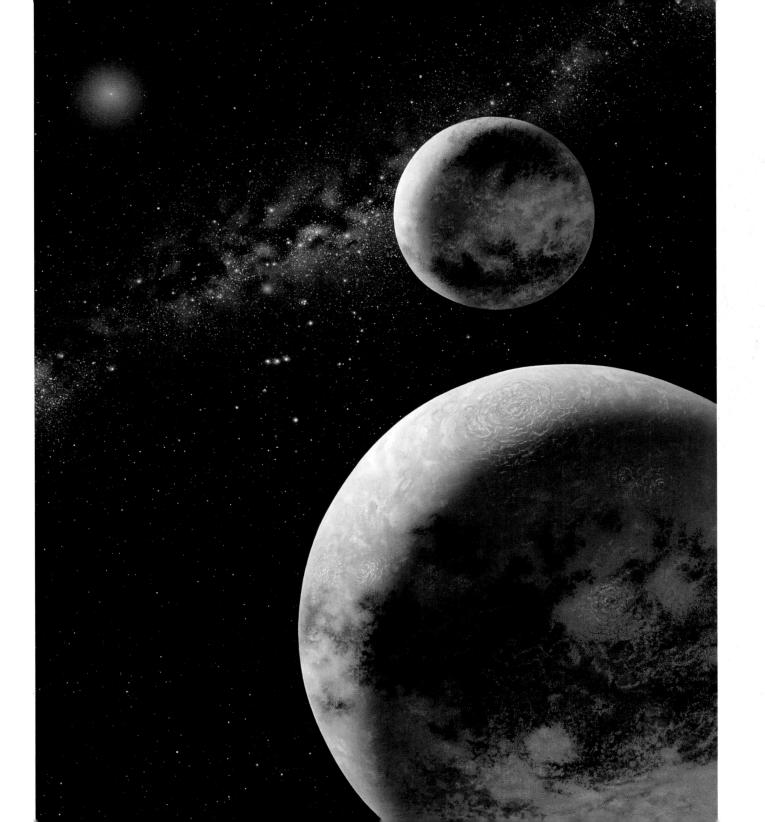

the illusion of a larger and brighter planet. This realization further showed that Pluto is too small to gravitationally perturb Uranus or Neptune.

Pluto's orbit is the most unusual of any planet in the Solar System. It is so elliptical that it actually passes inside Neptune's orbit. For every three orbits Neptune completes, Pluto completes two: this is called a resonant orbit and is more than coincidental. Neptune's gravity is perturbing Pluto. This was an early clue to the planetary billiard game that took place when the Solar System formed and was cluttered with many smaller bodies. These bodies were perturbed by the gravitational tug of the giant planets, and their orbits were modified and made more elliptical.

By the early 1980s computer simulations of the Solar System's formation predicted that a disk of debris should naturally form around the edge of the system, where Pluto and Charon dwell. Think of it as a second, outer Asteroid Belt, the big difference being that the debris are largely icy rather than rocky. Neptune's gravity keeps this area a rubble field, just as Jupiter's gravity keeps the Asteroid Belt a debris field. This so-called Kuiper Belt (named after Gerard Kuiper, who was one of several astronomers who hypothesized such a belt decades earlier) remained just a theory until the detection in 1992 of a 150-mile-wide body in the region. Several similar-sized objects were discovered quickly, and then hundreds of smaller bodies. By the early twenty-first century, astronomers had uncovered objects roughly half Pluto's diameter, icy worlds big enough to be given names. The two largest, Varuna and Quaoar, are named after Hindu and Native American creation gods, respectively.

Our collective knowledge of the Solar System today gives us a sample of the variety of planets that might be found around other stars. It also gives us a basic set of fundamental definitions. Foremost, the planets' coplanar orbits are evidence that they condensed out of a dust disk around the primeval Sun. Planets can be rocky, gaseous, or icy, depending on where they formed in the disk. If the object is too small to have enough gravity to pull itself into a sphere, it is an asteroid or comet. Whatever the mass of the body, it should be by far the most massive object along the path of its orbit. For

RING OF ICY BODIES *Many stars have regions very far out where small icy bodies exist in large numbers. The gravitational effects of gas giant planets create these debris fields, and they prevent smaller bodies from agglomerating into planet-sized worlds. If the orbits of giant planets are very elliptical, this effect can extend over a much wider range than we find in the Solar System. Our "local" icy ring, the Kuiper Belt, is located beyond the orbit of Neptune. Asteroid collisions close in to a star create a dust disk. The gap between the two debris fields houses planets that sweep up dust and ice. (The distances between particles are much greater than shown in this stylized view.)*

example, Jupiter has leading and trailing bodies in its orbit called the Trojan asteroids, but these are merely debris. Pluto, on the other hand, lies in the cluttered Kuiper Belt with some other objects at least half its diameter.

RECONNAISSANCE OF THE SOLAR SYSTEM

In October 1957 the former Soviet Union hurled a 187-pound, soccer ball–sized "artificial moon" called *Sputnik* ("fellow traveler") into an orbit around Earth. In the public mind the term "satellite" quickly would no longer be synonymous with "moon," but rather with a booming flotilla of communication, military, and weather satellites. Soon after *Sputnik,* rocket boosters initially developed to lob megatons of death halfway around the world instead were used to hurtle modest-sized probes to all of the major planets in the Solar System. The Soviets held sight of this vision from the beginning, according to the *New York Times* on October 5, 1957: "The Soviet Union said its sphere circling the earth had opened the way to interplanetary travel."

NASA was formed shortly after *Sputnik* was launched. The agency's primary goal, set in the early 1960s, was to send humans to the Moon and safely return them to Earth. But NASA very quickly began an ambitious but step-by-step approach to reconnoiter the Solar System with unmanned probes. Every planet visited turned up unpredicted details and surprises. Within a couple of decades a broad-brush picture of the origin and evolution of the Solar System came together quickly. Discoveries blossomed so fast that scientists could watch the new view of the Solar System unfold within a single generation. The planets, fleeting pinpoints of light to previous civilizations, were so

BEYOND THE HOME PLANET *Inspired by detailed photographs resulting from NASA missions— and impossible to create without them—this artwork is a composite of the planets of the Solar System, showing their wonderful variety and uniqueness.*

heavily photographed that they filled up archives of pictures for generations of scientists to peruse.

The strategy of exploration was first to fly by planets using minimum payload sizes and power. We first had to learn simply how to get to the planets—no easy task. Our nearest neighbor and easiest to reach was the Moon. All we could do in the early 1960s was crash probes into the Moon: just hitting it was a challenge. We missed the Moon several times before deliberately crash-landing the first *Ranger* probe. Robotic lunar landers followed, and then humans.

Next planetary orbiters were launched to carry out global surveys with simple cameras at modest resolution. Landers followed, poking, probing, and "chemically sniffing" interesting locations. Coming in the future are ever-larger rover vehicles, as pioneered by the skateboard-sized *Sojourner* rover on the 1997 Mars *Pathfinder* mission and the golf cart–sized *Spirit* and *Opportunity,* which landed in 2004. These adventurous explorers climbed hills and descended into steep craters on one of the most amazing scavenger hunts of modern science, looking for geologic evidence of ancient Martian lakes. By the end of this decade "smart landers" able to avoid ground hazards will carry nuclear-powered Volkswagen Beetle–sized roving laboratories to Mars.

The next big step will be sample-return missions from a variety of other bodies in the Solar System. The only "pieces of a planet" ever brought back to Earth date from the manned *Apollo* Moon missions of the late 1960s and early 1970s. Lunar samples brought back to Earth by the *Apollo* astronauts yielded clues to a violent genesis and the most devastating impact our young planet ever experienced. The rocks are very much like those in Earth's crust. This lent support to the theory that the Moon was born out of a collision between Earth and a body the size of Mars. Earth assimilated most of the object, but a small fraction of the debris from the collision went into orbit around Earth and coalesced to form the Moon. The oldest Moon rocks are 4.4 billion years old, meaning the Moon formed 100 million years after Earth's birth.

Besides knowing the origin and evolution of the planets, probably the most tantalizing question about the Solar System today is whether life exists on other planets or moons. Such a discovery might be our only chance of ever conclusively knowing what kind of life could independently arise on another world, since collecting samples from extrasolar planets may be forever technically unfeasible. Even more humbling might be the eventual realization that life on Earth and other bodies in the Solar System had a common origin. Planets or moons might have exchanged biological material with each other through collisions with asteroids that ejected debris into space. Microbes may have been the first interplanetary space travelers, or rather stowaways, on meteoroids roaming through space in the first billion years of the Solar System.

A century before Copernicus, the German theologian Cardinal Nicholas of Cusa also held that Earth did not rest at the center of the universe; he believed that it moved through space. This led him to speculate freely about life in the Solar System in his 1440 treatise *On Learned Ignorance*: "We suspect the inhabitants of the Sun are more Sunlike, more enlightened, inspired and intellectual; we assume they are more spiritual than those on the Moon, who are more variable; and finally on Earth they are more material and crude. The position is similar for the regions of other stars, . . . for we believe that not one of them is uninhabited."

The public's receptivity to the idea of life on other planets was best dramatized in 1835, when the August 25 edition of the *New York Sun* tantalized readers with the headline "Celestial Discoveries." A series of exclusive reports described the discovery of life on the Moon, which took the form of bison, goats, cranes, and humanoids with bat wings. Sir John Herschel at the Cape of Good Hope, using an "immense telescope of an entirely new principle," as breathlessly described by the *Sun,* reportedly made the observations. When the discovery of humanoids on the Moon appeared, the paper had

METEOROID STOWAWAYS *It might be common among terrestrial planetary systems that life first originates on one planet and then is spread to other planets by asteroid impacts. In this scheme microbes are essentially hitchhikers on debris blasted into space off low-mass planets. Some fraction of these meteoroids would hit other planets. If surface conditions were right, the hitchhiking microbes might find a new home, a new planet to colonize. In this scenario the first planet to originate life seeds other hospitable planets in the system. Though the hypothesis is controversial, the Mars meteorite AHL84001 may be prototypical of such planetary fertilization. Some scientists think that it—and other meteorites like it—could have seeded Earth with Mars microorganisms.*

the largest circulation of any contemporary newspaper in the world: 19,360. On September 16 the *Sun* admitted the hoax, but the paper never lost its increased circulation!

H. G. Wells's *The First Men in the Moon* (1901) correctly described the surface of the Moon as uninhabitable. Wells introduced the idea of life flourishing underground. The Moon inhabitants, called "Selenites," were insect-like creatures, their civilization structured like an ant colony. In a closing chapter one of the human visitors meets the "Grand Lunar" leader of the Selenites. Wells cleverly turns the tables by having the Moon people bemused by the idea of life on Earth: "From the solidity of the Earth there had always been a disposition to regard it as uninhabitable. He [the Grand Lunar] endeavored first to ascertain the extremes of temperature to which we Earth beings were exposed, and he was deeply interested by my descriptive treatment of clouds and rain. . . . He seemed inclined to marvel that we did not find the sunlight too intense for our eyes."

WHERE ARE THE MARTIANS?

No planet has captivated the imagination and stimulated the quest for life in the Solar System more than Mars. Science fiction and fact became entangled in 1877 when the Italian astronomer Giovanni Schiaparelli reported seeing linear features on Mars, which he called *canali* ("channels"). But the term was mistranslated as "canals," leading to speculation about life on the red planet. During the 1894 opposition of Mars (when Mars and Earth were at their closest point to each other), French astronomer Stéphane Javelle claimed to have seen a strange light on Mars, which further stimulated speculation about life there. Wells went on to populate Mars in his 1898 classic *The War of the Worlds* (which includes a character named after Javelle) with an advanced intelligent civilization that sought to colonize the greener pastures of Earth.

Unlike Wells's peace-loving Selenites inhabiting the Moon, the bellicose Martians

MARS AT 2003 OPPOSITION *The ruddy planet Mars is a striking example of a terrestrial planet entombed in a global ice age. Its suspected ocean and thicker atmosphere are now long gone. Nevertheless, this arid world is still quite Earthlike: it has water vapor clouds and icy polar caps. Legendary among the other planets in the Solar System as a possible home for life (past or future), it beckons would-be space colonists. The irony is that Mars may already be inhabited by microbial life even older than that found on Earth. This is an image of Mars when it made its closest approach to Earth in 60,000 years, from a distance of approximately 34 million miles (slightly more than three light-minutes). Details as small as 17 miles across can be seen, far greater resolution than was possible with telescopes made over a century ago. (Courtesy J. Bell, Cornell University, and NASA)*

invaded with what would prove to be an uncanny vision of twentieth-century war: mechanized warfare, aerial attacks on population centers, nerve gas, and directed energy weapons. Wells even envisioned the need for interplanetary biological quarantine. The malevolent invading Martians die because they have no natural resistance to Earth's microorganisms. Wells expressed it succinctly when he wrote that the Martians had been killed, "after all man's devices had failed, by the humblest things that God, in his wisdom, has put upon this earth." Ironically, we are now planning ways to quarantine Earth from Mars. Martian microorganisms could conceivably come here aboard a NASA Mars sample-return mission in the next decade. This would be a priceless catch, but top-quality biological quarantine facilities will be needed.

Percival Lowell seized upon Schiaparelli's *canali* as the first example of "astro-engineering," where an advanced extraterrestrial civilization modifies an entire planet. Lowell sketched a much finer cobweb of canals than those seen by Schiaparelli. These could not be photographed: the "canals" were visible only fleetingly when the air was briefly clear enough for surface details on Mars to pop out. They were unmistakably artificial (that is, not natural features on the Martian landscape) to Lowell. He thought they were quite linear and converged on nodes where he presumed the great Martian cities were located. As with the search for Pluto, Lowell had an acute skill of letting his imagination fill in where data were missing. In fact, the canals may have been an optical illusion caused by the wind streaks of dark dust that can be seen from spacecraft photographs. Human perception tries to "connect the dots" between such mottled and streaky features. Another, much more speculative, theory blames the particular eyepiece Lowell was using. Perhaps telescopic light bouncing off the retina of Lowell's eye was reflected in the eyepiece, and the perceived linear features were possibly the blood vessels in his retina.

But Lowell's writings, no matter how scientifically wrong, opened the twentieth century to such fantastic ideas as interplanetary communication, terraforming (that is,

remaking another planet to support life), planetary evolution, biological evolution, and advanced extraterrestrial intelligences undertaking macro-engineering projects.

Here on Earth these ideas were so compelling to some that they fostered the first serious discussion of communicating with an extraterrestrial intelligence. Ideas included lighting fires or aiming bright searchlights at Mars during opposition. In 1901 the prolific inventor and electrical engineer Nikola Tesla convinced himself that he had received an alien transmission on an experimental device called a "magnifying transmitter." He wrote in *Collier's* magazine:

> I can never forget the first sensations I experienced when it dawned upon me that I had observed something possibly of incalculable consequences to mankind. I felt as though I were present at the birth of a new knowledge or the revelation of a great truth. . . .
>
> . . . Although I could not decipher their meaning, it was impossible for me to think of them as having been entirely accidental. The feeling is constantly growing on me that I had been the first to hear the greeting of one planet [which he presumed was Mars] to another.

During a particularly close opposition in August 1924, a number of experimenters using the newly invented radio listened for intelligent radio transmissions from the red planet. Radio operators reported receiving a series of "four groups of dashes in groups of four." In London a specially constructed twenty-four-tube radio picked up "harsh notes" of an unknown origin. A Boston radio operator reported a strange ringing, ending with an abrupt "zzzip."

By the middle of the twentieth century, however, astronomers were discovering that Mars was cold and dry, with a bare trace of an atmosphere. Despite its marked seasonal variations, ice caps, and Earth-length day, Mars has been dismissed repeatedly as a dead world. But the red planet always rebounds with new clues that keep alive the glimmer of hope for extraterrestrial life there.

MARS PANORAMA *The Mars* Pathfinder *lander gives a panoramic view of the ancient floodplain at the mouth of the great Coprates Chasma. Billions of years ago a flood of biblical proportions may have swept through this region, carrying a variety of rocks downstream from the canyon system. But today it is arid and bleak. Where did the water go? That is a key question confronting Mars scientists. If there was once life on Mars, it presumably followed the water. (Courtesy JPL and NASA)*

On July 14, 1965, the first human emissary zoomed within 6,000 miles of Mars for a fleeting look. The *Mariner 4* spacecraft sent back gloomy pictures of a desolate, cratered landscape. Overnight, Mars was dismissed as being as dull and dead as the Moon. Lowell's great Martian cities and canals evaporated like a desert mirage. On July 30 and August 4, 1969, *Mariners 6* and *7* sent back similar lackluster pictures. Mars was boring.

In 1971 the first NASA planetary orbiter, *Mariner 9,* decelerated into a parking orbit that allowed it to swoop 900 miles above the Martian desert. Ironically, the planet was entombed in one of its seasonal global dust storms. As the dust settled, a world unimagined by anyone unveiled itself: towering volcanoes, immense rift valleys, and a cobweb of dried river channels eerily reminiscent of Lowell's illusory canals (he could have never seen these from Earth).

It was clear that Mars had an interesting history. It was an evolved world. But how much had it evolved? Did life start on Mars too? Is it there today? What was unequivocal in the early 1970s is that Mars offered the first direct evidence for geologic and climatic evolution on a world other than Earth. By the mid-1970s a pair of robust nuclear-powered landers were on Mars and looking for signs of life. In a bold but premature experiment, miniaturized biological laboratories on each of the *Viking* landers tried to incubate suspected Martian organisms. One experiment tested whether the Martian soil sample produced or consumed gases when exposed to a solution of the kind of simple organic nutrients on which Earth organisms feed routinely. The idea was that if there were any living organisms in the sample, they would take up the nutrients, which had been labeled with radioactive carbon. After digesting the nutrients, the organisms would release the carbon in a gas form that could then be measured. And that was exactly what happened in one experiment. In a second part of the experiment, the soil sample was baked. Any organisms would presumably be killed. The nutrients were reapplied. This time, no gas emerged. This meant that whatever had produced the gas in the soil before the heating was now dead.

However, most *Viking* scientists argued for a simpler, nonbiological interpretation. The intense ultraviolet radiation from the Sun created highly reactive compounds such as superoxides and peroxides in the Martian soil. When these bone-dry soils were exposed to water, they released gases like an Alka-Seltzer tablet. This nonbiological conclusion was bolstered by the absence of any organic compounds on the Martian surface. *Viking*'s Gas Chromatography Mass Spectrometer looked for carbon atoms—the building blocks of life—in the soil. It found none. In hindsight, at least a few astrobiologists today suspect that life really was there but went undetected. It could have been just a few feet away inside a rock, or a few feet under the surface.

In 2003 a team of scientists from NASA, the Universidad Nacional Autónoma de México, and Louisiana State University conducted a *Viking*-type experiment on Earth,

and found no life! They sampled Chile's Atacama Desert as a Mars proxy. Fifty times drier than Death Valley, California, the Atacama Desert is one of the most parched locations on Earth. The team analyzed Atacama's depleted Mars-like soil and found organic materials at such low levels that *Viking* would not have been able to detect them. Ironically, the team did discover a nonbiological oxidative substance in the Atacama sand that mimicked *Viking*'s results. Just as ironically, salt-loving bacteria do exist just beneath the desert surface, a few feet out of reach from the life detection experiment.

A tantalizing boost for Mars life, albeit very controversial, came in 1996 when scientists reported finding organic compounds in a Martian meteorite that they regarded as fossil evidence of ancient microorganisms hitchhiking a ride to Earth. The meteorite, called Allan Hills 84001 (ALH 84001), is by far the oldest Martian meteorite ever found. It cooled from molten lava 4.5 billion years ago and so is a sample of the early Martian crust. An estimated 15 million years ago, a major asteroid impact on Mars blasted material into space. Some of the debris circled the Sun for millions of years before eventually making a fiery crash landing onto an ice field in Antarctica about 13,000 years ago.

A team of Mars scientists from NASA and Stanford University found several intriguing features in the meteorite that hinted at life on Mars. They admit that nonbiological processes can individually explain each feature. But taken together, these features can best be explained by biological processes, they insist.

The team found small grains of carbonates in tiny fissures in the rock that appear to have been formed in the presence of liquid water or some other fluid. The key features are microscopic "carbonate globules." These carbonates have not been found in any of the other 11 known Martian meteorites. This is taken as evidence that at least three billion years ago water containing carbon dioxide percolated through the Martian rock that eventually became ALH 84001. This deposited carbonates inside the meteorite as well as organic molecules, minerals, and even the fossil remains of Martian bacteria that once flourished in the water.

But there is considerable debate that the rock was too hot for microbes when formed. Ralph Harvey (Case Western Reserve University) and Harry Y. McSween Jr. (University of Tennessee) propose that these carbonates formed as a pulse of steaming hot carbon dioxide (800°F) flushed through the primitive, impact-battered Martian crust. They say this happened when an asteroid smashed into Mars's surface only a billion years ago and crushed the rock beneath, creating miles of interconnected fractures and ground-up target rocks. Superheated carbon dioxide frost was melted and injected into rocks. This means that carbonates could have been deposited without liquid water, at temperatures too high to support life.

However, within the carbonates the NASA-Stanford team discovered minerals that could be associated with life. They found iron oxides and sulfides, which can be produced by anaerobic bacteria and other microbes. The team also found magnetite, a form of iron associated with some bacteria. The magnetites, the researchers claim, are identical to those produced by bacteria on Earth.

The scientists also identified organic carbon molecules that they believe originated on Mars. The organic carbon molecules, called polycyclic aromatic hydrocarbons (PAHs), were found in and on the carbonate globules. These PAHs could have been caused by the decay of living organisms that were introduced when the carbonates were deposited. However, PAHs don't necessarily indicate biological activity, say skeptics.

High-resolution scanning electron microscope pictures of tubelike structures inside the meteorite are even more controversial. They superficially resemble fossilized bacteria, though at a much smaller scale. But there is no evidence that they actually have cell walls. Opponents also say that the "nanobacteria" are really just natural bumps in the rock surfaces or artifacts of the metals used to coat samples before they were viewed with an electron microscope. Others argue the meteorite was simply contaminated with organisms from our planet when it landed in Antarctica.

Partly because the ramifications of such a discovery are so profound, the debate about this enigmatic meteorite may continue for some time. It seems increasingly unlikely

MARTIAN FOSSIL BACTERIA? *In the Martian meteorite ALH 84001 scientists have found several lines of evidence supporting the possibility of ancient Martian life. The meteorite contains microscopic mineral grains produced by bacterial and organic compounds from bacterial decay. A purely visual manifestation is microscopic shapes that resemble living and fossil bacteria on Earth. These structures are so small, each only 20 to 100 billionths of a meter across, that they can be seen only with an advanced electron microscope. Even though the shapes look like bacteria, they may not actually be from bacteria. (Courtesy D. McKay and NASA)*

WATER SEEPAGE ON MARS *The north wall of this small, four-mile-diameter crater has many narrow gullies eroded into it. These may have been formed by flowing water and debris that created lobed and finger-like deposits at the base of the crater wall. Many of the deposits contain small channels indicating that a liquid—most likely water—flowed in these areas. Hundreds of individual water and debris flow events might have occurred to create this striking texture. Each outburst of water from higher up the crater slopes would have constituted a competition between evaporation, freezing, and gravity. Estimates conservatively suggest that about 660,000 gallons of water are involved in each outflow event. (Courtesy JPL and NASA)*

that ALH 84001 will ever provide a definitive answer to whether life existed on Mars, say some astrobiologists. The question now is whether another Martian meteorite might reveal further clues, or whether a mission to bring back samples is the only way to solve the mystery. Whatever the ultimate answer, the meteorite has reinvigorated the astrobiology community, an interdisciplinary collection of biologists, paleontologists, chemists, planetary scientists, and astronomers.

In the search for life on Mars, the battle cry among astrobiologists is "follow the water." On Earth water provides a medium for assembling complex molecules. It also helps form stable cellular structures. So where there's water, there's life, say astrobiologists. They caution, though, that some watery realms might be uninhabitable because of carbon deficiencies, insufficient availability of biochemical energies, and extreme pressures, among other factors. Nevertheless, "our concept of potential habitable zones has increased dramatically in recent years," says planetologist Ralph Lorenz of the University of Arizona.

NASA's Mars orbiters, landers, and rovers continue finding more evidence that large quantities of water once existed on Mars. Besides the landmark river valleys and gorges, there is visual evidence of sediment-filled craters, muddy craters, and glaciers. One of the most exciting pictures to come back from the *Mars Global Surveyor* shows fingerprints of water that seeped out of the wall of a crater rim and down on young sand dunes. This dates the outflow to less than a million years ago. In terms of geologic history, that might as well be *today*. To some geologists this is compelling evidence for the presence of liquid water on Mars today. Near the equator water could be hundreds of feet beneath the frigid surface, but closer to the poles water could be only a few feet beneath the surface.

Dramatic photomapping shows that the massive outflow channels first seen by *Mariner* all lead to the northern hemisphere. Laser altimetry from the *Mars Global Surveyor* orbiter shows that the planet's southern hemisphere is mostly ancient highlands that slope toward the northern hemisphere, where flowing water collected in seas. Geologists quickly noticed that the border between two geologically dissimilar areas in the

northern lowlands is nearly level in elevation, suggesting an ancient coastline that appears to be at the same altitude, hence level, in a ring around the northern pole. They found that the topography below this possible shoreline is much smoother than that of the region above at higher altitudes, which is consistent with smoothing by sedimentation. Also, a series of terraces runs parallel to the apparent shoreline, bolstering the idea of receding waters. Low areas bear what appear to be mud cracks, like those in dry terrestrial lakebeds. The size of the suspected Martian sea lies within the range of previous estimates of water on Mars. Bigger than the Mediterranean Sea and Arctic Ocean combined, it would have covered about one-sixth of the planet up to a mile deep.

Using Mars photos and computer simulations, Owen B. Toon of the University of Colorado argues that instead of a gentle ocean, a flood of biblical proportions ravaged Mars 3.6 billion years ago. Water-bearing asteroids and comets "carpet bombed" the young planet toward the end of the great bombardment era. Titanic shockwaves also melted existing underground deposits of ice. The impacts would have heated the atmosphere, causing scalding rain. Rivers would have immediately sprung up everywhere.

The seesaw debate shifted again in 2002, when NASA's *Mars Odyssey* spacecraft detected enormous quantities of water lying just under the surface of Mars, enough water ice to fill Lake Michigan twice over. Scientists used *Odyssey*'s gamma-ray spectrometer to detect hydrogen, which indicated the presence of water ice in the uppermost three feet of soil in a large region surrounding the planet's south pole.

Dramatic fan-shaped, river-delta-like features offer some of the strongest evidence

MARTIAN OCEAN *There is growing evidence that not long after its formation Mars was a warmer and wetter world than it is today. The planet's topography suggests its northern hemisphere once held an ocean of liquid water. Back then active volcanoes would have pumped carbon dioxide into the atmosphere, increasing Mars's greenhouse effect, allowing it to more efficiently trap heat from the distant Sun. All too quickly the ocean froze and the area was covered with dust; it is unclear where the water went. All that is left is a telltale shoreline with sedimentation.*

DELTA FLOOD PLAIN ON MARS *A vast, fan-shaped deposit discovered by the Mars Global Surveyor provides evidence that some ancient rivers on Mars flowed for a long time, not just in brief, intense floods. The apron of debris filling the middle of this picture is a hardened and eroded so-called distributory fan. This is a type of geological feature that includes river deltas and alluvial fans. Sediments transported through valleys by water formed the six-mile-long deposit in the distant past, when it was still possible for liquid water to flow across the Martian surface. Because the fan is today a deposit of sedimentary rock, it demonstrates that some sedimentary rocks on Mars were deposited in a liquid environment. The fan's general shape, the pattern of its channels, and its low slopes provide circumstantial evidence that the feature was an actual delta—that is, a deposit made where a river or stream enters a body of water. (Courtesy NASA and Malin Space Science Systems)*

that Mars once had lakes. Clearly seen are ancient deposits of transported sediment long since hardened into interweaving, curved ridges of layered rock. Scientists interpret some of the curves as traces of ancient meanders made in a sedimentary fan as flowing water changed its course over time. "Meanders are key, unequivocal evidence that some valleys on early Mars held persistent flows of water over considerable periods of time," says Mars imaging expert Michael Malin. "The shape of the fan and the pattern of inverted channels in it suggest it may have been a real delta, a deposit made where a river enters a body of water."

Ocean or not, telltale scars from impact craters suggest that groundwater or ice in the northern lowlands lies near the surface. One theory is that water receded into the ground, and the upper layer froze as permafrost with this trapped liquid below. It may still be in a liquid form today. If so, some astrobiologists suspect it could be teeming with microorganisms that migrated down from the surface when Mars got colder and drier. This idea, combined with the discovery of bacteria living far down in Earth's crust, supports the notion that Martian microbes may have gone underground. The cumulative evidence from NASA's armada of Mars orbiters is that water could be present on Mars today in subsurface brine aquifers.

In early 2004 NASA landed two rovers, named *Spirit* and *Opportunity,* at sites on opposite hemispheres of Mars considered likely places to find water. Landing at the equatorial flatlands called Meridiani Planum, *Opportunity* sent back visual and spectroscopic evidence that liquid water once soaked the region. A robotic geologist, the rover found iron-sulfate hydrate, more valuable than gold to the geologists who study Mars. The mineral can be made only in the presence of water. In addition, BB-sized, perfectly round spheres, dubbed "blueberries," also point to a watery past because they appear to be what geologists call "concretions." Such spheres form from minerals that precipitate out of iron-rich water into surrounding sedimentary rock. Similar 25-million-year-old "blueberries" can be found in Zion National Park and other areas in Utah.

But this preliminary evidence does not tell whether the water pooled at the surface

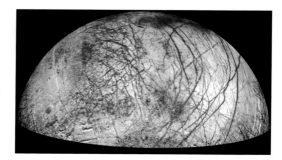

EUROPA'S MYSTERIOUS RED CRACKS *The "cracked eggshell" appearance of Europa's surface has been contrast-enhanced through the use of exaggerated color in image processing. The brown and reddish hues in the cracks indicate the presence of contaminants in the ice. Some scientists think these could be evidence of organic chemistry oozing up from the ocean beneath. The cracks are caused by tidal stresses from the gravitational pull of Jupiter and the other Galilean satellites. Smooth, icy plains are seen in bluish hues. The area covered is about 780 miles across. (Courtesy JPL and NASA)*

as a lake or simply percolated under the surface as groundwater. Nor does it tell when the water existed or how long it remained at the landing site. One possibility is that long ago a briny lake covered the area, depositing layers of rock that were later exposed when a meteorite blasted out a crater.

Opportunity found further tantalizing evidence in rocks that seem to have striations, which on Earth can form when waves or wind blows sediments back and forth. The rock is also randomly pitted with cavities called "vugs" that are created when salt crystals form in briny water and then fall out or dissolve away. This suggests that billions of years ago Meridiani was indeed a lake. If future roving robots are capable of looking for ancient microbial fossils and chemical evidence of life at sites like Meridiani, they may ultimately bring back rock and soil samples from Mars.

DARK, DEEP OCEAN

"There is life on Europa," screams the marooned Chinese astronaut in Arthur C. Clarke's novel *2010: Odyssey Two*. The astronaut describes a tentacle-like creature that bursts out of the ice and demolishes a spacecraft before quickly freezing solid in the Jovian moon's nippy noontime temperature of −230°F. The science fiction writer was inspired by a 1980 popular astronomy article that, based on *Voyager* data, suggested water exists under Europa today. In fact, Europa could have twice as much water as all of Earth's oceans combined. The oceans on Earth are a thin veneer over a rocky planet, but Europa is more like a "water planet": its global ocean could be 100 miles deep.

The moon's surface is flat and young, barely 50 million years old according to crater counts. It's a dynamic surface, resembling a jigsaw puzzle. So-called rafts of ice look like they have moved and rotated over miles, driven by geologic activity below. The few impact craters offer a clue to the plasticity of the crust; it looks like it temporarily melts and turns mushy when smashed by a comet or meteorite. The *Galileo* orbiter's

measurement of a magnetic field on Europa offers a second line of evidence for a salty ocean that acts as an electrical conductor.

Europa is a top target of astrobiologists because it is thought to contain three things necessary for life to evolve: a source of heat, from gravitational tides caused by Jupiter; organic material; and liquid water, in an ocean capped by ice. Also, Jupiter's intense magnetic field is constantly bombarding Europa's surface ice with charged particles trapped by the planet's magnetic field. Some researchers speculate that this could convert frozen molecules of ice and carbon dioxide into organic compounds for microorganisms.

When Jupiter first formed 4.5 billion years ago, it was hotter because it was quickly contracting under gravity. The newborn Europa may have had warm oceans that quickly incubated simple microorganisms under Jupiter's warmth. As Jupiter cooled, the water froze, and any life would have had to become subterranean or exist in the lower levels of the oceans. But how thick is the surface of the ice today? If it is too thick, the ocean is entombed, and life would have to harvest energy from radioactive decay at the seafloor. This may not be enough energy to support much of a biosphere.

Some chaotic-looking spots on Europa's surface may be pushed by upwelling plumes of warm water from seafloor volcanoes, say planetary geologists. Such plumes could dredge up seafloor material and even bring organic materials up to the frigid surface. If a thin enough layer of ice lies on top of the ocean, it might continually crack like an eggshell under gravitational tidal stresses from Jupiter. This would allow oxygen and radiation-cooked nutrients to reach organisms.

The reddish-brown color of the numerous cracks that crisscross Europa also tantalizes some astrobiologists. One speculative argument is that remnants of formerly living cells may be found in the reddish-brown deposits themselves. "Four billion years of subsurface microbes ejected from the bottom of the Europa ocean could mean the moon is a four-billion-year-old cesspool," says Peter Girguis of the Monterey Bay Aquarium Research Institute in California.

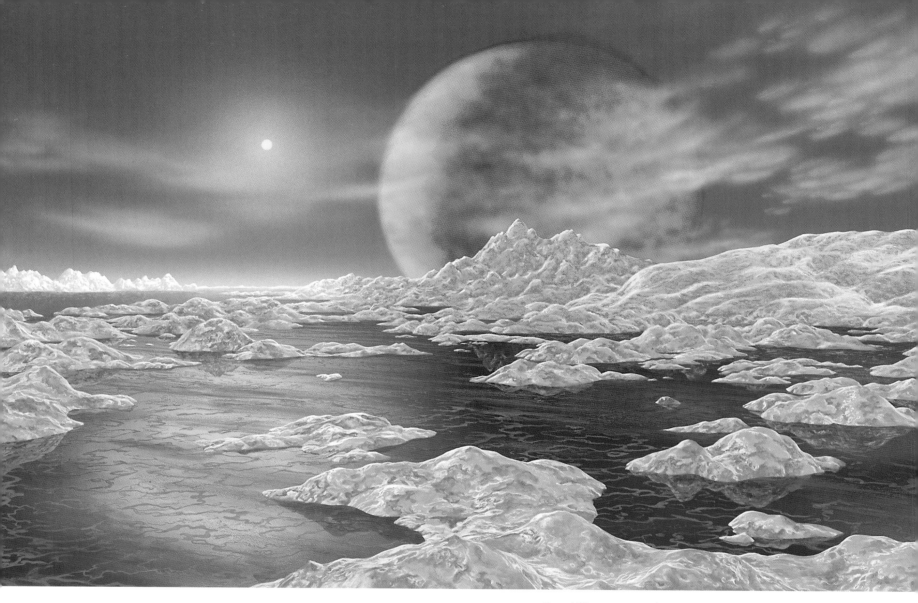

YOUNG EUROPA AND JUPITER *Four billion years ago the Jovian moon Europa may have had a water ocean at its surface. Jupiter was a hot, young protoplanet, releasing enough energy through gravitational contraction to keep Europa warm. The distant Sun, one twenty-fifth as bright as seen from Earth, could not keep Europa from eventually freezing over. This entombed the ocean under a thick crust of ice. Even today Europa could have more water than all Earth's oceans combined. It may be an abode of microbial life.*

In the next decade or two a nuclear-powered Europa lander could make a touch-down on the treacherous icy surface. Scientists have identified so-called ponds on Europa, flat areas that not only would be an ideal place to bring down a lander, but also may be thinner ice. The lander could do basic experiments for complex organic compounds that had been dredged up to the surface by water plumes. The problem is that those organic compounds probably don't stay intact for long on the harsh surface, which is bombarded by particle radiation from Jupiter's magnetic field and ultraviolet light from the Sun.

The lander would deploy a "cryobot." This torpedo-shaped probe would use heat from the decay of onboard radioactive material to melt through the ice. Depending on the power output of the cryobot and the thickness of the ice, which could be as much as 12 miles thick, the robot might reach the ocean within days. Once the cryobot broke through, it would deploy an autonomous submarine called a "hydrobot" that would navigate the inky black ocean and conduct experiments to look for evidence of microor-ganisms. The hydrobot could collect samples and burrow back up to the lander to have the samples launched back toward Earth for detailed analysis. In the not-too-distant future we could be looking at samples of an organism spawned one-half billion miles away. If such organisms exist, their ancestors may have been the first inhabitants of the Solar System, long before Earth was suitable for life.

TITAN: ASTROBIOLOGY ON ICE

A billion miles away, where the sunlight is only one-one-hundredth as bright as on Earth, lies the cloud-shrouded Saturnian moon Titan. Having a diameter of 3,500 miles, it would be a planet if towed into the inner Solar System, for Titan is larger than Mer-cury. "Titan is the largest single piece of unexplored real estate in the Solar System," says Lorenz.

TITAN *This infrared light view penetrates the clouds enshrouding the Solar System's only moon with a substantial atmosphere, Titan. Only slightly smaller than Mars, Titan is the only body in the Solar System, other than Earth, that may have lakes and rainfall on its surface, though the liquid would be ethane-methane rather than water. Titan is so cold that water ice would be as hard as granite. The suspected organic chemistry on Titan might be similar to that on Earth billions of years ago, before life began pumping oxygen into the atmosphere. The bright white region in the image could be a continent-sized land mass. (Courtesy P. Smith, University of Arizona, and NASA)*

Most importantly, Titan is the prototype of potential inhabitable moons that might orbit the dozens of gas giant planets discovered so far. Remote, utterly mysterious, Titan could be the Sleeping Beauty of the Solar System because it is presently entombed at temperatures of approximately −300°F. If it ever warmed up, it could be an interesting place for biology. Dominated by a photochemical smog that eternally shrouds its entire surface, Titan is the only planetary satellite with a thick atmosphere, four times denser than Earth's. The distant, dim Sun provides enough energy to cook up organic compounds in the planet's nitrogen and methane atmosphere. The atmospheric methane is also affected by cosmic rays and cooked into many other organic molecules such as ethane, acetylene, and propane. The atmosphere may rain organic materials onto the surface. Volcanoes or a large surface methane reservoir may replenish the methane in the atmosphere.

Because it is shrouded in clouds and haze, Titan is almost as mysterious as Venus, but 33 times farther away. It is reachable only by an arduous journey across the Solar System. Infrared images from the Hubble and Keck Telescopes reveal an intriguing range of features deep in the atmosphere and on the surface: dark areas that are literally pitch black, and other areas that return radar echoes consistent with standing bod-

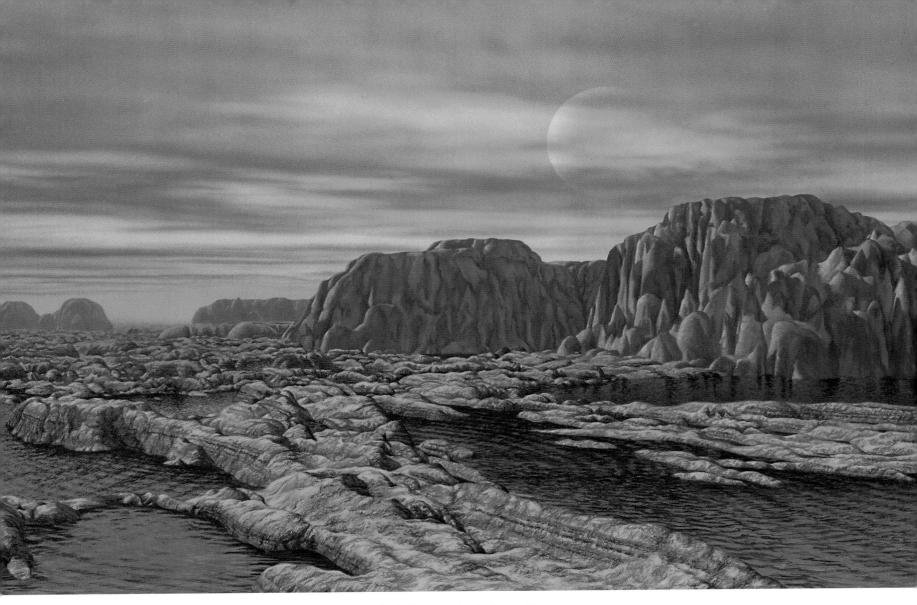

FUTURE TITAN *Sunrise on the Saturnian moon Titan is seen five billion years in the future. Now a bloated red giant star, the Sun is warm enough to melt ices on Titan. Organic chemistry, largely dormant on Titan since the moon's birth, now has a chance to evolve in the glow of the red Sun. Titan will have liquid lakes and pools to incubate life, in a brief replay of what happened 10 billion years earlier in the now incinerated inner Solar System. Saturn remains a mysterious, hazy gas giant; its icy ring is long gone because of dynamical evolution and the heat of the red Sun.*

TITAN'S HIDDEN SURFACE *The penetrating infrared eyes of NASA's* Cassini *spacecraft pierce some of Titan's thick, hazy nitrogen atmosphere to reveal tantalizing surface features. The bright area at center is called Xanadu, with a strange dark area to the west. In some places this dark material completely surrounds brighter features. Clouds swirl over the moon's south pole. Red and green colors represent infrared wavelengths and show areas where atmospheric methane absorbs light. These colors reveal a brighter (redder) northern hemisphere. Blue shows the high atmosphere and detached hazes as seen in ultraviolet light. (Courtesy NASA, ESA, and JPL)*

ies of liquid material. Titan is too cold for oceans of liquid water. Instead, it could have seas of liquefied natural gas.

What is fascinating is that Titan would likely be the only other body in the Solar System with a surface ocean or at least lakes. Gravitational tidal forces from Saturn might sculpt cliffs and tidal flats like those found on Earth's shorelines, and these tidal effects could stir up winds and ocean waves. Imagine liquid ethane waves lapping up on an imponderably bizarre alien shoreline of solidified hydrocarbons.

These conditions make Titan a planet-wide laboratory experiment for replaying some of the steps leading to life. "Titan is an in-situ example of early Earth's development," says planetary astronomer Jonathan Lunine of the University of Arizona. Occasionally comet impacts should locally heat the hydrocarbon crust. The resulting crater would make a natural "beaker" for organic chemistry to "cook" for perhaps 1,000 years before it refreezes.

But Saturn's Sleeping Beauty won't awake for another five billion years. The aging Sun will have then swelled to a red giant and devoured some of the planets of the inner Solar System. If Earth survives being assimilated, it will nevertheless be reduced to a blasted cinder 8,000 miles in diameter. Titan may warm to the point where the engine of evolution can crank up amid rising temperatures. In a cruel twist that betrays the universe's indifference to life, the Sun will collapse to a white dwarf star after only a few hundred million years. Any stirrings of life will come to an end as Titan again freezes over, this time for eternity.

SEEDS OF LIFE

The smallest objects in the Solar System might offer our best chance of looking back to the preconditions for life here. Meteorites are 4.5-billion-year-old time capsules pre-

serving valuable clues to the early Solar System. They are laced with unusual radioactive isotopes that are thought to be shrapnel from a supernova that exploded just a few million years before the meteorites formed in the young Solar System. The shockwave from the supernova may have triggered the collapse of an interstellar cloud to form the Solar System.

Even more exciting is the discovery of a meteorite on September 28, 1969, near the small town of Murchison, Canada, which offered evidence of organic material in the universe. The meteorite was found to contain a wide variety of organic compounds, including 70 amino acids. Amino acids are the building blocks of proteins, which carry out many functions in organic life. This was the first direct evidence that many organic molecules can be formed in space, and it raised the possibility that such extraterrestrial material might have a role in the origin of life on Earth. These organic materials may have been incubated inside icy comets and then transported to Earth aboard meteoroids that broke off from comets, if not by the comets themselves. Besides cooking up the chemistry of life, the emerging view today is that icy comets transported the solvent of life to Earth, water. Comets are 50 percent water, 30 percent volatile organic material (carbon monoxide, carbon dioxide, and various volatile organic molecules bearing nitrogen), and 20 percent silicate rocks.

Earth was born so close to the Sun that the dust grains that came together to form our planet were warmed to temperatures of 70°F. Such temperatures should have prevented ices from forming, so the dust grains would have consisted almost entirely of silicates and iron—the stuff of Earth's interior. One debated idea is that all the water now found on Earth came from somewhere else after the planet was formed. But the chemical signature of the water in the few comets studied to date is different from that of common seawater. Asteroids, however, do have a similar signature, so they could have been a source of water. "This is complicated by the fact that Earth would have been growing by collisions with these water-bearing planetesimals and planetary embryos

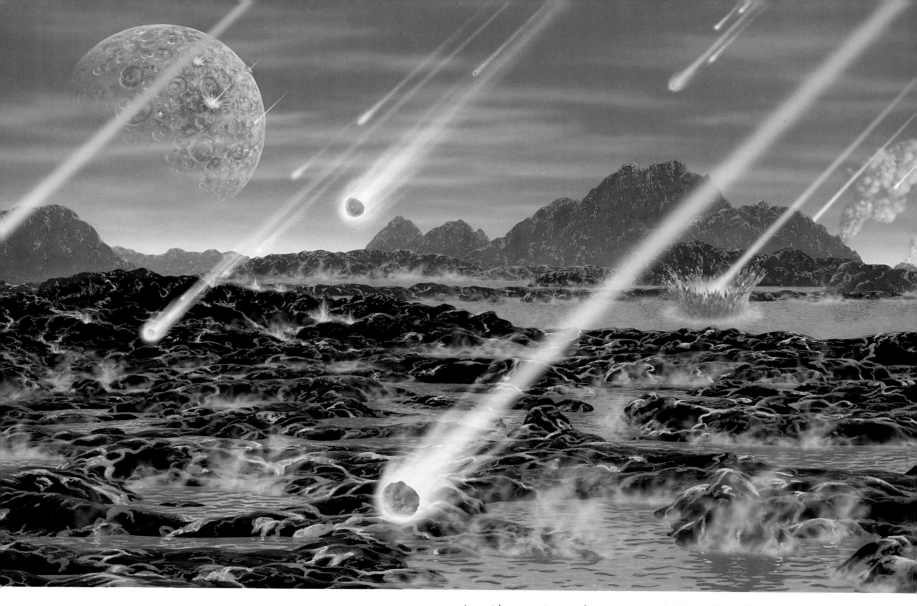

EARLY EARTH *Asteroids, meteorites, and comets pummeled the early Earth and Moon four billion years ago. Their impacts heavily scarred Earth's surface with craters but also brought water in the form of ice. The space debris may have even seeded Earth with the chemistry of life, amino acids. This planet irrigation eventually led to the development of oceans, providing a medium in which complex molecules and eventually life could develop. Life appeared remarkably early following the end of this period of heavy bombardment. As soon as Earth settled down, life took over the planet.*

from the very beginning, so it is unlikely [that Earth would have been] formed completely dry and then been hit with water-bearing bodies. In reality it was a continuous process," says Alan Boss.

Our present understanding of the origin and evolution of our Solar System—though still not complete—allows astronomers to compare it against planetary systems found around other stars. This is the one of the most exciting aspects of the current search for extrasolar planets. Is our Solar System the exception or the rule? How do other planetary systems evolve? Can they support life too?

4 Planetary Bonanza

THE ASSUMPTION THAT PLANETS ARE TO BE FOUND ELSEWHERE IN THE UNIVERSE IS NOT NEW. During the Renaissance a Dominican monk-turned-philosopher, Giordano Bruno, correctly deduced that any such planets would be too faint and small to be seen because they are lost in their host star's glare. "Innumerable suns exist, innumerable Earths revolve about these suns in a manner similar to the way the seven planets revolve around our Sun," he asserted in his 1584 book *On the Infinite Universe and Worlds*. The outspoken Bruno, a contemporary of Galileo, went on to declare: "God is glorified in . . . not a single Earth but in a thousand." This perspective marginalized Earth in the eyes of the Roman Catholic Church, since it implied that Earth was not a single enthroned example of God's creation but rather one among "an infinity of worlds." In 1600 the Church burned Bruno to death as a heretic.

It is little wonder that Johannes Kepler worried about the ramifications of finding planets around other stars: "If there are globes similar to our Earth . . . then how can we be masters of God's handiwork?" Kepler was relieved to hear about Galileo's discovery of four satellites orbiting around Jupiter. He assumed the stars were so close to Earth that Galileo could see any companion objects, as he had the moons of Jupiter, but none was detected. "If you had discovered any planets revolving around one of the fixed stars, there would now be waiting for me chains and a prison among Bruno's innumerabilities," Kepler wrote to Galileo.

The idea of extrasolar planets has been taken for granted in numerous science fiction stories, and widely popularized in science fiction films. "The Lord makes some beautiful worlds," exclaims an astronaut who steps foot on a planet orbiting the star Altair in the 1956 film *Forbidden Planet*. The dialogue in the 1960s *Star Trek* TV series

had the starship *Enterprise* crew nonchalantly chatting about cataloged planetary systems and even classes of planets based on their size, atmospheric composition, and orbital location in multiple planetary systems.

But when the first extrasolar planet discoveries were made, in the mid-1990s, planets proved to be much more diverse in terms of size and orbits than most astronomers had imagined. At first, so many oddball planets were found that they forced us to wonder if we were the oddballs. In hindsight this should not have come as a surprise. Prior to 1995, all our ideas about the planets came from just one example, our Solar System. Science once again revealed to us that the real universe is more complicated and full of intrigue than commonly imagined.

The View from Alpha Centauri

The daunting challenge is that finding an extrasolar planet around a neighboring star involves picking out a speck of light that is roughly one-billionth the brightness of the parent star. That's because planets are not hot enough to shine fiercely like a star, but shine only by reflecting light from the star. This may seem hard to believe if you've ever seen the planet Venus glowing brightly after sunset, or Jupiter high in the evening sky like a glowing lantern. Though they are only reflecting sunlight, they are much closer to Earth than the stars, and this makes them appear brilliant.

Today's most powerful telescopes can look across billions of light-years of space, almost back to the beginning of time itself. These telescopes have seen the dying flicker of stars that blew up many billions of years ago, some of the earliest building

WATER WORLD RISING *If as many terrestrial planets exist as some astronomers believe, an amazing assortment of Earthlike worlds may exist in our Galaxy and throughout the cosmos. Here another Earth rises beyond a cratered moon; both are warmed by the two large stars at upper left. This scene is reminiscent of our own home world, a "formula" that may be played out in an almost inconceivable number of variations all over the universe.*

blocks of galaxies, and gas spiraling into black holes. But looking for planets around neighboring stars is seemingly as impossible as staring directly into a car headlight miles away and trying to see a ladybug crawling on the headlight's rim. Like dying coals in a fireplace, planets do glow feebly. But they do so in a form of invisible light called infrared radiation. Stars glow dimly in the infrared spectrum, but planets radiate most of their energy in the infrared. Although observing in the infrared improves the odds of picking out a planet from a star's glare, even bigger telescopes than those of today are needed before this can be tried.

The challenge of seeing extrasolar planets was dramatized in a historic "family portrait" taken of our Solar System by the *Voyager I* space probe in February 1990, when it was four billion miles from the Sun and beyond the orbit of the outermost planet, Pluto. Even from that relatively near distance—merely one-six-thousandth the distance to the nearest star—the planets rapidly dwindle to feeble pinpoints of light in *Voyager*'s peering camera. Earth is reduced to resembling a mote of dust caught in a beam of sunlight.

If there were a civilization orbiting the nearby star Alpha Centauri (at a relatively short hop of 4.3 light-years, or roughly 300,000 times the distance between Earth and the Sun), the inhabitants would need to build extraordinarily big telescopes to see our Solar System. Jupiter would be hidden in the Sun's glare. However, there are other ways Jupiter would make its presence known. This giant planet, more massive than all of the other planets in the Solar System combined, is engaged in a perpetual gravitational tug of war with the Sun. The Sun keeps Jupiter in orbit, and Jupiter's gravity pulls back on the Sun. The result is that the Sun and Jupiter move around a common center of gravity just beyond the Sun's visible radius. It's like watching an ice skater pivot while swinging a much lighter companion. To a much lesser extent the weak pull of the other planets also affects the Sun, but this would be even harder to measure.

Anyone living on a planet around Alpha Centauri could indirectly detect Jupiter by trying to measure a minute wobble in the Sun's motion. This could be an up-and-down wobble as seen on the sky, or a back-and-forth wobble as measured in very tiny shifts in velocity. Either way, it would take the Sun 12 years—the time it takes Jupiter to com-

STARRY NIGHTS AT LICK *Perched on top of Mount Hamilton, California, Lick Observatory has a magnificent view of the heavens. Lick is typical of the large, world-class observatories that have made astronomical history throughout the decades. Over a dozen extrasolar planets have been discovered here. One of the telescopes used in the planet search, the 120-inch Shane reflector, is just seen through the open slit in the right-hand dome in this artwork. Ground-based telescopes offer great light-gathering power and large platforms to support the biggest spectrometers and cameras, making them complementary to the smaller spaceborne telescopes above Earth's atmosphere. Lick is operated by the University of California and is one of the locations where the California and Carnegie Search team conducts its research.*

plete one orbit around the Sun—to complete one wobble. The up-and-down wobble can be measured as a wavy motion of the Sun against the background of other stars. This process of precise positional measurement is called "astrometry."

As a planet circles a star, the planet's gravitational field tugs on the star. This can be measured as a slight movement toward or away from the observer, what scientists call "radial motion." In other words, the star appears to be moving back and forth along an imaginary line drawn from Earth. This is akin to standing in front of a child on a playground swing, and watching her rhythmically come toward, then away from you. If the child were blowing a whistle, the pitch of the whistle would rise and fall with each full swing.

This change in pitch is called the Doppler effect, after Austrian physicist Christian Doppler, who theorized in 1842 that both light waves and sound waves can be compressed or stretched, and the amount of stretching or compressing used to calculate velocity. Measuring the rhythmic shift in a star's apparent velocity toward or away from Earth is called the "radial velocity" technique. The challenge to planet hunters is that the velocity added to the star can be extremely small, in some cases only a few miles per hour, not much faster than a person can run. Jupiter's tug on the Sun causes it to wobble at a speed of 22 miles per hour toward or away from an observer.

Viewed from Alpha Centauri, it would take 12 years to see the Sun complete a single wobble. For about half of that interval the Sun would appear to be nudged toward Alpha Centauri, and for the other half of that period it would appear to be nudged away, an example of the radial velocity technique.

False Starts, Failed Dreams

The road to finding extrasolar planets is littered with purported planet discoveries that later turned out to be wrong. The years 1963 to 1991 witnessed announcements of 14

planet discoveries that were later retracted because of errors and misinterpretations in the extraordinarily precise observations of tiny stellar wiggles. Probably the most famous false alarm came in the search for the long-suspected planet around Barnard's star, a dim red dwarf that is only six light-years from Earth. It moves across the heavens at a faster rate than most stars, partly because of its close proximity to the Sun and partly because of its high-velocity orbit. Peter Van de Kamp of Swarthmore College's Sproul Observatory spent three decades of his life dutifully tracking Barnard's star. In 1963 he confidently announced the existence of at least one and perhaps two Jupiter-sized planets whirling around it.

Regrettably, the observations were disproved a decade later. Careful analysis of the motion of the star was eventually attributed to changes in the telescope itself. When the telescope's lens was remounted, midway through Van de Kamp's observing program, it shifted the telescope's focus such that the position of the star was shifted in the telescope's field of view. This gave the illusion that it was wobbling relative to the background stars.

In 1991 University of Manchester astronomer Andrew Lyne reported a planet orbiting an unlikely target: the spinning, crushed core of a burned-out star, called a neutron star. The neutron stars that emit a rapid stream of radio pulses are also known as pulsars (short for pulsating stars). These precise pulses that Lyne detected varied slightly, indicating that the pulsar was wobbling. It was strange enough to find a planet orbiting a burned-out star. What was even stranger was that the planet completed an orbit once every six months—exactly half the time it takes Earth to go around the Sun.

After rechecking his readings from the Jodrell Bank radio telescope in Great Britain, Lyne had to admit that the planet didn't exist. The apparent wobble of the neutron star was actually a reflection of Earth's orbital motion—Earth was producing the "wobble" in the pulses, not the dead star itself. However, in 1991 radio astronomer Alexander Wolszczan, using the Arecibo radio telescope in Puerto Rico, found complex variations in the rapid machine-gun stream of radio energy from a pulsar 1,200 light-years

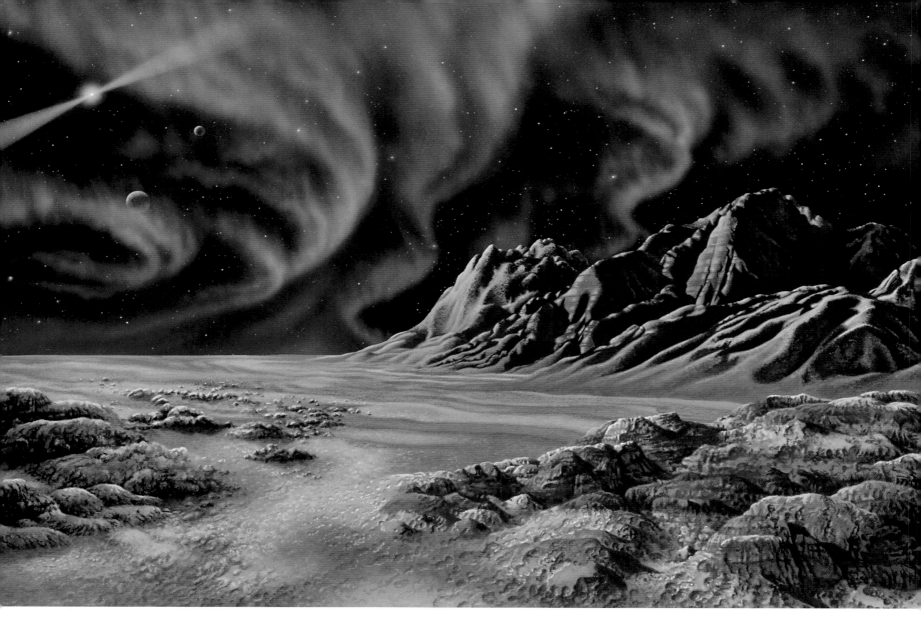

PULSAR PLANETS *The planets orbiting PSR 1257+12 are barren, and life cannot survive the extreme radiation from this pulsar. As the radiation sweeps over the outermost planet, the atmosphere puts on a beautiful auroral display that bathes the landscape in an eerie green light. The inner worlds appear in the distance, shown larger than they would actually be seen from this vantage point.*

away in the constellation Virgo. These changes meant the dead star was wobbling, but the effect was too complicated to be caused by the tug of a single invisible companion. After years of cautious analysis he announced that two or even three planets orbited the neutron star.

But these planets present a bleak landscape for our imaginations to conjure up. Under the intense pinpoint glare of the ultrahot but tiny neutron star there can be no clouds, no oceans, no life—at least certainly not life as we know it. Even more bizarre, the planets probably formed *after* the star exploded! So they tell us nothing about the abundance of normal planets as we know them. A disk of dusty debris may have been cast out from the star following the explosion, and these so-called pulsar planets precipitated out of the disk. Or perhaps the pulsar evaporated a stellar companion, and planets formed from the debris. Yet another possibility is that two white dwarfs merged. One was dissipated to form a disk around the more massive star, which accreted and collapsed to form a neutron star. Material far in the disk formed planets.

Nevertheless, enough information is revealed in the changing pulses to show that the three planets have masses roughly equal to 2.8, 3.4, and 1.5 times Earth's mass. What's especially interesting is that they are spaced at a ratio of distances that is extremely close to the ratio of the distances of Earth, Venus, and Mercury from the Sun. At first glance this suggested a uniform rule for the formation of planets. But new discoveries would quickly overturn conventional wisdom and common sense.

The Star 51 Pegasi: Breaking All the Rules

The first normal star that was caught wobbling from the invisible tug of a planet came as a complete surprise. In 1995 Swiss astronomer Michel Mayor was looking for a wobble in the yellow Sunlike star 51 Pegasi, located 50 light-years away in the constellation Pegasus. Using a modest-sized 76-inch telescope, he was hunting for the class of strange

low-mass stars called brown dwarfs. Mayor's team collected a full week's worth of observations of 51 Pegasi.

To his puzzlement Mayor found that 51 Pegasi completed one wobble in only four days. All concurrent planet searches were looking for Jupiter-sized planets in billion-mile-wide orbits like Jupiter's. Giant Jupiter takes 12 years to make one orbit around the Sun: this meant that it would take at least a decade to collect enough data to prove a planet built roughly to the same blueprints as Jupiter was there. The conventional wisdom held that Jupiters had to form far from a star, where they could retain lighter elements like hydrogen and helium, and molecules like water, methane, and ammonia. But the body that tugged at 51 Pegasi was at least half the mass of Jupiter. It was unbelievable that a planet more than half the size of Jupiter could orbit so closely it could whirl around the star in just four days.

The discovery sent a scientific and philosophical tsunami across our little blue planet. At first glance it seemed to remove any last pretense that planets are rare and unique in the universe, and it challenged scientists' preconceptions of what a planet should look like. Over 400 years after Copernicus dethroned Earth as the center of the Solar System, scientists now had long-sought evidence in hand that a planet did in fact whirl around another pinpoint of light in the nighttime sky. The discovery opened the floodgates to the possibility of many other planetary systems. Overnight this seemed to increase the chances of there being life—perhaps even intelligent life—somewhere else in the universe.

The discovery alerted astronomers Geoffrey Marcy of the University of California at Berkeley and Paul Butler of the Carnegie Institution of Washington, who had patiently spent eight years observing dozens of stars in the search of planets. They were

51 PEGASI *The planet that orbits the star 51 Pegasi is the first extrasolar planet discovered around a Sunlike star. Because of its four-day orbital period, the planet keeps one hemisphere locked on the star. Atmospheric gas flows from the perpetually lit daytime side of the planet around to its dark side. Atmospheric temperatures sizzle at over 1,000°F.*

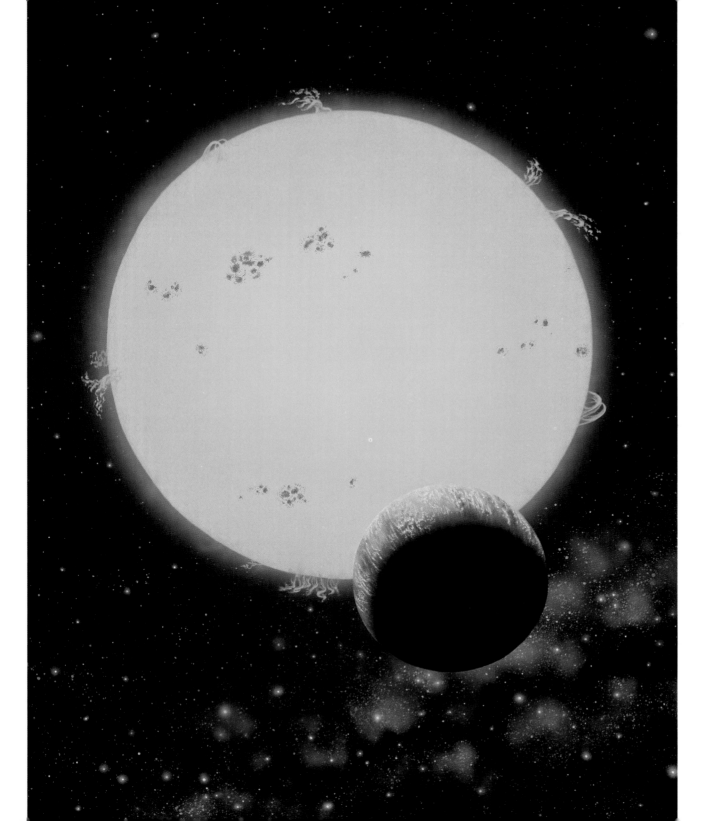

looking for Jupiter-sized worlds in Jupiter-sized orbits. Marcy and Butler were young and ready to patiently keep taking the pulse of stars, even if it meant spending half a lifetime and most of a career to uncover the plodding giants. Now they thought that perhaps encoded in the data they had already collected lay hidden the full orbits of other giants whirling perilously close to their parent stars in periods of days, not years, as everyone had expected.

Sifting through eight years of telescope measurements, Marcy and Butler began searching for other massive planets that might be orbiting extremely close to their parent star. In the process of their review they uncovered two other gas giants orbiting close to their stars. One star, called 70 Virginis, is 59 light-years away; the other, 47 Ursae Majoris, is 46 light-years away. Amazingly, the orbit of each new planet turned out to be at about the distance of Mars, significantly closer than Jupiter is from the Sun.

Like the Swiss team, Marcy and Butler have developed an ingenious observational technique that allows them to measure extremely tiny Doppler-shift changes in a star's spectrum due to the minute tug of a low-mass unseen companion. They monitor over 1,300 stars yearly to patiently look for variations in their motion. Surveys select stable, middle-aged stars between .3 and 1.3 solar masses that are similar to the Sun in temperature.

The data that show stellar velocity changes form a vertical zigzag pattern when plotted, revealing a telltale pendulum effect. The team wrote a computer program that models different hypothetical planet orbits. Their program is relatively simple, using gravitational equations developed by Isaac Newton over three centuries ago. Because the tilt of the hypothetical planet's orbit is not known, its mass can be estimated only from the probability that the tilt is oblique in most cases. The rare chance of a face-on orbit would make the planet seem misleadingly low in mass.

The astronomers plug into the program the planet's estimated mass, distance from the star, and orbital shape—circular versus elliptical. They then compare the resulting S-shaped plots against the data points they collect from different nights of observation.

47 URSAE MAJORIS SYSTEM ORBITS AND ORBIT OF 16 CYGNI B PLANET *The planets of the Solar System follow nearly circular orbits as they move around the Sun. This helps to create a stable environment on Earth for life to thrive. An extrasolar system much like our own is the 47 Ursae Majoris system, with its two planets having orbits that are almost circular. Many exoplanets discovered so far, such as the planet orbiting 16 Cygni B, follow much more highly elliptical orbits than those in the Solar System, a finding that has surprised astronomers. The wide temperature fluctuations that these planets experience as they travel close to their stars and then move farther out probably reduce the opportunity for life to exist.*

The data fit the theoretical plots like a game of connect-the-dots. Often the S-shape is really more of a saw-tooth shape, the signature of a planet in an elliptical orbit that is markedly different from what we find in our Solar System. About 80 percent of the stars are dismissed as "flatliners": they show no swing toward or away from Earth.

By the end of 1996, 10 extrasolar planets had been found by using the radial velocity technique. A mere six years later, this number had ballooned to over 100. By the end of 2005 it will likely exceed 200. The first planets discovered are at least several hundred times the mass of Earth and presumably gas giant–type planets. The survey techniques that detect a star's subtle wobble are best at finding big planets in short-period orbits. The big planets pull hard enough on stars to be detected, and the short orbits mean that they can be detected in short order—just a few years.

As Marcy and Butler improved the precision of their observing techniques, they began to uncover gaseous planets smaller in mass than Saturn, which is only one-third the mass of Jupiter. By 2004 they had identified two planets merely 15 to 20 times the mass of Earth. It is not known whether these planets are gaseous or whether they are solid like Earth. They are the most recent additions to a growing list in which relatively

HD 16141 b AND MOON *Most of the first exoplanets to be discovered were several times the mass of Jupiter, and smaller bodies continue to be confirmed. In some planet systems, such as Upsilon Andromedae, the first planet discovered was the innermost planet and designated "b." The additional planets are labeled sequentially through the alphabet from the star outward, since the more distant planets were discovered later than the ones closer in. HD 16141 b has 70 percent of the mass of Saturn and an orbit similar to that of Mercury. Its estimated surface temperature is 1,530°F. Any moon circling the planet would be parched and unsuitable for life.*

low-mass planets outnumber earlier discovered giants several times the mass of Jupiter. These discoveries solidify the notion that the unseen planets are part of a different population of objects than the brown dwarfs, which should be no smaller than about 10 Jupiter masses.

Although brown dwarfs are similar in size to Jupiter, they are much more dense and produce their own light, while Jupiter shines with reflected light from the Sun. When brown dwarfs are very young, they generate some energy from the fusion of heavy hydrogen, or deuterium, into helium. But this supply is used up in a few tens of millions of years. Because a brown dwarf has a mass of less than about 8 percent of the mass of the Sun, it cannot sustain significant nuclear fusion reactions in its core. Because of their intrinsic faintness and low temperature, brown dwarfs were not discovered until 1995.

Hot Jupiters

The strangest finding from the planet surveys so far is the unpredicted new class of planets dubbed "hot Jupiters," of which the one circling 51 Pegasi is an example. These planets orbit precariously close to their stars in periods of only a few days. They are made of gaseous and liquid hydrogen, rather than the rocky composition that would be expected in a world baked so close to a star. It is interesting that these planets get no closer than a few million miles from their stars. This may offer clues to their origin and evolution.

The gaseous nature of the hot Jupiters was confirmed in 1999 during an observation of the star HD 209458, 150 light-years away in the constellation Pegasus. The planet had been detected orbiting the star earlier because of a stellar wobble. It was independently confirmed by precisely measuring a very slight dip in the star's light as the planet passed in front of it.

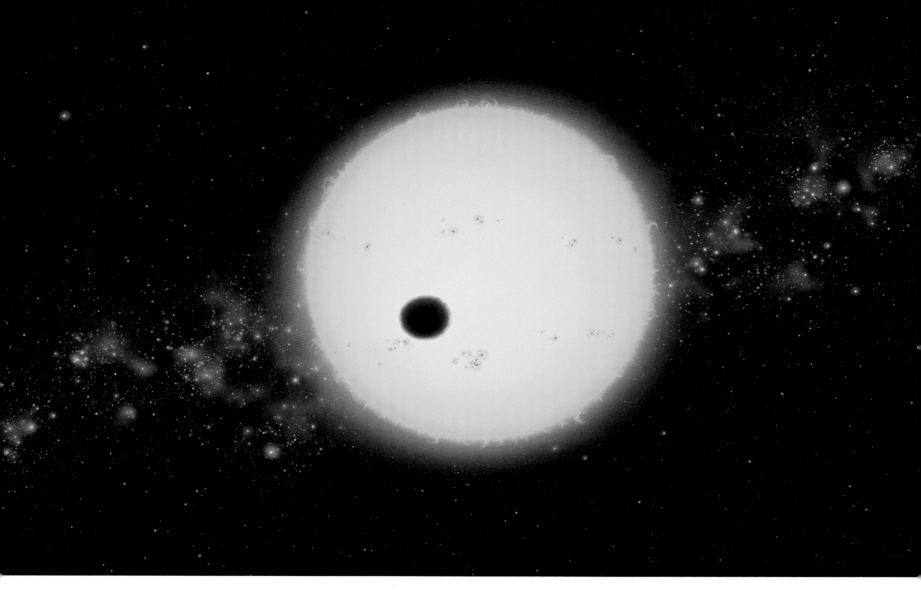

TRANSIT OF HD 209458 *This is the first planet ever discovered passing in front of its star, HD 209458. The orbit of the planet is edge-on to Earth, allowing astronomers to witness such passages, called transits. Astronomers observed a dip in the star's light as the planet passed in front of it. This provided direct and independent confirmation of the existence of extrasolar planets, which to that date had been inferred only from the wobble of their star. The planet completes an orbit in only 3.5 days, making repeatable planetary transit observations feasible.*

The observation was possible only because the planet's orbit happens to be tilted edge-on to our view from Earth. The planet has such a fast orbit, every 3.5 days, that it was easy to catch the fleeting transit. A transit is a bit like a solar eclipse, when the Moon passes in front of the Sun. During a planetary transit a planet briefly passes in front of the star. The planets Mercury and Venus routinely transit the Sun, as viewed from Earth. The planet orbiting HD 209458 is so tiny compared to the star that it dims the star's light by only 1.7 percent, but this is still measurable from Earth. An amateur telescope outfitted with the proper electronics could find Jupiters transiting nearby stars.

Based on data obtained by the Hubble Space Telescope and ground-based observations, the planet was proven to be a puffy gas giant. Hubble telescope light measurements were so precise that they showed the planet could not have a moon much larger than Earth, and that it couldn't have a system of rings comparable to those of Saturn. Astronomers estimate the planet is about 35 percent larger in diameter than Jupiter, though it is less massive. That means the planet has the lowest density ever measured for a planet, only one-third that of water.

In 2001 a follow-up observation by the Hubble telescope measured the colors of starlight passing though the edge of the planet's atmosphere. Astronomers measured the spectral signature of sodium in the atmosphere, expected to be a trace element in a gas giant's composition. Using techniques such as this, astronomers eventually will be able to characterize the gas giants according to their trace elements. It is predicted that the Jupiters orbiting other stars at about Earth's distance from the Sun are so warm that they have water clouds. Jupiters that orbit at only one-tenth Earth's distance from the Sun are expected to have atmospheric temperatures exceeding 1,000°F.

During an observation in 2002, the Hubble Space Telescope detected a huge cloud of hydrogen gas boiling off into space from the surface of the planet orbiting HD 209458, making it by far the hottest of the "hot Jupiters." The planet's dense atmosphere is being blown off at the rate of more than 10,000 tons a day in a puffed-up,

elongated comet-tail feature nearly 125,000 miles long. The planet is doomed to evaporate eventually, or become a hydrogen-poor, Neptune-mass planet.

These discoveries have forced scientists to revise their theories to explain how these large planets might have formed at a greater distance from their stars and then moved in closer. One idea is that they could have exchanged momentum with much smaller planetary bodies. This planetary billiards game would have shrunken the giants' orbits as the smaller bodies robbed momentum from them and were propelled away. Another idea is that the circumstellar disk may be so massive with dust and gas that it forces a planet to ride along a spiraling gap in the disk, which brings it closer to the star. Researchers have also found that even hot Jupiters can get only so close to a star. Maybe this is where the circumstellar disk stopped, and planets could not migrate in any closer. A chicken-and-egg puzzle is found in stars with hot Jupiters that have a larger fraction of heavier elements than the Sun. Does this mean that only a massive disk clogged with a lot of dust and gas can reroute the planet? Or does it mean that some giant planet spiraled into a star, enriching its metallicity?

Equally puzzling is the fact that young stars pour out blistering X-rays and ultraviolet radiation, because many young stars rotate rapidly, in a matter of days. This tangles up their magnetic fields at a much faster rate than the Sun's 11-year cycle of activity, marked by sunspots and other solar activity that upsets electronic communications here on Earth. (The mature Sun spins slower than in its youth, at a rate of one rotation approximately every 28 days.) Such young stars must be freckled with "starspots" and spit out huge flares and coronal-mass ejections. One idea is that the hot Jupiters have powerful magnetic fields like our own Jupiter, which serve as a shield for redirecting the blast of charged particles from a young star. This theory was confirmed in 2004 when astronomer Eugenya Shkolnik of the University of British Columbia identified a magnetic "hotspot" on the star HD 179949. A Jupiter-mass planet completes an orbit around the star every three days, at a distance of barely five million miles. The interaction between the planet's magnetic field and the star's surface creates the hotspot and drags it around the star like a dog on a leash, completing one circuit every three days.

The first observations of multiple-planet systems around other stars deepened the worry that astronomers and theorists really don't know how planets behave once they form. In 1999 Marcy, Butler, Fischer, and their colleagues announced the detection of the first planetary system around a normal star beyond the Sun. They found three planets orbiting the star Upsilon Andromedae, 44 light-years away, and visible to the naked eye as a fourth-magnitude star in the autumn constellation Andromeda. This is a planetary system of Titans. At least two of the planets are more massive than Jupiter. The inner planet, which is about half Jupiter's mass, is so close to Upsilon Andromedae it completes an orbit once every 4.6 days. The outer two planets circle in 242 days and about three years, respectively.

Sometimes giant planets appear to migrate until they settle into resonant orbits with companion planets, which also can make orbits more elliptical. A resonant orbit means that two planets are locked into orbits that are synchronized, like the rotating hands of a clock. On a clock face the minute hand sweeps around 12 times for every full sweep made by the hour hand. We would say that the hands are in a 12:1 resonance. Planet resonant orbits are more like 2:1 or 3:1 ratios: they are locked together in synchronization, just like the hands of a clock. Every time the faster-moving planet laps the slower-moving planet, they gravitationally tug at each other and stay perpetually in sync. One of the most unique planet systems that behaves like this can be found around a diminutive red dwarf star, Gliese 876, located 15 light-years away in the constellation Aquarius. The pair of planets are locked in resonant orbits, whirling around the star with orbital periods of 30 and 61 days, so the inner planet goes around twice for each orbit of the outer one.

Given the initial discoveries of hot Jupiters and Jupiters in destructive elliptical orbits, it was reassuring when the first of the Jupiter-analog systems was found, meaning that these predicted systems have gas giants in reasonably circular Jupiter-sized orbits. This allows room for rocky, terrestrial planets closer to the star to survive. The first such sys-

UPSILON ANDROMEDAE SYSTEM *This is a conceptual view of three planets orbiting Upsilon Andromedae, the first planetary system discovered around a Sunlike star. Though the ring is hypothetical, studies of the outer planets in the Solar System show that a thin ring of icy debris is common to gas giant planets. There is a good likelihood that they exist around extrasolar worlds also.*

tem of Jupiter analogs was found around the star 47 Ursae Majoris. The inner planet orbits at about twice Earth's distance from the Sun, while the outer planet orbits at a little more than half the distance between Mars and Jupiter.

Planetary modeling indicates that, while not impossible, it is unlikely that a terrestrial planet could exist in the habitable zone around 47 Ursae Majoris because the inner planet is so close to the star. Therefore, astronomers were excited about the discovery of a planet found around the star HD 70642, located 90 light-years away in the constellation Puppis. The six-year orbit of this two-Jupiter-mass planet is just slightly smaller than that of the outer planet orbiting 47 Ursae Majoris, at a distance about halfway between Mars and Jupiter. Most reassuring of all is that there is no evidence of any giant planets orbiting between HD 70642 and the planet, leaving a swath of space where smaller terrestrial worlds could exist. At only 90 light-years away, this is a system that should eventually be scrutinized for terrestrial planets.

Undetectable but important in the planet quest is the possibility of moons expected to be orbiting the giant planets. In our Solar System alone we have moons of rock, ice, possible subsurface oceans, and one with an atmosphere even denser than ours. Moreover, our Solar System contains eight major planets but dozens of moons. Extrapolating from what's been discovered so far, we can cautiously assume there are at least several hundred moons among the planets discovered to date. Going further, even if only 10 percent of the stars in our Galaxy have planets, some astronomers estimate that there could be over 100 billion moons in the Milky Way alone. It may turn out that satellites are the best places to look for life in our Galaxy. Many could exist comfortably inside warm habitable zones where their gas giant parent planet orbits a Sunlike star at an Earthlike distance. It's hypothetically possible that a gas giant orbiting a star at Earth's distance from the Sun could have liquid-water oceans on a moon the size of Earth. You would need a substantially large moon to retain an atmosphere.

According to a study by Jason Barnes of the University of Arizona, the minimum distance from a parent star for a gas giant planet to maintain a satellite system is about half the distance of Earth from the Sun. If the planet is any closer to the star, the orbits

47 URSAE MAJORIS SYSTEM *Two Jupiter-like planets orbit the star 47 Ursae Majoris. They have nearly the same mass ratio as our own Jupiter and Saturn and travel in almost circular orbits at distances far beyond the distance at which Mars orbits the Sun. These similarities indicate that this system may have formed in a similar way as the Solar System. At one time theorists suspected that a low-mass, Earthlike planet might exist around 47 Ursae Majoris in its habitable zone, although this now seems unlikely. This view is from a hypothetical volcanic satellite of the outermost planet. Also shown are the confirmed inner planet and an imagined (but undetected) pale blue dot close to the star—a possible "water world."*

HD 177830 b AND MOON *Located 192 light-years away in the constellation Vulpecula, the 1.28 Jupiter-mass planet HD 177830 b travels within the star's habitable zone during a portion of its highly elliptical orbit. While water and life are unlikely to be found on the planet itself, the gas giants of the Solar System have satellites, and it is theorized that moons may exist around the gaseous extra-solar giants as well. If they do—and if HD 177830 b sports a moon of its own—there is a chance that the satellite could have liquid water. If it is large enough in mass, it could have an atmosphere and show characteristics similar to some of Earth's.*

of satellites will become unstable because of the star's gravity. More distant moons may spiral away from the planet, and closer moons may have decaying orbits, causing them to eventually fall into the planet. Stable orbits would remain only in the case of small satellites and those orbiting very close to the planet.

A big hazard is that the gravity of a giant planet would tend to pull in comets and asteroids, and moons could get in the way. We have dramatic evidence of such collisions on the Jovian satellites. A striking feature called a crater chain bears silent testimony to what is suspected to have been a torn-apart string of cometary bodies that long ago hit the icy moon Callisto, instead of the body that was actually pulling the comet toward itself, Jupiter. Also, giant planets should have powerful magnetic fields that trap the charged particles from the stellar wind. This would create radiation environments deadly to any struggling surface life. Life may survive only underground on many moons.

One problem in predicting life on extrasolar planets is that many of the ones discovered so far swing close to and then far away from their parent stars. This can make the surfaces of any moons furnace hot and then freezing cold, sometimes within days. One example is the planet orbiting 16 Cygni B in a highly elliptical orbit. It travels as far from its yellow star as our Asteroid Belt is from the Sun, and then swings as close to the star as Venus's orbit. Any moons orbiting this planet might behave more like comets: their atmospheres would thicken, puff up, and grow tails when close to the star. Another world with one of the most elliptical orbits known travels around HD 222582. Water existing on satellites of this planet would go through repeated melting and freezing, possibly forming seasonal lakes.

LOOKING FOR PLANETS BEYOND OUR NEIGHBORHOOD

Most successful planet searches have been in our own cosmic backyard, within a range of a few hundred light-years. That's "one small step" for planet-hunting astronomers—

HD 222582 b AND MOON *The planet orbiting the solar-type star HD 222582 moves in one of the most eccentric orbits known to date. The 576-day orbit takes it closer to the star than Venus to the Sun, and out to a distance slightly farther than Mars's orbit. It is located in the constellation Aquarius, 137 light-years away. The water on any of this world's satellites, if they exist, melts and refreezes with the seasons. Could life arise in such a torturous environment of temperature extremes?*

a puddle-jump across the Galaxy. If the Milky Way were the width of the continental United States, then the region surveyed by radial velocity studies would, on scale, be about the diameter of Lake Okeechobee in Florida.

A longer-distance technique, called microlensing, looks for a companion planet when a foreground star passes in front of a background star. These observations typically look in the direction of the center of the Milky Way, where the highest density of background stars can be seen in the sky. The gravity of the star and planet acts like a lens (as first predicted by Einstein) to bend the light of a background star. This happens briefly as the foreground star drifts between the background star and Earth. When a lensing (foreground) star has a companion planet, the planet causes an extra flickering of light in the lens. Precise measurements of the light could actually tell the planet's mass and orbital distance from the star. Unlike many other planet survey techniques, which are sensitive to stars only within roughly 100 light-years, microlensing is useful out to thousands of light-years. Microlensing is also sensitive to planets as small as or smaller than Earth. One drawback is that a microlensing observation is definitely a one-shot event. You could not catch a planet repeating an orbit. Because these are one-shot events, astronomers do not have as much information as they would glean from watching a planet orbiting its star, such as its distance from the star.

The first detection of a planet using gravitational lensing took place in July 2003. A team of astronomers led by Ian Bond of the University of Edinburgh were monitoring 200 million stars simultaneously when they observed the brightness of one of the stars increase twice over a period of about 40 days. This indicated that two objects had passed in front of the background star sequentially. Calculations based on the amount of brightening for each event showed that the second object is slightly less than one-half percent the mass of the companion star. This figure corresponds to a body one and a half times the mass of Jupiter—too small to be anything other than a planet.

In 1999 astronomers went hunting for star-hugger–type planets much farther away in space by using the stellar transit method, where a star's light dims for a few hours when a planet passes in front of it. Photometric transit method presents a unique sig-

nature that would be different from that of an intrinsically pulsating star as it changes brightness. Astronomers aimed the Hubble Space Telescope at a target 35,000 light-years away, an ancient city of stars called globular cluster 47 Tucane. Hubble was used to look simultaneously at 34,000 cluster stars for eight consecutive days to try to catch the chance passage of a planet across the face of the star. However, not one planetary transit was detected, even though at least seven fast, orbiting hot Jupiters were predicted based on the statistics of such planets in our own stellar neighborhood.

At first it was thought that planets might not be able to stay in stable orbits without being gravitationally derailed by the effects of a bypassing star in the center of such a crowded cluster. Though hot Jupiters are too close to their stars to be hijacked by a bypassing star, they must have initially formed far from the star, where they could have been disrupted before migrating inward toward it. Another possibility was that a torrent of radiation blasted out from the biggest and most powerful stars that first formed in the cluster may have blowtorched away embryonic planetary disks deep inside the cluster.

These explanations were largely discounted in 2004, when David Weldrake of the Mount Stromlo Observatory in Australia did a wider search for planets in the 47 Tucane cluster, covering 250 times as much area as the initial Hubble survey. He and his colleagues looked for any telltale transits among 22,000 low-mass stars in the much more sparsely populated outer halo of the cluster. Not one hot Jupiter–class planet turned up. "We conclude that 47 Tucane is a very different environment for hot Jupiter formation. This rules out all explanations except for metallicity deficiency," says Weldrake.

Because the 47 Tucane globular cluster is so ancient—13 billion years old—its stars formed at a time when the universe consisted almost entirely of hydrogen and helium, and very few heavier elements were available to make the seeds of gas giant planets. Though 47 Tucane is higher in heavier elements, or metallicity, than other globular clusters, it is still low relative to those in our own galactic neighborhood. The cluster's stars have only 30 percent the metallicity of stars near our Sun. Like our Sun, the neighboring stars formed later in the universe's history.

GLOBULAR CLUSTER 47 TUCANE *This is a close-up view of the globular cluster 47 Tucane, located 15,000 light-years from Earth in the southern constellation Tucana. Astronomers went hunting in this star city for planetary companions: bloated gaseous planets that snuggle close to their parent stars, completing an orbit in three to five days. To their surprise, they found none. The cluster's environment may be too hostile for breeding planets, planets may not stay gravitationally bound to their stars, or the ancient cluster may lack the necessary elements for making planets. (Courtesy R. Gilliand, STScI, and NASA)*

This assessment is bolstered by the observation that most of the planet-bearing stars discovered in our neighborhood are rich in heavier elements. In a 2003 survey of 754 nearby stars, astronomers found that those with roughly the same amount of iron and other metals as the Sun had an 8 percent chance of hosting planets. "Once we see stars with three times the metal content of our Sun, the planet detection rate goes up to 20 percent," says Debra Fischer. But none of the 29 surveyed stars with less than one-third the Sun's level of metals has had planets detected to date. Weldrake agrees: "Metallicity is a keystone to planet formation, and it seems to be a universal phenomenon, in agreement with both distant and local planet searches."

The idea that metal-rich stars are more likely to host planets supports the most popular hypothesis about how planets form. Its proponents say that as an interstellar cloud collapses to form a star, solid grains in the rotating disk of matter around the new star aggregate to form planets. "More metal would provide more grains to stick together," says Fischer.

This conventional wisdom was challenged in 2003 when astronomers found a roughly Jupiter-mass planet in the nearby globular cluster M4. This ancient cluster has only about one-fifth the amount of heavier elements than even the cluster 47 Tucane. Even more surprising, it has no more than one-twentieth the amount of heavier elements found in our Solar System. The M4 cluster's stars all came into being 13 billion years ago, so the planet is far older than those found in our own stellar neighborhood. This makes it the first of a new class of "first-generation" planets born in the universe. To many astronomers it is astounding that a planet could come into being a mere one billion years after the Big Bang. "This is a stunning revelation, absolutely unprecedented," says Alan Boss. "It has far-reaching implications for astrobiology: life may have arisen and died out long before life ever appeared on Earth."

An alternative explanation for a planet found in a low-metallicity star cluster is that the object may only be masquerading as a planet. There is a chance that a Jupiter-mass body might be the residual core of a star that had most of its mass stripped away by a

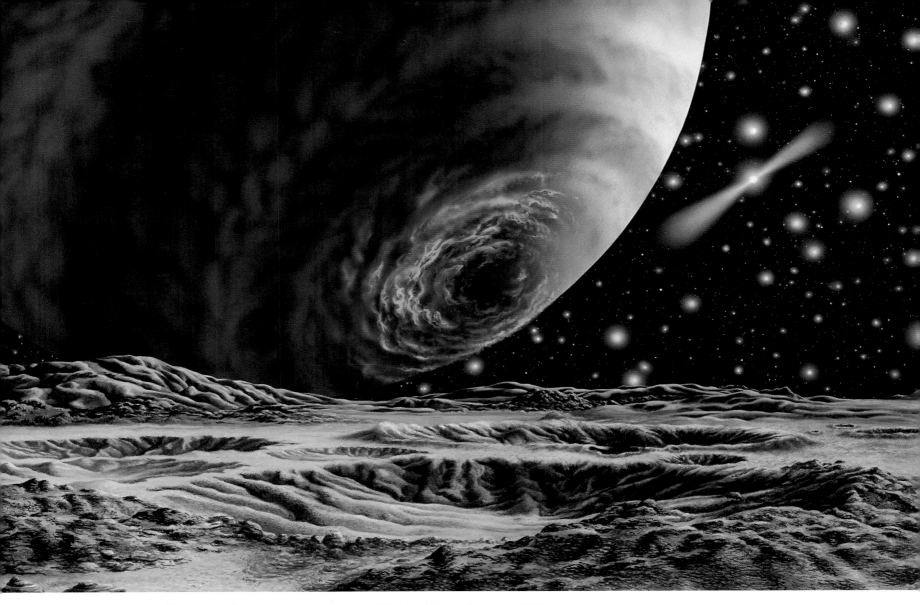

M4 PLANET *The oldest known planet to date is a gas giant world in the globular cluster M4. With an age of 13 billion years, it may represent the first generation of planets that formed in the young universe. The planet orbits about two billion miles from a tight binary system consisting of a pulsar and a white dwarf star. Here the planet's auroral polar cap is seen from the surface of a hypothetical moon that was thrown into a highly inclined, elliptical orbit—perhaps when the planet and its parent star met up with a neutron star several billion years ago, or perhaps when a terrestrial planet ejected from the star gravitationally disrupted the giant planet's satellite system.*

companion star in a binary system. The companion then exploded as a supernova and catapulted the surviving star into space, where it was later captured by another binary system. "Any scenario like this strains credulity, but strange and unlikely things do happen," says Ron Gilliland of the Space Telescope Science Institute.

Planet Inventory

There is no end in sight to the planet bonanza. The radial velocity surveys are only the first wave of ingenious techniques that will complement the work of teams looking at stellar wobbles. The planet ledger may be balanced when these exotic techniques find smaller planets, more like Earth, and Jovian-type plants in more distant, Jovian-type orbits. The radial velocity surveys yield an estimated minimum mass for an extrasolar planet. But the exact mass can be determined only once the tilt of the planet's orbit along the line of sight to Earth is known. This can be calculated by also measuring the star's zigzag motion on the plane of the sky, in addition to its back-and-forth motion measured by the radial velocity technique.

This was successfully demonstrated in 2002 when astronomers used the Hubble Space Telescope's Fine Guidance Sensors (FGS) to measure a small side-to-side wobble of the red dwarf star Gliese 876. This is accomplished through interferometry, in which the wave nature of light is use to amplify the effect of minute changes in an object's position. To accomplish this the FGS measured angles equivalent to the size of a quarter seen from 3,000 miles away. It turns out that because the orbit is nearly on-edge, the two-Jupiter mass of the companion planet was close to original minimum mass estimates.

One of the most promising techniques is looking for planet transits. In 2004 astronomers used the Hubble Space Telescope to look one-quarter of the way across the Galaxy in search of planets. The Hubble telescope gazed at a small region of sky in

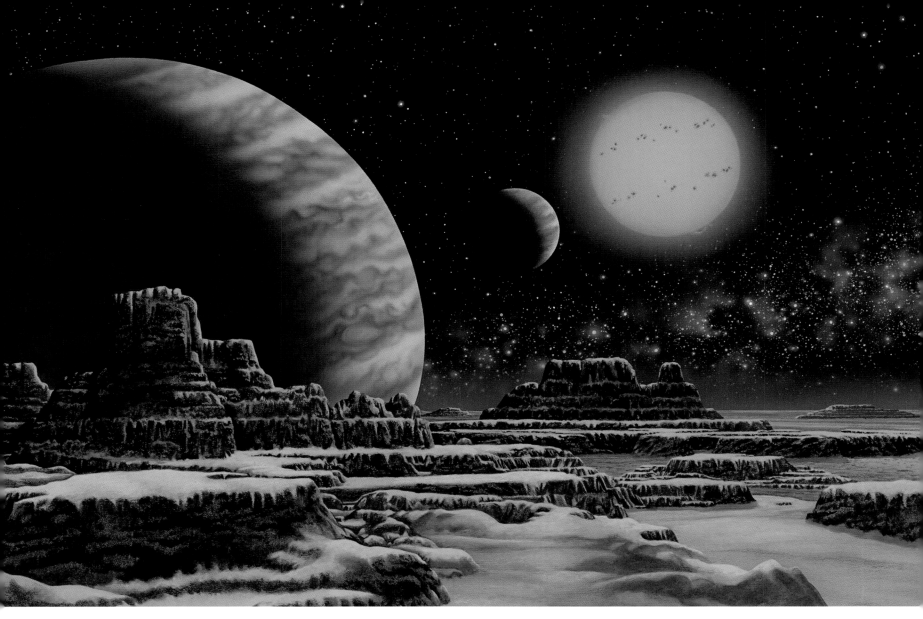

GLIESE 876 SYSTEM *The planetary system Gliese 876 b and c are seen from the surface of a hypothetical moon. In the case of Gliese 876's worlds, the outer planet was discovered first and the inner planet discovered second. In this painting we are standing on the surface of Gliese 876 b's moon, looking past Gliese 876 b and toward Gliese 876 c.*

the direction of the galactic center. This 25,000-light-year-long sightline allowed the telescope to include stars in the galactic bulge. All told, 100,000 stars were monitored for one week. Candidate stars showed slight dips in their brightness that could be caused by the passage of "hot Jupiter"–class planets in front of the stars. Only hot Jupiter–type planets were detectable in this observation because they block out a measurable fraction of a star's light, and they orbit the star so quickly that their passage can be caught on camera in only a few days of monitoring. Follow-up radial velocity observations of the brighter candidate stars that had been identified were made with the Very Large Telescope in Chile. Preliminary analysis by astronomer Kailash Sahu suggests that the statistical fraction of hot Jupiters in the field may be consistent with the fraction of candidates found in our stellar neighborhood. Further analysis of the Hubble observation is needed, however, before he can reach any definite conclusion. This finding, extrapolated to the entire Milky Way stellar population, means there could be as many as 100 million hot Jupiter–class planets in our Galaxy alone.

NASA's planned Kepler Space Observatory will keep a steady gaze on a field of about 100,000 Sunlike stars for four years. The telescope will measure the minute dimming of a star's light caused by the transit of an Earthlike planet. The chance of any one planet's orbit being edge-on to the telescope is only about 0.5 percent for those worlds that are as far from their star as Earth is from the Sun. This is why Kepler needs to monitor so many stars simultaneously. Kepler will have to make repeated observations of candidate stars to prove that the dimming of the star is due to an orbiting object. The star would have to repeatedly dim on a regular cycle—for example, yearly for an Earthlike planet in an orbit the size of Earth's. (Closer planets will transit many times in four years of observing, offering good statistical data on the frequency of terrestrial planets that might be too close to the star to be habitable.) Minimally, three transits of a star, all with consistent periods, brightness changes, and duration, will provide compelling evidence for the presence of a planet. It will be important for Kepler to measure a planet's orbit to determine if it lies in a habitable zone, far enough from the star for liquid

water to exist on its surface. Scientists predict that Kepler will find about 30 Earthlike planets. The observatory will give astronomers statistics on the abundance or dearth of Earthlike planets and will tell how deep follow-up searches have to look.

NASA's planned Space Interferometry Mission (SIM) is expected to detect several Earthlike planets from a survey of 200 nearby stars. It will measure the minute side-to-side gravitational wobbles that planets produce in stars through their gravitational pull. It will have two visible-light telescopes mounted at opposite ends of a six-foot boom and will be able to measure astrometric wobbles as small as the apparent diameter of a dime located four times farther away than the Moon is from Earth. This will enable it to detect planets a few times Earth's mass up to 30 light-years away, and Earth-sized planets around the Sun's closest neighbors. SIM will set the stage for follow-up telescopes to seek out the indirectly detected planets.

The techniques pioneered by SIM may eventually lead to a flotilla of space telescopes precisely spaced to combine starlight into a "nulling interferometer." This is one concept proposed for NASA's Terrestrial Planet Finder (TPF). In this scheme the independently collected waves of light from a central star are adjusted to cancel each other out. The interferometer essentially wipes out the glare of the blinding star while allowing light from planets to be detected. This works best at infrared wavelengths, where planets would be one-millionth the brightness of the star, verses one-billionth the brightness at optical wavelengths. This type of interferometry could reveal the architecture of planetary systems.

An alternative strategy for the TPF is to put a visible-light coronagraph on a large, optical, space-based telescope. A coronagraph is a device that blocks a star's light but passes the dimmer light from planets onto detectors. A coronagraph could find Jupiter-sized planets around nearby stars, but this would be no simple task. A coronagraph needs to block out one billion photons from the star for every single photon that dribbles in from a planet.

A 10- to 30-meter-wide optical telescope, called the Very Large Space Telescope

(VLST), is a logical successor to NASA's first generation of planet-hunting observatories. A 30-meter VLST would extend the planet search to five times farther than the TPF, encompassing a much greater volume of our stellar neighborhood. For every one Earthlike planet that the TPF detects, the VLST could find 100 planets. This increased success rate is mandatory for beginning to assemble a statistically meaningful sample of Earthlike planets in our Galaxy.

The VLST's sensitivity at visible wavelengths would allow astronomers to spectroscopically measure oxygen on terrestrial exoplanets. Even the atmospheric pressure could be deduced by measuring the amount of reddening of starlight as it passes through a planet's atmosphere. The VLST could be located at a gravitational balancing point between Earth and the Sun, an ideal stable location for parking large space telescopes of the future. Another place to locate planet-searching telescopes is the Moon. A lunar outpost could serve as a base to erect and service large, remotely operated observatories.

The next step beyond even the VLST is NASA's Terrestrial Planet Imager. This is a telescope that could actually resolve the disk of an extrasolar Earthlike planet. If the telescope were powerful enough to resolve a planet's disk at a resolution of 10 pixels across, astronomers could identify green spots similar to Earth's Amazon basin. A good example of what the first resolved terrestrial planet might look like can be seen in the Hubble Space Telescope's first pictures of Pluto, which is so small and distant it fills only about a dozen pixels. Detectable seasonal changes on an exoplanet might provide circumstantial evidence for whether photosynthetic life exists there, similar to life on Earth. An optics system big enough to make a planet image 1,000 pixels across would allow for local weather on the planet to be studied. "This is insanely difficult," however, cautions space optics engineer Gerard van Belle of Caltech.

Such a Herculean task would call for a hyper-telescope using precise optical interferometry to combine the light from multiple telescopes so precisely aligned that they would provide the same resolution as a single giant telescope. A hyper-telescope that

is an interferometric array 60 miles across could view extrasolar planets with sharpness 40,000 times better than even Hubble's view. One design calls for 150 telescopes, each about the size of the Hubble telescope's 2.4-meter mirror. These would be arranged in three concentric circles, with a baseline of 100 miles or so. Another design involves two clusters of eight-meter mirror telescopes spaced dozens of miles apart to function as an interferometer.

To keep the mirrors flying in formation, lasers would be needed to gauge the distance between free-flying spacecraft. Exquisitely precise low-thrust engines, ejecting one atom at a time, would maintain separation distances between mirrors to a tolerance of a small fraction of the thickness of a human hair. This would all be done autonomously through a computer guidance system. Once connecting telescopes as free-flying arrays is shown to be technically possible, space interferometers could be scaled up to hundreds or thousands of miles across, according to engineers. Short of traveling to these worlds, such telescopes would at last tell us if Earth analogs are truly to be found out there. The next step would be to ponder what kind of life dwells on such remote worlds.

5 Looking for Habitable Planets and Life

EVERYTHING ABOUT EARTH SEEMS JUST RIGHT FOR LIFE. Earth orbits a stable star that provided enough time for life to evolve over billions of years. Earth is at just the right distance from that star for water to remain liquid over billions of years. Earth's seasons are not too extreme because it moves in a nearly circular orbit. Yet Earth's 23.5-degree inclination and 24-hour rotation seem ideal for evenly heating the planet. Earth's geologically active surface keeps greenhouse gases in the atmosphere to help trap solar radiation to warm the planet.

But in reality, Earth may be just one example of a diversity of other possibilities for inhabited terrestrial worlds. One of the most enticing frontiers for astronomy over the coming decades will be to survey extrasolar terrestrial planets that may have atmospheres and surfaces reshaped by some sort of biology. Such discoveries could expand the envelope between the possible and impossible when it comes to life in the universe. Some subset of other planets may be Earth analogs. But others may not be immediately recognizable as abodes of life. The excitement over discovering an Earthlike planet will be dampened by not knowing exactly what lives on the planet. Some people will wonder if any life forms are looking back at us with similar curiosity and intellect.

A fundamental problem is that we really don't have a universal theory of life. Some astrobiologists feel that they can't develop such a theory until we find examples of life elsewhere in the universe. The dilemma is a little similar to that of less than a century ago, when chemistry majors were taught the structure of the carbon atom (six electrons orbiting a nucleus of six protons and six neutrons), but there was no theory of how and why it was constructed that way. It just *was*. By looking at other stars, astronomers

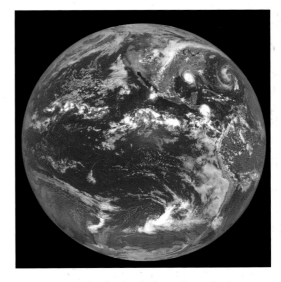

EARTH *Earth, the third planet from the Sun, may already be cataloged in planet surveys by nearby alien civilizations. They could calculate from Earth's orbital period that it lies in a habitable zone around a main sequence star. They could also deduce that it is a terrestrial planet where liquid water should be available. Through spectroscopy they could deduce that the atmosphere is in disequilibrium, probably due to the effects of a surface biosphere. How many planets like ours exist in the Galaxy? Even by very conservative estimates the number could be in the millions. (Courtesy NASA)*

in the 1950s developed the theory of nucleosynthesis that explained the buildup of elements through nuclear fusion. But imagine if the Sun were embedded in a dark dust cloud and we could not see any background stars. We might be forever clueless as to how the elements arose.

Within the next two decades samples returned from Mars or Europa might contain the first evidence of life independently arising off Earth. But until then the best we can suppose is that anywhere matter can exist there is a potential for highly organized processes using available energy. Life basically taps into an energy flow to increase complexity and store order. This notion is propelled by the emerging realization that life is not nearly as fleeting and fragile as once thought. It is aggressive, opportunistic, incredibly diverse, innovative, in a furious state of flux, always trying out new adaptive techniques, and always competing for resources. On Earth life is ubiquitous on the planet's surface, found deep in the oceans, and has been discovered even deeper inside Earth's crust. But no life evolved in our atmosphere; birds and insects use it only for transit. Might perpetually airborne life be possible on extrasolar planets where there are fewer environmentally favorable niches for organisms to occupy? What is the limit in the range of environments where life might be found?

"Life is no more—and no less—than a special type of organic chemistry," asserts Princeton geoscientist Tullis Onstott. "Any chemical system having the capability to spontaneously combine and self-replicate will undergo natural selection. It will evolve in structure through more efficient use of molecular resources and energy." SETI Institute astrophysicist Emma Bakes is just as succinct: "Life is merely a thermodynamically convenient arrangement of information that adapted to its environment. In short, life appears to be the coding of large amounts of information for the sole purpose of complexity."

Another universal definition for life comes not from biologists but from a physicist and a chemist, respectively, Gerald Feinberg and Robert Shapiro. In their 1980 book *Life Beyond Earth* they wrote, "We see life as being an integral and essential part of the

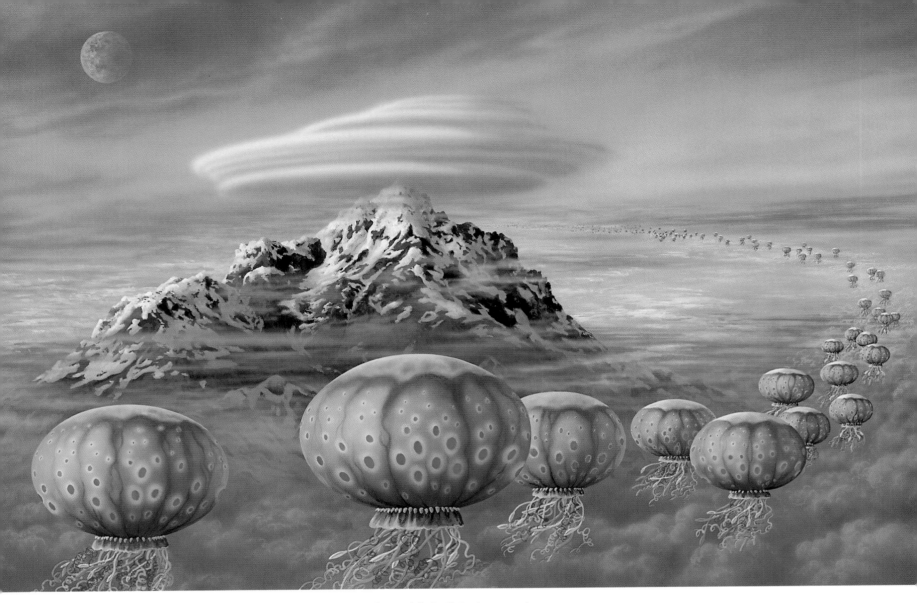

FLOATERS *Life on Earth dwells on the land and in the ocean, but no life dwells in the atmosphere, aside from becoming temporarily airborne. However, many planets in the Galaxy are gaseous, without a solid surface. If they possessed life, this could open exciting new habitats. In this imaginary view life forms resembling large gas bags ride on currents of air rather than currents of water. Perhaps a floating organism of this type could thrive on a terrestrial planet with heavy cloud cover and little solid surface.*

universe, a preferred expression of possibilities inherent in natural laws rather than a rare accident never to be repeated." From this general definition, Feinberg and Shapiro went on to hypothesize life inside stars as "plasmobes": self-stabilizing patterns of magnetic force and charged particles that naturally arise to store and transmit information to successive generations. At the other extreme would be worlds whose temperature lies just above absolute zero. These scientists hypothesized bacterium-sized bits of solid hydrogen living in a cryo-ocean of liquid hydrogen and undergoing reproduction. The problem is that just the timescales for conducting metabolism would be vastly different, so we could hardly recognize such life.

The challenge today is figuring out what characterizes the basic signatures of life. It's reasonably safe to say that life must have structure, shape, and composition. Life must convert one type of energy to another. This means life can thrive only where there is chemical disequilibrium. Life must be able to maintain complexity, requiring a stable environment. More generally, life replicates, evolves, moves in a nonrandom way, and creates waste products from its energy-conversion activities. This should provide detectable "biosignatures" on other planets, provided we can learn how to recognize them. A world of microbes, for example, could produce an atmosphere with a lot of methane. This is what Earth would have looked like from space billions of years ago, before its atmosphere became oxygen-rich from microbes using sunlight to manufacture oxygen, which "polluted" our early atmosphere.

Beyond these simple parameters, nothing else may be universal to life. In searching for extraterrestrial life, some of these characteristics simply can't be observed, such as evolution and probably actual replication. A planet like Earth has been so reshaped by life that the effects are measurable from light-years away. But a body like Mars or Europa, where microbial life may thrive only underground, would probably have no obvious biosignatures such as oxygen and methane at the surface. Perhaps more complex organisms thrive in specialized niches that are undetectable in a planet's biosignatures.

Earth microorganisms give new insights into chances for other life-bearing planets

UNDER THE ICE *A liquid ocean exists under the frozen surface of a Europa-type moon. Shafts of sunlight filter through cracks in the ice. Fish and small invertebrates swim in the dark water, invisible to anyone who might be looking at this world from a distance. Though sunlight doesn't reach very deep into the abyss, it does photodisassociate water ice on the moon's surface into oxygen and hydrogen, which provides oxygen to power multicelled life.*

and moons. The microbial biodiversity on Earth suggests that alien life forms may also very well be tough, tenacious, eat and breathe almost anything, globally modify their planet, and move underground when conditions get tough. Microorganisms have been found that can thrive in conditions previously defined as sterile: extreme temperatures, pressures, acidity, alkalinity, and salinity.

A stunning example of exotic life makes its home in the deep-sea volcanic vents found in mineral-rich boiling water. Life there ranges in size from microbes to eight-foot-long tubeworms. The heat-loving microbes, called hyperthermophiles, breathe iron and make magnetite. One type thrives at 250°F, the sterilization temperature commonly used in industrial applications. Moreover, these alien organisms are among the most primitive forms of life ever discovered, leading University of Massachusetts microbiologist Derek Lovley to suggest that all life on Earth may have originated from a microbe that breathed iron.

LIFE EMERGING

Through all of civilization humans have been pondering the origin of life. Aristotle's explanation was "spontaneous generation." He held that life springs from decaying organic matter. For example, if meat is left out, maggots appear in it as it decays. No one in Aristotle's day saw where the maggots came from, so they were considered to have arisen spontaneously. When Dutch scientist Antonie van Leeuwenhoek invented the microscope in the late seventeenth century, he discovered that a simple drop of pond water contains innumerable moving creatures he called "animalcules." The observation was as profound as Galileo's observations of the starry Milky Way. A world of the infinitely small populated with life sprang into view. Little might Leeuwenhoek have imagined that his "animalcules" were the most ubiquitous manifestation of life on our planet.

By the early twentieth century Swedish scientist Svante August Arrhenius proposed that life came to Earth as bacterial spores from outside our Solar System. When meteorites bearing these spores hit Earth, the spores found an environment suitable for life. This has become known as the "panspermia" hypothesis. A big problem, however, is that it doesn't explain how and where life initially originated. Nor does it consider the vast distances between the stars and the long incubation times required.

In the 1920s the Russian scientist Aleksandr I. Oparin hypothesized that life could arise out of natural chemical reactions. British geneticist J.B.S. Haldane came up with the same idea independently a few years later. Both reasoned that under the right conditions molecules naturally tend to organize and grow in complexity into bigger macromolecules. These macromolecules are the precursors to life and tend to aggregate into the molecules that will eventually organize themselves into living cells. The concept that life arises out of the same matter that exists throughout the universe was beautifully Copernican. However, Oparin and Haldane concluded that billions of years would be needed for chemical evolution to work. Because the first life forms, bacteria, appeared very early on Earth, there must have been more to this process than the random reshuffling of molecules.

The speed of chemical organization as a precursor to life was dramatically demonstrated in a classic experiment by chemists Stanley Miller and Harold Urey in 1953. They mixed simple gases that were assumed to be common on the primordial Earth: methane, ammonia, water, and hydrogen. When isolated in a beaker and subjected to electrical energy (simulated lightning), about 12 percent of the material converted into amino acids, the building block of proteins. The striking conclusion was that the material we're all made of is easily made from the conversion of these gases under conditions found on the early Earth.

However, a serious problem is that subsequent geological research indicated that this combination of gases didn't represent the primordial Earth's atmosphere. In the early 1950s astronomers thought all of the planets had once shared a primordial atmospheric

chemistry because of their common birth around the Sun. While the gas giants retained this early atmosphere, lower-gravity Earth had lost some of its primeval hydrogen, ammonia, and methane into space. But soon geologists realized that volcanoes would have pumped out about 80 percent water vapor, 15 to 20 percent carbon dioxide, and traces of carbon monoxide and molecular hydrogen. It would be tough to make amino acids in such an atmosphere. There was too much oxygen, which would have been poisonous to early life.

Nevertheless, the volatile elements in the Miller-Urey experiment are abundant elsewhere in the Solar System, including the massive Jovian atmosphere. The chemistry is also more typical of conditions on Saturn's moon Titan, which may be hundreds of feet deep in pre-biotic carbonaceous "goo." The Miller-Urey research "almost overnight transformed the study of the origin of life into a respectable field of inquiry," wrote marine chemist Jeffrey Bada of the Scripps Institution of Oceanography on the fiftieth anniversary of the experiment.

Miller and Urey's landmark experiment was published just weeks after a pair of scientists, James Watson and Francis Crick, showed that the twisted-ladder shape of deoxyribose nucleic acid (DNA) spells out in pairs the chemical four-letter programming code needed to describe the construction of a man, monkey, or microbe. Watson and Crick showed that each strand of the DNA molecule was a template for the other strand. During cell division the two strands separate, and on each strand a new second strand is built, identical to the previous one. In this way DNA can reproduce itself without changing its structure—except for occasional errors, or mutations.

By 1990 the U.S. government had committed $10 billion to determining the exact location, chemical composition, and ultimately function of 50,000 to 100,000 separate genes that make up the human DNA ladder. By the early twenty-first century scientists had at last mapped out the blueprint of life. DNA contains the master program for generating a 10-trillion-celled organism from a single egg, guiding the life-cycle instructions for the cell from birth to adolescence and maturity and finally to decline and eventual death. "It is plausible that the same kind of molecule with a similar

DNA GALAXY *The DNA molecule is an organic computer that stores the codes and instructions for all life on Earth. Its twisted-ladder structure, with only four chemical bases, is robust and functional. It is plausible that DNA, which may represent the optimum composition and molecular structure for life in space, is fundamental to carbon-based life throughout the Galaxy. Nature may converge on favored geometries from infinite possibilities. For example, on a much vaster scale, spiral structure is common to the architecture of myriad galaxies.*

number of bases codes a staggering variety of life on other planets with similar environments," says Emma Bakes.

Researchers found that DNA turns out to be not only a blueprint but also a history book of how life evolved over 3.5 billion years. A "universal tree of life" has been constructed from analyzing similar gene sequences that crop up in many different species. It shows an orderly branching into the three primal kingdoms of life known as the bacteria, the archaea, and the eukaryota. Our lineage is along the eukaryota branch, which accounts for all multicellular forms of life like plants and animals and the vast majority of the organisms that paleontologists work with. Although they show unbelievable diversity in form, eukaryota share fundamental characteristics of cellular organization, biochemistry, and molecular biology.

Earth's first homesteaders may have been the archaea. We call them the "extremophiles" because they thrive in conditions we would consider inhospitable. They were first discovered in the mid-1960s in scalding hot springs in Yellowstone National Park. In the 1970s they were found at the bottom of the ocean, along the steaming hot volcanic midoceanic trenches. During volcanic eruptions on the ocean floor vast outpourings of extremophiles are spewed up from inside Earth's rocky crust. On the early Earth sharp differences in temperature at the boundaries around these vents could have been good catalysts for chemical reactions, say microbiologists. Just as surprising are the discoveries that extremophiles can also withstand freezing, bone-dry conditions, and near starvation. They have been found surviving blistering atomic radiation inside nuclear reactors, in ultradry bitter cold of the Antarctic dry valleys, and in caves dripping with sulfuric acid. They can feed on such inorganic materials as manganese, iron, and sulfur compounds.

The extremophiles' existence hints at a vast potential for diversity of life on other planets. But just the term "extremophile" is biased and betrays the pitfalls of looking for life "as we know it." From the perspective of a microbe comfortably living at a thermal vent, *we* are the extremophiles. We live on the surface of a planet subject to tem-

perature extremes, volcanism, radiation from the Sun and exploding stars, meteorite impacts, and a corrosive, explosive atmosphere.

BAPTISM OF FIRE

We must take a giant leap back in time to try to understand life's origins. But *what* exactly originated? When did the first unambiguous step from inanimate to self-reproducing matter occur? Events on Earth over the past 4.5 billion years are our only case study of the emergence of life on a water-class planet (one possessing stable oceans over geologic time) orbiting a yellow dwarf star. These can be cautiously extrapolated to the rest of the Galaxy, so long as we do not exclude a variety of other niches for life.

Because Earth is much more massive than the Moon, it would have been hit by at least 10 times as many space rocks as its satellite over four billion years ago. The largest craters on Earth were the size of continents. During one cataclysm it is estimated that 17,000 craters were created in the 200 million years that "rototilled" Earth's surface. Wayward asteroids and comets carried water to the parched Earth from asteroids in a "refrigerator zone" beyond Mars's orbit and thus may have seeded Earth with organic compounds. As we have seen, such compounds have been found in meteorite samples. Ultraviolet light and cosmic rays provide energy for complex organic molecules to form in space, and the intense cold inside dusty interstellar clouds prevents the organics from breaking down. However, most meteors vaporize in our atmosphere. What fraction of interstellar organics might have made it to the surface without being fried to a crisp?

Wherever the amino acids on early Earth came from, they were the first key ingredient for life as we know it. Out of myriad chemical combinations, one molecule took on the ability to assemble a copy of itself. Once that awesome capability was achieved, the entire planet was life's for the taking. That was no easy step and one that is not understood for now. Yet it is critical to predicting the abundance of life on other worlds.

THE CRATER COPERNICUS *Visible to the naked eye, the Moon's immense impact crater Copernicus is 60 miles wide and located within the Mare Imbrium basin. This dramatic image from NASA's Lunar Orbiter shows the crater floor, floor mounds, rim, and rayed ejecta. The period of heavy bombardment of the Solar System ended nearly four billion years ago, at which time craters much larger than this, and far more abundant, pockmarked the young Earth. Somehow the first primitive life arose out of that deadly and hell-ish environment. Since most of the evidence of Earth's bombardment has been lost because of the planet's constant resurfacing, astronomers look at the Moon to determine what cosmic events may have happened more recently in our part of the Solar System. Copernicus is a relatively recent titanic impact on the Moon, dating back about 100 million years; thus it is evidence that wayward asteroids still menace the terrestrial planets. (Courtesy NASA)*

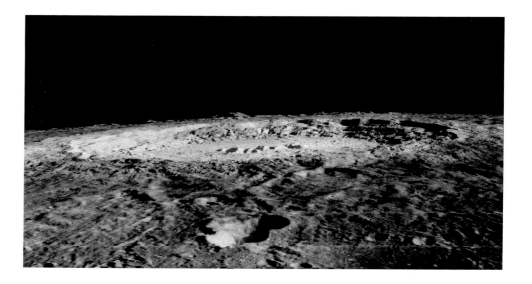

Fossil evidence shows that this happened quickly after Earth cooled. The biggest step was to create a vessel to distinguish *self* from environment—in other words, to set up a boundary with the outside world within which life processes could control an inner "universe" of proteins and amino acids. This means that life by definition began as a bounded system of interacting molecules. The earliest life generated proteins that caused these complex molecules—polymers—to transfer information to replicas of themselves. The earliest replicating molecules later acquired membranes and became cells. Within the cell ribonucleic acid (RNA) transferred genetic information, and DNA ultimately stored this information.

The first primitive cell, called a prokaryote, was nature's first "microscopic machine" for storing and transmitting information to replicant cells via nucleic acid. Because these earliest cells lacked a central nucleus, there must have been some other way of translating the genetic information into the construction of proteins. But the translations were no doubt often inaccurate, so lots of mistakes (mutations) likely were made. This probably set the stage for rapid evolution. As copying became more error-proof,

direct genetic transmission from mother cell to daughter took over. The three-branched tree of life emerged.

LIVING PLANET

In the 3.5 billion years that have elapsed since the emergence of the first living cell, the raw power of biological evolution has created a remarkable "living planet" that flourishes with life from pole to pole, from mountaintops to miles beneath sea level and even deep inside the planet's crust. The incredible diversity of life on Earth today results from the interplay between genetics, metabolism, and our planet's dynamic environment. This is collectively called the "biosphere." The idea that Earth's biosphere behaves as a "global organism" is embodied in the somewhat mystical-sounding "Gaia hypothesis." Gaia is the Greek goddess of mother Earth. Thirty years ago British chemist and biophysicist James Lovelock and Boston University biologist Lynn Margulis proposed the idea that Earth can be regarded as a "meta-life form" that began transforming the planet 3.5 billion years ago. By 2.8 billion years ago cyanobacteria (also called blue-green algae) were using sunlight to manufacture oxygen like little biochemical factories. Molecular oxygen was a deadly poison to methanogenic bacteria of that time and forced evolution to come up with new life forms. Given another two billion years, oxygen would allow for the evolution of multicelled creatures—plants and animals—to extract enormous amounts of energy from the biosphere through combustion.

An important lesson here is that coevolution between organisms and their environment should be an inherent feature of living systems on a planet. Just as life evolves in response to changing environments, changing ecosystems could alter the environment of a planet. As here on Earth, environmental and biological changes on other planets should be interlinked. Future research on Mars rock samples will look for evidence of how past biological activity may have altered the rocks. Spectroscopy of the atmo-

SEA-VIEWING WIDE FIELD-OF-VIEW SENSOR
IMAGE OF EARTH *NASA's Sea-viewing Wide Field-
of-View Sensor (SeaWiFS) has given researchers an
unprecedented view of the "Gaia" biological engine
that drives life on Earth—the countless forms of plants
that cover the land and fill the oceans. SeaWiFS mea-
sures chlorophyll concentration in the oceans and the
amount of phytoplankton (microscopic plants). Land
images show the density of plant growth. These activ-
ities follow dramatic seasonal cycles that, when all the
data are combined, give Earth the appearance of a
global living organism. (Courtesy GSFC and NASA)*

spheres of extrasolar planets will look for evidence of how the gases in an atmosphere
could have been altered by biological evolution.

Gaia or not, Earth's biosphere seems impressively resilient. It has survived billions
of years of volcanoes, meteor impacts, radiation from supernovae, reversals of Earth's
magnetic field, and changes in the Sun's luminosity. In fact, such stresses may be the
driver needed for biological evolution, as popularized by the evolutionary biologist
Stephen Jay Gould. This idea is that biological evolution proceeds mainly by huge leaps
and bounds, rather than by slow, minute adaptations as earlier proposed by Charles
Darwin. Species may remain unchanged for long periods of time until some major
event, most probably environmental and possibly global, creates an opening for entirely
new species to emerge in very brief bursts. Mass extinction is a key driver for evolu-
tion, and there have been at least five such events since life emerged on Earth nearly
four billion years ago, all acting on entire arrays of species. This theory of "punctuated
equilibrium" may have serious ramifications for planets in even more hostile places in the
universe. Does an increase in the rate of mass extinctions rapidly propel biological evo-
lution into new directions? Or at some point does it retard evolution on a planet?

A 2003 study of meteorite fragments found in Antarctica concludes that the great-

est extinction in Earth's history may have been triggered by an asteroid that smashed into what is now western Australia (the continents were combined into one giant land mass when it hit). Meteorite debris from this event were laid down at the start of the Permian-Triassic extinction, which happened 250 million years ago, when an estimated 90 percent of all Earth life was wiped out. Other geologic evidence exists that intense volcanic activity in what is now Siberia also took place at the time. This could have reduced the atmosphere's oxygen content and created hot greenhouse conditions. Could an asteroid that punctured Earth's crust have triggered this volcanism?

The dinosaurs arose not long after this extinction and apparently flourished because they may have had a physiology that allowed them to live on our oxygen-depleted planet (with oxygen levels equivalent to oxygen-poor conditions at an altitude of 14,000 feet). The dinosaurs vanished about 65 million years ago following another mass extinction triggered by yet another asteroid or comet impact. All species of dinosaurs (except birds, which might be their descendants) vanished rapidly along with a major part of the world's marine species. Physicist Luis Alvarez and his son, geologist Walter Alvarez, proposed the impact extinction theory in the early 1980s after studying a layer of meteoric iridium deposited at the boundary between the Cretaceous and Tertiary geologic periods. The "smoking gun" impact crater was identified under Mexico's Yucatán peninsula several years later. After this "K-T extinction" Earth's newly emptied ecological niches speedily filled with new emerging species: mammals and ultimately our own hominid ancestors. "It appears to us that two mass extinctions in Earth's history were both caused by catastrophic collisions," says geoscientist Asish R. Basu, of the University of Rochester, New York.

The second largest extinction of the five great periods of extinctions is the so-called Ordovician extinction of 440 million years ago, when 70 percent of Earth's species vanished. This has been attributed to a great ice age, but some astronomers suggest this was caused by a powerful burst of gamma rays coming from an exceptional powerful stellar explosion called a hypernova. In such explosions much of the energy in the core

of a collapsing, very massive star is concentrated along two narrow beams. This makes the hypernova sort of nature's own high-energy weapon: anything lying along a beam's narrow path will get zapped.

Researcher Adrian Melott of the University of Kansas theorizes that a burst of gamma rays striking Earth 440 million years ago tore apart molecules in the stratosphere, causing the formation of nitrous oxide and other chemicals that obliterated the ozone layer and shrouded our planet in smog. "The sky would get brown, but there would be intense ultraviolet radiation from the Sun striking the surface. The radiation would be at least 50 times above normal, powerful enough to kill exposed life," he reported in 2004. According to this theory the brown smog caused Earth to cool rapidly, triggering an ice age. Before the extinction, Earth was unusually warm. Climatologists have been unable to find a model that would explain the sudden onset of massive glaciers at this time, so the gamma-ray burst may have "jump-started" the ice age.

HUNTING FOR PLANETS WITH OCEANS

The search for terrestrial planets seeks the answers to these and other mysteries of life in the universe. The first step in assessing whether a rocky planet is inhabitable will be to compare its distance from its parent star with the region within which liquid water can remain stable without boiling away or freezing, its habitable zone. This notion of a habitable zone goes back at least several decades. In the 1970s astronomer Michael Hart calculated that the present habitable zone for the Sun extends between 88 and 94 million miles from the Sun. Earth's average distance is 93 million miles from the Sun, so our planet orbits on a very narrow tightrope. Hart also deduced that the width and radius of the habitable zone depends on the parent star's temperature. It widens and moves farther out with a hotter star, and narrows and moves closer in for a cooler star. This presents a problem with red dwarf stars, where a planet's habitable zone is so close

to the dwarf that the tidal pull from the star would slow down the planet's rotation until it fell into tide-lock, with one side always facing the star, just as our Moon keeps one hemisphere locked on Earth. Climates on such a world would be problematic for life like that on Earth.

Recent studies have given more elbowroom to the boundaries of the habitable zone for a Sunlike star. A terrestrial planet just on the inner edge of the habitable zone might become a moist greenhouse-type world, a little reminiscent of Venus except that there would not be a runaway greenhouse effect to boil away oceans. A terrestrial planet just beyond the outer edge may be habitable if it has a thick atmosphere and robust greenhouse effect. We know Mars was warmer and wetter once because it possessed a thicker atmosphere. Planets in elliptical orbits may remain in a habitable zone only for part of each orbit. Perhaps some life-forms might have managed to adapt to these extremes and go deep into suspended animation for the cold, outward-bound part of a planet's orbit.

Further encouragement for the existence of planets in habitable zones comes from a recent study involving 44 computer simulations of planet formation near a Sunlike star. Astronomers found that each simulation produced one to four Earthlike planets, including 11 habitable planets about the same distance from their stars as Earth is from the Sun. "Our simulations show a tremendous variety of planets. You can have planets that are half the size of Earth and are very dry, like Mars, or you can have planets like Earth, or you can have planets three times bigger than Earth, with perhaps 10 times more water," says Sean Raymond of the University of Washington.

SEEING IS BELIEVING

The first image of a terrestrial planet may be barely two pixels wide. But it will be the dot seen around the world. The planet will likely be detected at a feeble thirtieth mag-

SPRING THAW ON AN EXTRASOLAR MOON *No doubt giant extrasolar planets have families of satellites, forming miniature "solar systems." Moons could be the most common abodes for life in the Galaxy. Many extrasolar giant planets move in eccentric orbits that take them within the habitable zone during part of their travels. As they approach their star, the water on any such moon could melt and form ponds and lakes. Their spring is a result of the planets' orbit rather than the tilt of the planets' axis. Springtime on an eccentric world's moon could be a time when life flourishes—such as the algal mats shown here—only to become dormant again as the planet moves farther out in its orbit, a colder season when ice and snow blanket the ground.*

nitude, orbiting a star within 100 light-years from us. The first measurements will be to see how the planet varies in brightness as it rotates. The plot of the change in brightness over time, called the light curve, will yield the planet's rotation rate. We will then be able to measure the length of a "day" on an extrasolar world. Light glinting off oceans and bright clouds would come and go in a daily rhythm. The more complicated the light curve, the more excited the astronomers will get, since it will mean the planet's surface is variegated. This appearance could likely be caused by oceans, continents, and atmospheric patterns. The cloudier the planet, the brighter it will be, but this will wash out light reflected from surface features, so light curves will have to be taken for several days.

The planet's color, even from one pixel, could be telling. Astronomers expect several basic "Crayola colors" for planets. One is "Mercury Red." Though the Moon and Mercury look gray, they reflect a lot of red light. A similar extrasolar terrestrial planet would look quite dark and red and presumably be a lifeless rock. Another color, "Venus Latte" (for the light brown of caffe latte), would be a cloud-enshrouded terrestrial planet reflecting the star's full spectrum. A planet dubbed "Green Giant Jupiter" would have methane and ammonia absorption in the atmosphere to give a greenish spectral signature. Finally, "Earth Blue-Gray" would have bright scattering from a relatively clear atmosphere, punctuated by changes in daily cloud cover.

The next step will be to spectroscopically probe the atmospheres and other properties of terrestrial planets. When studied with even larger telescopes, spectroscopic measurements will likely show an extrasolar planet's atmosphere with a mix of gases that will at first befuddle scientists. Unless the planet is a true biological duplicate of Earth, it probably will not be immediately clear whether its atmosphere is being modified by life or by some exotic nonbiological process.

Further analysis might convince the harshest skeptics that the atmosphere is truly a snapshot of a biosphere. Ironically, the bulk atmospheric composition of an Earthlike planet will be hard to measure. Oxygen, nitrogen, and argon are hard to detect

EARTH AND MOON AS SEEN FROM MARS *This is the first image of Earth ever taken from another planet that shows our home as a planetary disk. NASA's Mars Global Surveyor spacecraft took the photo from a mere 86 million miles, or seven light-minutes, away. It is NASA's dream to someday have a gigantic flotilla of interconnected space telescopes that could yield similarly sharp pictures of Earthlike planets orbiting nearby stars dozens of light-years away. Such views would yield invaluable clues about the geography of an extrasolar planet. For example, the bright area at the top of the image of Earth is cloud cover over central and eastern North America. The bright feature near the center-right of the crescent Earth consists of clouds over northern South America. The slightly lighter tone of the lower portion of the image of the Moon results from the large and conspicuous ray system associated with the giant impact crater Tycho. (Courtesy NASA, JPL, and Malin Space Science Systems)*

spectroscopically. Trace gases will be easier to detect. One example is ozone, which is produced by the photo-disassociation of oxygen: ozone is very valuable observationally because it is a proxy for oxygen, meaning that if you can detect ozone, you know that oxygen must be there too. Also, methane from bacteria would cycle in the atmosphere. A cloudy atmosphere will make it difficult to see light reflected from layers deeper in the atmosphere or the surface. Infrared observations would be more penetrating, probing deeper layers.

Carl Sagan conducted an imaginative experiment when he used the Jupiter-bound *Galileo* spacecraft to look back at Earth during a December 1992 flyby of our planet (for a gravity-assisted boost to Jupiter). With the dispassion of alien explorers, Sagan and colleagues pretended that they knew nothing about Earth. They then used *Galileo* to search for signs of life. *Galileo* measured that the atmosphere had far more oxygen, methane, and nitrous oxide than a lifeless planet would normally have. That was coupled with an unusual reddish surface caused by the chlorophyll of plants using photosynthesis. The scientists' conclusion was that life has strongly influenced the evolution of Earth's atmosphere. But Sagan mused in a 1993 paper in *Nature,* to observers from another planet, "how plausible [is] a world covered with carbon-fixing photosynthetic organisms, using water as the electron donor and generating a massive (and poisonous) oxygen atmosphere"?

It is probably wishful thinking that we should be lucky enough to come upon a terrestrial planet in our stellar neighborhood that either chemically or physically looks exactly like Earth. Anticipating this conundrum, NASA has set up the Virtual Planetary

FOUR TERRESTRIAL PLANET TYPES *There are four basic types of terrestrial planets imaginable around other stars. Upper left: A dry, barren desert world in a system devoid of water. Upper right: A warm and moist jungle world covered with plant life and a rich carbon dioxide atmosphere, and located at the inner edge of the habitable zone. Lower left: A frozen, ice-covered planet just outside the habitable zone. Lower right: A water world with large oceans and little land mass in the middle of the habitable zone.*

Laboratory at Caltech to come up with templates of plausible atmospheres on terrestrial planets. A complex computer program creates synthetic spectra. In computer models of a lifeless Earth, the atmosphere settles into equilibrium. When life is added, new chemical sources and sinks that trap certain chemicals are introduced on the planet, and the scales tip radically. The oxygen level goes up five orders of magnitude, and the methane level, boosted by bacteria, goes up by 50 percent.

The final list of possible environments on extrasolar planets may look like the planets from the *Star Wars* movies: a planet in global glaciation (Hoth), a hot, oceanless planet (Tatooine), and a lush, tropical planet (Dagobah), not to mention an almost totally ocean-covered planet (Kamino). In fact, there could be terrestrial planets that are mostly water around a small rocky core. Rather than forming close to the star, they would be Pluto-like worlds that migrated in toward it, just as the hot Jupiters do. Located at Earthlike distances from a Sunlike star, such ice balls would melt and develop thick steamy atmospheres that would protect the water worlds from totally evaporating.

Complex processes in an atmosphere modified by an unknown biology could look truly bizarre. This modeling of terrestrial planets is complicated by the fact that biology will modify a terrestrial planet's atmosphere over time. So models need to be done for Earths at different geologic epochs, from hothouse to ice house. The ultimate payoff will be finding a planet with an atmosphere in chemical disequilibrium much like Earth's.

ANIMAL, VEGETABLE, MINERAL?

One of the most historic watersheds in our civilization will be the unequivocal announcement of the discovery of an extrasolar terrestrial planet with a biosphere. This likely

will not happen until after years of spirited debate among scientists following the initial observation. Such a pronouncement will be of such momentous importance that every effort will be made to rule out all nonbiological explanations. To the general public, weaned on science fiction movies, the display of squiggly spectral lines from a dot of light dozens of light-years away will be far from compelling. This will likely drive a long-cherished dream of NASA's to improve space telescopes to a point where the disk of a planet can be imaged as more than just a few pixels across.

In the late 1990s former NASA administrator Dan Goldin spoke enthusiastically of the day when elementary school classrooms would be decorated with posters of extrasolar planets as photographed from such a telescope. The pictures would show continents, great rivers, and oceans on other worlds. With such data, these planets would become much more real to the public than a squiggly spectrum. But common questions will be: What kind of life is there? What does it look like? Is it intelligent life?

One prediction comes from John Alroy of the National Center for Ecological Analysis and Synthesis at the University of California at Santa Barbara: "Even for multicellular, complex organisms, diversification can reach its limit in a few hundred million years. If we find multicellular life on other planets, it should be close to the limit of diversity [for the specific environment of a given planet]. When you step on that planet, you are likely to see the carrying capacity [the amount of natural resources on the planet that can sustain life] of that planet in terms of biodiversity." Imagine a planet teeming with life from pole to equator. How truly diverse would it be? Would some elements of evolution converge on similar biological designs, such as the optical eye? Would the robust, flexible DNA molecule be the prototypical architecture of what might be driving extraterrestrial life forms?

What about the physical structure of extraterrestrial life? Science fiction stories are notorious for depicting "bug-eyed monsters" that visit Earth from other planets. According to some entomologists, this might not be so far from the truth. Harvard University

ALIEN LANDSCAPE *Curious rock formations dominate the landscape of a distant planet, the kind of world astronomers hope to announce they have found one day. A stream of water meanders across the parched, desert-like ground, sustaining plant life. The planet's two moons are visible in the blue sky. Worlds such as this, with life, water, and an atmosphere—a biosphere—have a unique signature that researchers hope to be able to identify through spectroscopy, even though the worlds will be dozens of light-years away.*

biologist Edward O. Wilson, who has spent many years studying and sketching the activity of ants, explains one motive for his interest: "Just drop some sugar on the ground and watch the ants come. Their behavior will tell you more about extraterrestrial life than anything else on Earth."

A Cornell University professor of chemical ecology, Thomas Eisner, emphasizes that insects are the most diverse life-forms on Earth and in fact have conquered the planet. They are incredibly adept and ingenious in terms of evolving novel survival strategies. Some of them foil their predators by spraying defensive chemical weapons. Others fight back by mimicking bigger creatures. "Insects, by virtue of [their] enormous variety, have managed to . . . come up with endless numbers of solutions to the problem of survival. And it becomes incredibly interesting to see this, because you see yourself in perspective," says Eisner. "They are animals that constitute an alternative universe, under rocks, in soil, or flying in the night sky."

Given a long-term will and commitment, curiosity about an exoplanet's native biology will spur the development of advanced propulsion technology to send probes to investigate it. We will want to see and study native organisms up close. Physically escaping from a planetary system's gravity to travel to the stars is no problem even for our young technology. For us, it means reaching velocities of 35,000 miles per hour to escape the Sun's pull. We have four spacecraft that have already left the immediate Solar System: the NASA space probes *Pioneer 10* and *11* and *Voyager 1* and *2*. But the gulf between stars is so vast that it imposes a type of cosmic quarantine. These probes will take 80,000 years to reach the nearest star.

Carrying a big enough fuel tank for interstellar voyages of shorter durations is daunting. Fuel for even a nuclear fusion engine would require the mass of a thousand ocean supertankers. Even at ultimate top efficiency, matter-antimatter engines working at 100 percent efficiency would still require at least 10 railway cars of propellant. Today it would cost 100 billion dollars to create one milligram of antimatter in a particle accelerator. It takes a lot of energy just to make antimatter, which does not exist naturally

INSECT LIFE ON A WATER WORLD *Insects are among the most hardy and adaptable organisms known. It is conceivable that insects similar to those on Earth have evolved on another world. In this imaginary view alien dragonflies swarm toward a tree on the surface of a planet in the habitable zone of its star. This planet has two large moons.*

in the universe, in any quantity we would need. Clearly, interstellar exploration will require "out-of-the-box" thinking. Rather than a rocket carrying propellant, it might make more sense to have a probe propelled by energy transmitted from Earth. A powerful laser beam from a solar power station near the Sun could push a small lightsail vehicle like a leaf caught in a water jet.

To keep propulsion energy needs minimal, a probe would have to be ultra-miniaturized, relying on nanotechnology. The goal would be to fit computers and instruments into something no bigger than a soup can. Just as important as interstellar probe propulsion will be the development of true artificial intelligence. A robot light-years from Earth will have to assess the planetary system environment, make exploration decisions, and digest and analyze information for reporting back to Earth.

Even with incredibly powerful propulsion systems, generations of scientists would have to wait for the probe to arrive at the planet. Traveling at a fraction of the speed of light, the first probe would send back a flood of data collected during the few hours it swept past the planet. It would take years more for radio or laser transmissions from the probe to reach Earth. A clever strategy would be to send a series of probes toward a planetary system, like a string of freight cars. The first flyby probe would reconnoiter the system and send its findings not only to Earth but also to a trailing interstellar probe. The second probe would autonomously reprogram its flyby based on the first probe's visit. For example, the first probe may find a biologically interesting moon around one of the system's gas giant planets. The follow-up probe would retarget to swoop close to this moon. Based on those findings, a third probe would strategize a refined surveillance, and so on.

Because every ounce of payload weight will cost enormous amounts of energy to propel it, a logical strategy for any interstellar traveler is to "live off the land." The probe might land on an asteroid in the target planetary system and would deploy one or more "nanobots" (microscopic machines) to assemble out of raw materials all the machinery

SOLAR SAIL CARAVAN *One scheme for surveying an extrasolar planetary system would be to place a small interstellar payload aboard a huge lightsail that is propelled by a powerful laser based in the Solar System. This would avoid carrying and accelerating huge amounts of fuel aboard the spacecraft, which is a big stumbling block to interstellar travel. In this stylized view a fleet of probes arrive at an extrasolar terrestrial planet. In reality, the lightsail probes might be spread apart in space by months or years. The first flyby probe would relay its findings to the next probe, so that it could reprogram its path to look at the most interesting planets in the system. Every new discovery would be relayed to successive follow-on probes en route to the system. The probes would need to have advanced artificial intelligence to make decisions while in cruise mode across interstellar space.*

needed to explore the planet and any companions in the system. One of the first tasks would be to erect a radio or laser transmitter to "call home," just like the marooned little alien in the 1982 movie *E.T.: The Extra-terrestrial.* A truly intelligent and resourceful artificial explorer could reconnoiter the system indefinitely.

The galaxy is a big place, and we may be removed from other life-forms in space, time, and certainly biology. Though there may be countless millennia ahead for our inquisitive species to explore our universe, we know enough about our own galaxy to take at least an imaginary journey to ponder the potential diversity of places and worlds.

6

Galaxy Odyssey

Unless we someday realize the dream of interstellar travel, we will be able to make a detailed telescopic survey for planets covering only a few percent of the Galaxy's volume. But we know enough about the Milky Way to extrapolate cautiously about what could possibly exist much farther beyond our local stellar neighborhood. We know the Milky Way's composition, structure, stellar populations, and evolutionary history. Based on our theories of star formation and extrasolar planet discoveries, planets and moons should be abundant. Planet discoveries thus far form only the tip of the iceberg.

From what we know about life it is reasonable to assume that some fraction of these worlds harbor simple organisms. A smaller fraction might host multicelled life, which, we think, takes much longer to evolve under the right conditions. The power of biological evolution ensures a virtually infinite variety of shapes, forms, and behaviors. If other intelligent life-forms exist, we would expect their cultural evolution to be quite diverse, in dimensions only imagined by science fiction writers. But we might share at least one common question with other intelligent life: Are there other civilizations in the Galaxy?

Greatly encouraged by the most recent astronomical information and insights, we can take an armchair journey across the 100,000 light-years that span our Galaxy's disk. Our journey takes us ever deeper into the uncertainty and conjecture that the first explorers setting sail across the seas must have experienced. Generally, conditions in the Sun's backyard are probably typical of those near most of the Galaxy disk population of stars. Our imaginations will probe the possible landscapes where intelligent life

MILKY WAY GALAXY *Detailed planet searches and follow-up observations for atmospheres and life can cover only a small fraction of our Galaxy. But what we do find in our stellar backyard is probably similar to conditions elsewhere in much of the spiral-shaped galactic disk. It might take a civilization over 100 million years to physically explore the entire galaxy, assuming it had technologies far more advanced than ours today.*

may ponder the universe. Arthur C. Clarke expressed this best in his *Profiles of the Future*: "The only way of discovering the limits of the possible is to venture a little way past them into the impossible."

If we could travel high above the disk of our Galaxy and look down on our stellar neighborhood, a remarkable quilt would stretch out before us. Directly below we would notice the three parallel lanes of bright stars forming the Galaxy's spiral arms. From our overhead view the Sun would sit near the edge of the middle stellar lane, the Orion

arm. Looking outward, toward the Galaxy's edge, we would see the Perseus arm, thousands of light-years from Earth. Our own Orion arm, in fact, may be a spur that connects to the Perseus arm in the direction of the summer constellation Cygnus. There may even be an outermost arm beyond Perseus. Inward from the Sun, and 6,000 light-years closer to the Galaxy's center, stretches the Sagittarius arm. Along this arm structure, commonly seen in other galaxies, lie scattered blue clusters of young stars that shine like brilliant pieces of turquoise. Interspersed are luminous puffs of cotton candy–like structures, glowing clouds of hydrogen surrounding cradles of newborn stars. Etched across the glittering tapestry are the black, filamentary molecular clouds destined to spawn new generations of stars and planets.

All across the majestic disk we would see cobwebs of dust, bright stars, and pink clouds sprawling in all directions. It would be like flying over a great city at night with avenues and boulevards stretching as far as the eye can see. Our attention would be drawn to the brilliant hub of the Milky Way pinwheel. Gliding above this hub are the globular star clusters, each of these silent sentinels a glittering jewel box of at least 100,000 stars, mysterious, majestic, and ancient. They are the first homesteaders of the Galaxy and contain the universe's oldest stars.

Our tranquil bird's-eye view is misleading. If we could compress billions of years into just a few minutes, like a time-lapse movie, we would behold a very different type of galaxy. Erupting and exploding stars, novae, and supernovae go off like aerial bombs in a fireworks show. Even more frequently, the burnout of Sunlike stars casts off bubbly wisps of glowing gases.

Over millions of years, dark molecular clouds slam into the leading edges of the spiral arms. Compressed by the collision, these clouds give birth to new stellar generations. Blisters form on the edges of the clouds and then explode with new stars amid a pink glow of iridescent gases. Brilliant young star clusters form along the trailing edge of the spiral arms. Globular clusters whirl around the Galaxy's hub, some barreling though the Galaxy disk, where gravitational tidal stresses pull some of them apart like

taffy. Meanwhile space around the monster black hole in the Galaxy's center occasionally flickers in X-rays as a wayward star gets swallowed up.

STAR TREKKING

Our first port of call is a mere 4.4 light-years away from the Sun, the Alpha Centauri binary star system. Alpha Centauri A and B are two Sunlike stars separated on average by a little over two billion miles. It's probably not coincidental that a binary system is found so close to the Sun, because double star systems account for at least half of the Galaxy's population of stars. So Alpha Centauri provides a fascinating test case for what planetary system scenarios might be possible in multiple star systems. Simulations show that a protoplanetary disk could not survive beyond about 200 million miles from each star. The gravitational tug of the companion star would tear apart the fragile disk. Therefore, any planets in this system must huddle close to their stars, within the same orbital radius found for the four terrestrial planets in our Solar System.

It might be unlikely that gas giants could form around either star. The disk would not stay intact at the distances beyond the "frost line," where ices and gases would agglomerate on a rocky core. There would be no Asteroid Belt or Kuiper Belt to supply wandering rocky objects bearing ices, and no gas giants to deflect these bodies to help irrigate the terrestrials. Consequently the Alpha Centauri system could harbor nearly bone-dry terrestrial planets.

This is disappointing because Alpha Centauri is so close. It is reachable in a relatively short 44 years by a spaceship traveling at one-tenth the speed of light. Imagine if a pair of Earths could be set down around Alpha Centauri A and B. Short-period travel from one of the pair to the planet around the companion star would be feasible for a technological society. Trading and cultural exchange could occur between civilizations on a pair of planets in such a system. The companion star might also be used

ALPHA CENTAURI SYSTEM *The yellow star Alpha Centauri A looms over an arid landscape of a hypothetical planet. The companion star Alpha Centauri B appears as a brilliant speck of light in the distance. The Sun would be noticeable as a bright star in the constellation Cassiopeia. Any planets around either star might be bone-dry and lifeless. The gravity of the two stars would make disks unstable beyond a few hundred million miles from each star. This would disrupt the formation of comets that might be needed for transporting water to terrestrial planets. Nor would there be gas giant planets for enhancing the influx of comets to the inner planetary system.*

for a gravity assist for interstellar probes. Therefore, such a system might be more likely to harbor a space-faring civilization, if technological intelligence arose.

An intriguing place for finding a habitable moon lies about 45 light-years away in the constellation Cepheus, around what looks like a third-magnitude star when viewed with the naked eye. But even powerful telescopes cannot split the light from Gamma Cephei into its two individual stars. En route to the system we would see the two stars resolve into a yellow and a red companion. The yellow-white star and the red dwarf lie as far apart as the Sun and Uranus. The one discovered planet in the system is slightly more than 1.5 times the mass of Jupiter, orbiting the yellow-white star at a little farther than Mars's distance from the Sun. This giant, embedded in the star's habitable zone, might have moons, and it is close enough to the star that any moon could possess liquid oceans of water, if ices were available in the system.

Red Dwarf Kingdom

Red dwarf stars fill most of the volume of our stellar neighborhood. For every star like the Sun, 10 red dwarfs are found in space. They will be the longest-lived stars once the Sun and similarly hot stars have long since burned out. This means that their accompanying planets will survive the longest in our Galaxy—well after the Sun shrinks to a burned-out cinder. The most common planetary landscapes in the Galaxy may be illuminated by the cool glow of a red dwarf.

A planet capable of receiving enough heat to sustain a liquid water ocean would have

RED DWARF PLANET *Red dwarfs are the most common and longest-lived stars in the Galaxy. Planets orbiting red dwarfs will offer the last harbors for life after Sunlike stars have all burned out. However, life on such a planet would be challenging. Searing blue-white flares from aging red dwarf stars would unexpectedly zap planets with radiation from time to time. This would be challenging for all but the hardiest and most adaptable forms of life.*

to be much closer to the cool red dwarf than Earth is to the Sun. Such a planet would orbit so close that gravitational tidal forces would keep one hemisphere perpetually facing the star, just as one side of the Moon always faces Earth. In other words, the planet's orbital period would be synchronized with its rotation rate. What would life be like on such a planet?

A liquid planet would be expected to have ice on one side and a warm ocean on the other, and air currents would flow between the two. The planet Venus and the moon Titan offer models for how such a weather system might behave. Venus has a sluggish rotation, and Titan is tide-locked to mighty Saturn. On a tidally locked planet orbiting a red dwarf, life might flourish only in a narrow oasis strip along the terminator, the boundary between perpetual night and day. It might be premature to rule out life on such planets. If Earth is any example, life may be opportunistic enough to spread to unlikely environs from its birthplace. Such an environmentally extreme planet would present a challenge for life seeking out new ecological niches. Vastly disparate forms of life may rule the day, the night, and the terminator strip on such a planet. And because of the preponderance of red dwarfs in the Milky Way, these kinds of bodies orbiting them might prove to be the most common type of terrestrial planets for life.

Unless it was marine or subterranean, any life on such a world would have to come to grips with unpredictable and violent flares from red dwarf stars. Flares occur when magnetic fields suddenly snap like rubber bands after they break and then splice together in new configurations. Within minutes, and without warning, a bright blue-white hotspot would grow across the surface of the star. Withering ultraviolet rays and deadly X-rays would spit out from the spot like the superheated breath of a fire-breathing dragon. It's unlikely to imagine life surviving on the starward side of a planet orbiting

BINARY RED DWARF STAR SYSTEM *A planet existing in the habitable zone of a binary red dwarf star system would be tidally locked with the eclipsing red dwarfs. Cloud patterns originate at the substellar point and radiate toward the dark side of the planet. Flares from the stars are reflected in the water on the lit side. The polar cap is on the dark side, at the point farthest from the star.*

such a tempestuous star. Life that ventured into the sunlit side would play a deadly game of Russian roulette with the star.

As a red dwarf ages, the flare activity subsides. The star also grows brighter as nuclear fusion slowly migrates out from the core, and as it does, the habitable zone around it will widen and move outward too. Outer planets in these systems may have to wait many billions of years for temperatures to be right for life to start. That doesn't present a problem, because the red dwarfs can burn for over one trillion years, nearly 100 times the present age of our universe. Since the last possibly inhabitable planets in the universe will be those orbiting red dwarfs, they could be the final stronghold for biological life forms.

Red dwarfs are so abundant that nearly half of them should be found in close binary pairs. One of the most interesting is the star system CM Draconis, a mere 54 light-years away in the circumpolar constellation Draco. The two red stars are so close that they whirl around each other in less than two days. What fascinates astronomers is that the orbital plane is edge-on so that one star passes in front of the other. Any planets should lie along this orbital plane too and transit their star, though searches have been unsuccessful so far. Inhabitants of a planet in such a system would be fascinated by the frequent stellar transits. Depending on the planet's distance and orbital speed, the transits could occur like clockwork, every two days or so. The landscape would get noticeably darker as one companion blocks out the light of the star it is transiting.

BROWN DWARF STARS

Cruising within our local neighborhood we would also come upon dim, stillborn stars, the brown dwarfs. Because these stars formed through the collapse of a gas cloud, they too should form a disk and planets. At least 60 young brown dwarfs in the Orion Nebula are known to emit unusual amounts of infrared radiation, which indicates that disks

BROWN DWARF WITH PLANET AND MOON *A planet orbiting a brown dwarf star is shown from the surface of an icy moon. The brown dwarf casts only a feeble light, largely in the infrared portion of the spectrum, and so the landscape is illuminated primarily by a star outside the picture plane. Although it is very likely that planets exist around brown dwarfs, they would be far too cold for life as we know it. Surface temperatures of a close-in planet would never rise above −400°F.*

of warm dust surround the stars, disks that should eventually coalesce into planets. However, a brown dwarf is too small to sustain nuclear fusion to shine and thus warm its planets. Because a brown dwarf is over 100,000 times dimmer than the Sun, planets around such a star would be bleak and devoid of any semblance of life as we conceive of it. A planet as far from a brown dwarf as Earth is from the Sun would have surface temperatures of −440°F. Superficially, these stars might resemble Jupiter, with horizontal bands and zones and even weather systems with "clouds." Though they are dozens of times more massive than Jupiter, they are a bit smaller than it because they are much denser. Brown dwarfs also rotate much faster than Jupiter, with rotation rates as short as 1.5 hours!

55 Cancri: Solar System Clone?

The star 55 Cancri, in the constellation Cancer the Crab, might well be one of the nearest stars with one or more inhabited planets. There's room enough for terrestrial planets to be distributed between the three largest planets that have been discovered in this system. One is a star-hugger, at only 10 million miles from the star, and a second giant lies 20 million miles out. The third, outermost planet has one-quarter of Jupiter's mass and orbits the star at a distance of over 500 million miles.

The large inner planets are too close to the star to gravitationally affect any terrestrial planets. The two innermost giants must have migrated in toward the star early in the system's formation and ripped up any nascent planetary disk. Even closer still, at a distance of 3.5 million miles from the star, is a fourth planet only 18 times the mass of Earth that may be either gaseous or rocky.

These inner planets would be brilliant companions to the star, possibly visible as morning or evening stars, as the planets Venus and Mercury are to us here on Earth. Beyond these planets lies a vast debris field of icy bodies, much like our Kuiper Belt.

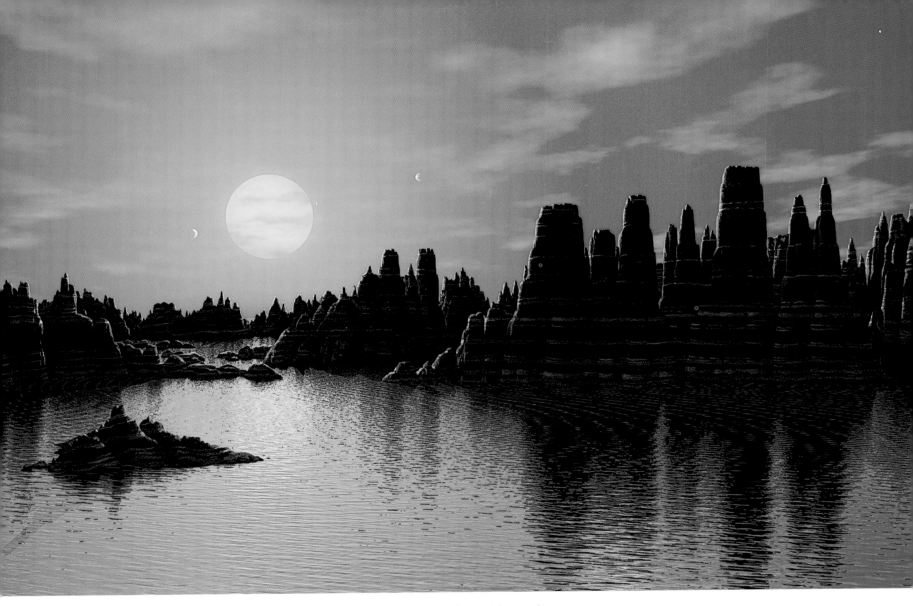

TERRESTRIAL PLANET AT 55 CANCRI *The Sunlike star of the 55 Cancri system has a wide enough gap between its giant planets to allow for the presence of a terrestrial planet within the habitable zone. From the lakeshore of such a world the morning sky would be glorious. This terrestrial planet would lie beyond the star-hugging orbits of the three innermost worlds, but inside the orbit of the outermost known Jupiter-sized planet. Even if, as scientists speculate, the planet closest to the star is rocky rather than gaseous, it would still be uninhabitable. It is so close to 55 Cancri that its sunlit side would be hot enough to have an ocean of magma bubbling at 2,200°F.*

YOUNG CLUSTERS

Like streetlights along a boulevard, hundreds of open star clusters line the Milky Way's spiral arms. But these clusters will not hold together gravitationally over the long haul. One of the nearest is the Hyades, located 146 light-years away in the winter constellation Taurus the Bull. The V-shaped cluster of about 400 known stars outlines the face of the bull, and this collection of newborn stars, all 635 million years old, could be orbited by young planets. Any planets here would be so young that they could be taking only the first baby steps toward evolving life, if conditions are right. Any young planetary systems are no doubt in their final stages of bombardment from large chunks of rock wandering through space, with the remaining debris gravitationally swept up by fully formed planets. So it's very unlikely that any intelligence has yet evolved in the Hyades to behold the starry splendor, though the Hyades would be a wondrous place for outsiders to visit. Though the cluster is only 35 light-years across, the stars are far enough apart that only rarely would a passing star gravitationally disrupt the protoplanetary disk around a neighboring star.

SURPRISES IN INTERSTELLAR SPACE

In the vast gulf of space between the stars hydrogen is so thinly dispersed that interstellar space is more devoid of matter than the purest vacuum on Earth. Orphaned planets untethered from their birthplaces around stars may ply these great voids. Planetary system formation models predict a game of musical chairs where many more planets form than finally settle down into stable orbits. Computer simulations show that in the early Solar System there may have been 5 or 10 planets the size of Earth. However, unlike Earth, they may have been pumped up into elliptical orbits by close encounters with other planetesimals, which may have led them to perilously cross the orbit of

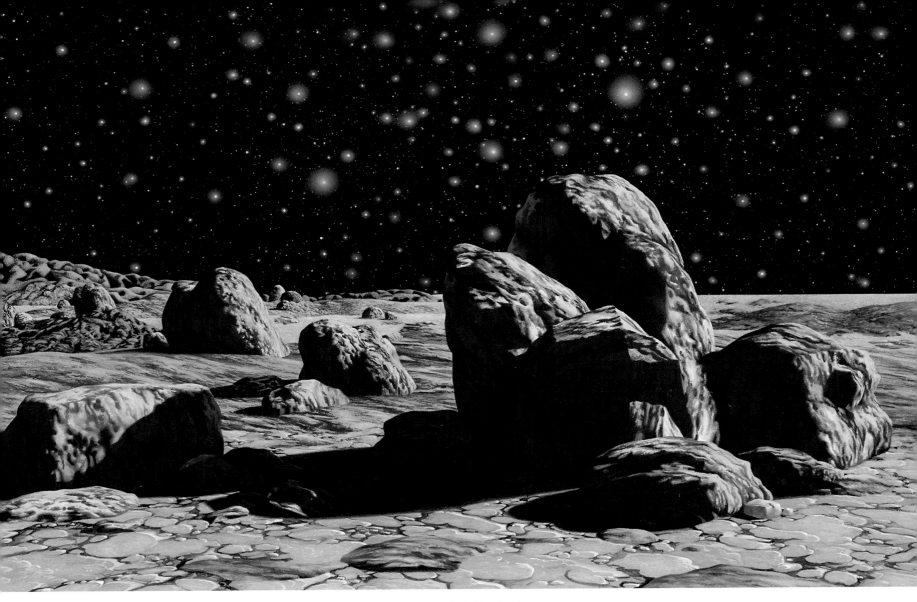

PLANET IN AN OPEN STAR CLUSTER *A brilliant starry night glitters over the lifeless landscape of a planet in an open star cluster. The sky is dazzling because the cluster's stars are closer together than stars in our own galactic neighborhood. The hottest and most massive stars are brighter than Venus. The cluster does not have enough stars to gravitationally keep it bound together, and so the stars will eventually disperse into the Galaxy.*

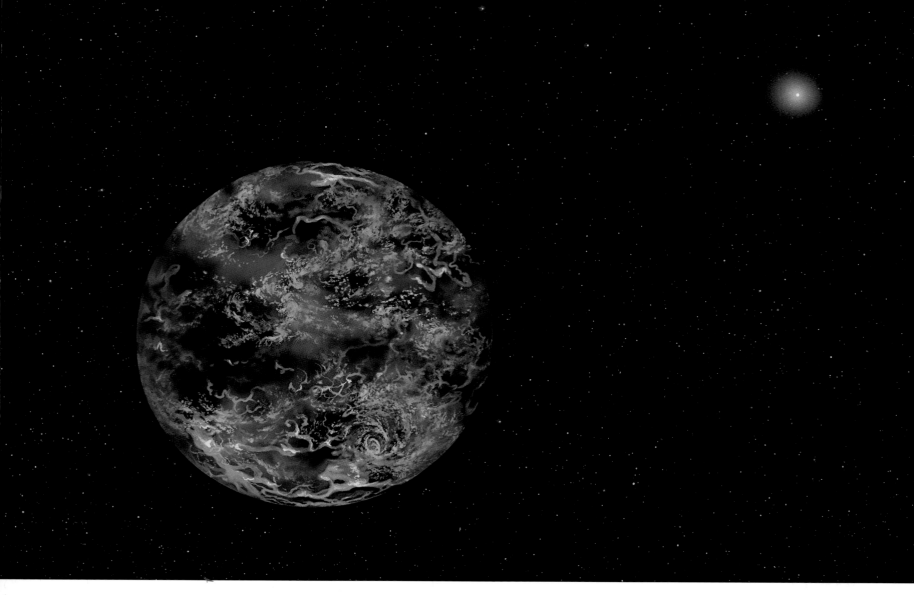

VOLCANIC PLANET WANDERING IN INTERSTELLAR SPACE *This young planet was thrown out of its orbit around its parent star (upper right) and now wanders alone in interstellar space. This could have happened through an encounter with a migrating gas giant planet. Shrouded by clouds and the ash from its active volcanoes, its eerie red light glows in the blackness of space. With stored-up geothermal energy as a power source, simple life might arise on such a world, even in the absence of sunlight. Innumerable "rogue planets" could wander adrift in our Galaxy.*

Jupiter, which probably swallowed up some of the primeval planets. Others were catapulted out of the Solar System following a close encounter with the giant planet. Given the discovery of over 100 Jupiter-like worlds around other stars, this planetary pinball game could be a common scenario.

Hurtled out of a star's gravitational grasp, such hypothetical orphaned planets are doomed to wander interstellar space forever. Because they are so far from their parent star, it would be easy to conclude that these worlds are frozen solid—but not necessarily. These lost worlds might retain a thick, primeval hydrogen atmosphere that traps warm air like a blanket. An Earth-sized planet would also have a hot core powered by radioactive decay, and heat would percolate to the surface through volcanoes and other geothermal activity. Enough subterranean energy might exist to maintain a liquid ocean for nurturing life. In the absence of sunlight, life would need to tap into the planet's heat for energy, just as life does at the thermal vents at the pitch-black bottom of Earth's oceans. The surface of such a rogue planet would be gloomy. The cloudy, inky black sky would be punctuated by the crimson glow of erupting volcanoes and the electric blue of accompanying lightning bolts. Countless millions of these "Flying Dutchman" planets may forever crisscross the twilight zones of interstellar space.

Journey to the Center of the Galaxy

The region within a few hundred light-years of our Galaxy's center is probably the most spectacular place a space-faring civilization would ever want to explore. The "eye" at the center of a hurricane here on Earth is relatively calm. But the center of our Galaxy is a chaotic maelstrom, compared to the routine cycle of star birth and star death in the arms. Gravity is intense in the core of the Galaxy and whips up the motions of stars, star clusters, and giant molecular clouds into a frenzy.

X-RAY PANORAMA OF THE GALACTIC CENTER
The center of our Galaxy is hidden from view in optical light. This dramatic false-color view from the Chandra X-ray Observatory captures the intensity of an environment that may be hostile to planets and life. This 400 by 900 light-year mosaic of the central region reveals hundreds of white dwarf stars, neutron stars, and black holes bathed in an incandescent fog of multimillion-degree gas. The supermassive black hole at the center of the Milky Way is located inside the bright white patch in the middle of the image. The colors indicate red (low), green (medium), and blue (high) X-ray energy bands. (Courtesy NASA, CXC, and SAO)

The galactic core is home to incredibly large super–star clusters that form because the region favors the formation of massive stars. The strong magnetic fields and large turbulent velocities make it difficult for gas to collapse to form smaller-mass stars. Only comparatively huge clouds of gas can collapse with enough gravity to overcome these forces. "The galactic core is like a boiling cauldron of raw creation, where all components such as stars, cold and hot gas, magnetic fields, and the central black hole show an intimate interplay," says astronomer Heino Falcke.

Mysteriously, the formation of massive bright clusters seems common in galaxies like the Milky Way, but they remain intact for only 10 million years before being ripped apart. Then, through largely unknown processes, new clusters form over and over. Three giant star clusters dwell within 100 light-years of the center of the Galaxy. One actually lies on top of the three-million-solar-mass black hole lurking in the Galaxy's center. This central cluster, estimated to be only five million years old, contains very young stars that may have formed farther out in the Galaxy and moved in through dynamical friction. The biggest stars in these clusters will explode in a crescendo of supernovae that will flood the core with radiation. That we can see these clusters now means that star birth is ongoing, and at any one time several monster clusters may dwell in the core of the Galaxy. This rapid star formation also means the area is flooded with radi-

GALACTIC CENTER *The nighttime sky as viewed from a planet near the galactic core would be ablaze with new star formation as well as myriad older stars in the ancient galactic bulge. In this view the brightest known star in the Galaxy, dubbed the Pistol Star, shines with the radiance of 10 million Suns. Farther to the left, the giant Arches cluster crams 100,000 stars into a volume of space no bigger than the distance between the Sun and the nearest star. In the upper right, stars cluster around the supermassive black hole at the Galaxy's core. The environment of the core favors the growth of massive clusters and stars.*

ation from frequent supernovae, and strong stellar winds from young stars would collide and spin out X-rays and gamma rays, making this a harsh neighborhood for life.

The core presents a very rough environment for planet formation. Embryonic planetary disks would be blowtorched away by ultraviolet radiation from massive stars. If planets do form, they are bathed in radiation from the frequent supernovae explosions. A unique danger lies in the black hole at the very center of the Galaxy. When it occasionally swallows a hapless star that wanders too close, a flare of X-rays erupts from the black hole. This phenomenon was caught for the first time in 2001, when the Chandra X-ray Observatory watched the black hole region abruptly brighten in X-rays. After about three hours, the X-ray intensity rapidly declined to the pre-flare level.

In the seemingly unlikely chance that civilizations manage to survive in the galactic core, it would be tempting to think that they are quite ancient. The star-forming rate here is so voracious that heavier elements for planets and life must have formed quickly and very early in the Galaxy's history. In fact, the abundance of heavier elements may be so high that thick circumstellar disks form and planets spiral into their stars or only very massive planets form.

GALACTIC HALO STARS

We cannot see the center of our Galaxy directly in visible light. What we know is deduced largely from radio, infrared, and X-ray telescopes, since these invisible forms of radiation can penetrate the great star clouds and dust clouds in Sagittarius. Only one-trillionth of the visible light trickles through the thick dust and star clouds that lie between the center and Earth. But anyone living around stars that orbit high above the plane in our Galaxy's halo has a bird's-eye view of the center of the Galaxy. The Milky Way's halo is a vast spherical shell of stars enveloping the disk, a vast frontier where

stars are more widely scattered than they are in the galactic plane. The magnificent globular star clusters, the first homesteaders of the Galaxy, dwell here too.

The halo is the largest component of the Galaxy, extending 150,000 light-years from the disk, or 1.5 galaxy diameters. Because the galactic halo contains very little dust or gas, no star formation currently takes place. Many of the halo stars may have formed in globular clusters and dwarf galaxies, scattered into space when the cluster was ripped apart by tidal forces from passing through the disk of the Galaxy.

Just as we find in the Milky Way's disk, the Galaxy halo is also littered with the corpses of stars: white dwarfs, neutron stars, and black holes. It is a little biased for us to call a white dwarf a dead star when it comes to looking for planets and life. Maybe a "retired star" is more accurate. It's no longer making a living through nuclear fusion but glows as a result of the trapped heat from its final collapse. To any inhabitants on accompanying planets, however, a young white dwarf is still a hot object in a black sky, a fountain of light and ultraviolet energy from a seething surface of 50,000°F. This blistering temperature comes simply from the fact that a small dense star has trapped a lot of heat and can radiate it only slowly into space given its small diameter and high density.

When a white dwarf first forms it pumps out deadly ultraviolet radiation. As the star cools, it reaches the surface temperature of the Sun. But at Earth's distance from the Sun, the dwarf would be only one-ten-thousandth the brightness of the Sun. Any life would have to be found on a planet much closer to the white dwarf than Earth is to the Sun, but the problem is there would be no planets left! The red giant that preceded the white dwarf's collapse would have devoured them.

If any civilizations dwell in the halo, their home planets must have survived innumerable catastrophes along the roller-coaster elliptical orbits of their parent stars around the Galaxy's hub. Far-advanced and long-lived civilizations may have historical records of plane crossings and the dangers posed by supernovae and black molecular clouds as

their solar systems plunged through the disk. Ironically, because we live in the plane of the Galaxy, we face these dangers more frequently. Astronomy might quickly develop as a science for any technological civilization living in the halo, since it would have the entire disk of the Galaxy to peruse.

Star Hives

The oldest structures in the Milky Way are the magnificent globular star clusters. At least 150 circle the Galaxy in long, looping orbits that occasionally send one plunging through the plane of the Galaxy. Globular star clusters, along with dwarf spheroidal galaxies, were likely the "bricks" that came together to build the Milky Way's central bulge over 10 billion years ago. Those early days must have been glorious. The clusters then were blazing with blue-hot stars. In a crescendo of supernova explosions the massive stars expelled all the remaining dust and gas lying anywhere near them. This was a tough and dangerous neighborhood in which to build fledgling planets. The intensive flood of ultraviolet light from the most massive stars probably evaporated many protoplanetary disks of any bypassing stars.

Planets that managed to form in such a stellar cauldron would be the oldest planets in the Galaxy. However, even after condensing they would eventually face another serious threat: a collision of their parent star with neighboring stars. That's because the density of stars in a globular cluster is much higher than in our stellar neighborhood.

WHITE DWARF IN THE GALACTIC HALO *The halo of our Galaxy contains myriad stars that are older than the Sun. This includes a large population of burned-out stars, the white dwarfs. The view from such a star far out in the halo would be truly spectacular. The spiral structure and stellar populations of our Galaxy would be immediately evident to alien astronomers possessing our level of technology. Civilizations would have to come up with technologies to cope with the deaths of their stars rather than flee across the vast gulf of space between stars in the halo.*

MILKY WAY CONSTRUCTION *The early formative years of the Milky Way Galaxy, circa 12.7 billion years ago, probably looked like this simulation. The majestic spiral arms of our Galaxy had not yet formed. The bright blue star cluster at center left is embedded inside tattered filaments of glowing magenta-colored hydrogen gas that has been blown out of the young star cluster by a crescendo of supernova explosions. It is among hundreds of primeval globular star clusters that came together to build up the Galaxy. The cluster, full of young and blue-white stars in this artwork, probably started forming several hundred million years after the Big Bang. At right of center, the hub of the Galaxy is beginning to form. Lanes of dark dust encircle a young, supermassive black hole. An extragalactic jet of high-speed material beams into space from the young black hole, which is feeding on stars, gas, and dust. A string of supernova explosions from the most massive stars in the cluster creates pink bubbles of hot gas around each star cluster. (Courtesy A. Schaller and NASA)*

Near the cluster's center the average distance between stars is only half a light-year. Still, the term "collision" is a misnomer. Only rarely do stars actually collide deep inside clusters. When they do, they make a new type of star called a blue straggler. It's like smashing two old subcompact cars together and getting a new sedan. The blue straggler stirs up nuclear fuel and burns hotter than its neighbors. Since it is the only blue star around, all other blue stars from the early epochs of star formation being long

PLANET NEAR THE CORE OF A GLOBULAR CLUSTER *A planet inside a dense globular cluster would have a magnificent view of the heavens unlike anything ever seen from Earth. Without gas or dust to block the view, inhabitants could see all the way into the dense core. Hundred of stars would be brighter than Venus, and many thousands more would be visible to the naked eye. In this compelling view the cluster's core rises over the lake on a planet.*

extinct, astronomers call it a straggler. In many cases two stars might capture each other. More frequently in globular clusters, a pair of stars may get close enough to each other to tidally disrupt any nascent planetary systems.

Life on planets at the periphery of a cluster would have an astounding view of the heavens. Depending on the orientation of the planet's orbital plane, the core of the cluster could dominate the night sky for at least half of the planet's "year." The core might be as big as 10 full Moons across and almost as bright as a full Moon. Thousands of stars would be fourth to fifth magnitude, sitting on top of the diffuse light of the still fainter stars. Add to these the jewels of hundreds of brilliant red giant stars, many as bright as or brighter than Venus. The nearest stars could be resolved as disks with a small telescope or binoculars. For the other half of the year the inhabitants would be staring out into the galactic halo and the Milky Way. With such a clear view, cluster civilizations might conclude that the cluster core is the "center of the universe." It would have an uncanny resemblance to our own early theories of the universe—a dense ball of stars. However, the inhabitants might conclude that the universe is only a few hundred light-years across!

Though very speculative, it's possible that the oldest civilizations in the Galaxy might live in globular clusters. Globular clusters were the first objects to form in our Local Group of galaxies and therefore contain the oldest stars. Fully mature planetary systems, with complex life, could have been established in globular clusters before the Sun ever formed. The oldest planets in globular clusters could be nearly three times the age of Earth, possibly a true litmus test for how long a given intelligence might expect to survive. Is it remotely possible for a technological civilization to reach enough stability that it lasts indefinitely? The nature of such a 10-billion-year-old civilization lies far beyond our meager comprehension.

At least some of these technologically advanced societies would have a burgeoning interest in astronomy. Alien astronomers might muse about the civilizations that could live in the spiral lanes of the Milky Way disk. They might conclude that life is rare,

given radiation from supernovae, gamma-ray bursts, and other cosmic catastrophes that don't happen in the cluster.

THE VIEW FROM ANDROMEDA

Moving far beyond the globular clusters and our galactic halo, we enter the much more vast and even emptier realm of intergalactic space. The magnificent Andromeda Galaxy, the nearest large galaxy to the Milky Way, can be seen in the autumn constellation Andromeda the Princess as a faint, cigar-shaped spindle of light, over twice the diameter of a full Moon. It was at Andromeda in 1923 that Edwin Hubble aimed the 100-inch Hooker telescope atop Mount Wilson in southern California to find Cepheid variable stars. As noted earlier, astronomers at the time debated whether this cigar-shaped cloud was an oblique disk around a young star, or a vastly more distant "island universe" unto itself. By using the intrinsic brightness of these variable stars to calculate distance, Hubble finally had observational evidence to prove the latter. The Andromeda Galaxy lies at an extraordinary cosmic distance at least 20 times the diameter of the Milky Way.

If life is as abundant as some astrobiologists suspect, civilizations could be scattered across this companion galaxy to the Milky Way. At least some fraction of these hypothetical "Andromedans" would have dutifully plotted the heavens, pondered the expanding universe, and gazed out in curiosity at the Milky Way. From anywhere in the Andromeda Galaxy the Milky Way would look so small that it could easily be covered with two outstretched fingers (or tentacles of comparable size). For our imaginary alien astronomers there must have been a "eureka moment" (as Edwin Hubble experienced) when they discovered that the Milky Way contains stars and is many galaxy diameters away.

The Andromeda Galaxy (also frequently referred to as M31) is more like a distant

HALO OF THE ANDROMEDA GALAXY *Myriad stars on top of myriad galaxies offer a humbling view of the vast universe beyond the Milky Way. The celestial objects in this six-panel photograph are just a sampling of the more than 300,000 stars and the thousands of distant galaxies seen in a small region of the Andromeda Galaxy's halo, a spherical cloud of stars around the galaxy. The galaxies seen in five of the panels represent some of the background galaxies located far beyond Andromeda. A few of them appear distorted, such as the curved red streak of material seen at top row, center. The white spherical object (bottom row, right) is a collection of more than 100,000 stars called a globular cluster, located in the galaxy's halo. The Andromeda Galaxy is located 2.2 million light-years from Earth. (Courtesy T. Brown, STScI, and NASA)*

cousin than a twin to the Milky Way. Apparently M31 went through a major "corporate merger" with another large galaxy, or a series of mergers with smaller galaxies, billions of years ago. Astronomers cannot yet tell whether this was one tumultuous event or a more continual acquisition of smaller galaxies. Recently discovered younger stars in Andromeda's halo are richer in heavy elements than the stars in the Milky Way's halo.

The Milky Way and Andromeda are part of the Local Group of predominantly dwarf galaxies, small islands of stars situated on a side street tens of millions of light-years from the great intersection of two dark matter filaments that created the magnificent Virgo Cluster of about 2,500 galaxies. To alien astronomers living in the Virgo Cluster, our own little galactic neighborhood would appear as two smudges of light coming from the two large spiral galaxies.

From our backyard view, the Virgo Cluster practically fills much of the spring zodiacal constellation of Virgo the Virgin. It is cluttered with disk galaxies and puffy elliptical galaxies. In crowded clusters like Virgo, frequent near encounters between galaxies can scatter stars into the vast unknown region of intergalactic space. Such wandering stars have been identified with the Hubble Space Telescope. Life on planets orbiting these stars would have a truly curious view of the nighttime sky. There would be no single stars visible to eyes like ours, but hundreds of visible galaxies, resembling faint cotton balls against a charcoal black sky. Astronomy would follow a strange course of cosmic awakening to anyone living on a planet orbiting one of the "castaway" stars. Inhabitants might easily surmise that they are at the center of the universe because their view would look the same in all directions. Without the example of another star nearby, they would probably never deduce that the faint galaxies are actually islands of stars. Without using stars as milepost markers they could never measure the distances to the Virgo galaxies. They might resort to launching space probes on the gamble that the galaxies are reachable—almost like Columbus sailing westward without knowing that Earth's circumference is *twice* what he had calculated.

PLANET IN THE VIRGO CLUSTER *A planet orbits a Sunlike star in the Virgo Cluster, about 50 million light-years from Earth. The star has been ejected into intergalactic space by a near encounter with another galaxy. It now drifts freely among the thousand of galaxies in the cluster, without being gravitationally bound to any one galaxy. From this unique perspective the night sky is a wondrous tapestry of galaxies too faint and far away for their individual stars ever to be seen with the naked eye. A relatively nearby galaxy that we call M88 appears to reign supreme over hundreds of galaxies in the distance. A civilization here would develop a markedly different cosmology because it would not have nearby stars for comparison.*

INFINITE GALAXIES

Galaxies are so scattered in time and space that it is extremely unlikely we will ever have an inkling of the range and variety of intelligent species that inhabit them, on myriad planets with every conceivable—and inconceivable—type of environment. We cannot begin to imagine the infinity of civilizations dwelling in these galaxies so long ago and far away. A self-aware entity with a view of the universe comparable to ours would ask many of the same questions we do. A scientific civilization might be expected to conduct similar observations. They would surely measure the expansion rate of the universe. More advanced societies would realize that the universe is accelerating, and those even more knowledgeable would come up with unified theories for explaining dark energy and dark matter. Others would possibly discover shortcuts across dimensions to break free of the tyranny of time and space. Finally, still others may achieve immortality, buying a practical infinity of time to ponder the cosmos.

7

Life in an Evolving Universe

IT MAY HAVE TAKEN THE UNIVERSE BILLIONS OF YEARS FOR INTELLIGENT LIFE TO BLOSSOM SUDDENLY AMONG THE MILKY WAY'S HUNDREDS OF BILLIONS OF STARS, LIKE A FIELD OF FLOWERS COMING INTO BLOOM ON A SPRINGTIME AFTERNOON. Flowers bloom and then wither, but how long does an extraterrestrial civilization last? For those that can survive a daunting array of cosmic disasters, how long can life go on in an expanding universe that may evolve in unpredictable ways, given our uncertainties about the behavior of space itself?

Is life a passive rider along the universe's journey toward seeming oblivion? Life reshaped the face of Earth. Could far-advanced life reshape a galaxy, or the entire universe? What are the absolute limits of a civilization's domination over matter and energy? Intelligent life may have plenty of time to ponder this. The last star may burn out 100 trillion years from now. A lot can happen until then. Reflecting on 13 billion years of cosmic evolution, Georgetown University theologian John F. Haught wrote in his 1993 book, *Mystery and Promise*: "[We] wonder, as humans always wonder when they attend to a tale, where this immense story might be heading. Toward what sort of destiny does it possibly tend?"

Physicist Freeman Dyson presented an upbeat assessment in a 1985 lecture, published as "How Will It All End?" in his book *Infinite in All Directions*. "Suppose that we fail to find traces of life anywhere outside our own planet. . . . It is not absurd to think of redesigning terrestrial creatures so as to make them viable in space or on other celestial bodies. Once we have successfully planted a variety of species in space . . . we can safely rely on the ancient processes of mutation and natural selection to take care

of their subsequent evolution." Dyson's "manifest destiny" for humanity optimistically anticipates a practically eternal universe: "No matter how far we go into the future, there will always be new things happening, new information coming in, new worlds to explore, a constantly expanding domain of life, consciousness, and memory."

Imagining such a far-off future may be premature because our species and other star civilizations must cope with more immediate threats. A long list of cosmic disasters are capable of wiping out complex life-forms. Space debris in the form of wayward comets and asteroids will continually threaten terrestrial moons and planets. Advanced civilizations will find a way to catalog and deflect space debris, a task essential to survival that we on Earth have only just begun to do. At 100 million years between potential planet-killer impacts here on Earth, there is plenty of time to come up with a planetary protection strategy.

A bigger challenge might be finding underground shelter on a home planet flooded with lethal radiation shot out from supernovae. Statistically there have probably been so many nearby exploding stars over Earth's history that it's hard to imagine how life here has survived so long. A supernova explodes somewhere in the universe once every second, but major eruptions from stars exploding nearby are spaced every 200 million years apart, according to best estimates. If a supernova explodes close enough, underground shelters don't work. The intense flux of neutrinos would pierce the planet like zillions of invisible bullets.

The most titanic stellar explosions, called hypernovae, unleash a "death-star" narrow beam of energy called a gamma-ray burst. Because the burst lasts only about 10 seconds, the rays probably wouldn't directly affect life on Earth's surface. But that's

GAMMA-RAY BURST *The explosion of a supermassive star, called a hypernova, sends out a narrow beam of radiation called a gamma-ray burst. The blast of energy lights up nearby pillars of gas and dust. Planets orbiting stars along the beam's path will be sterilized by the unexpected but brief blast of radiation. Events like this pose a great danger to the long-term survival of intelligent life in the Galaxy.*

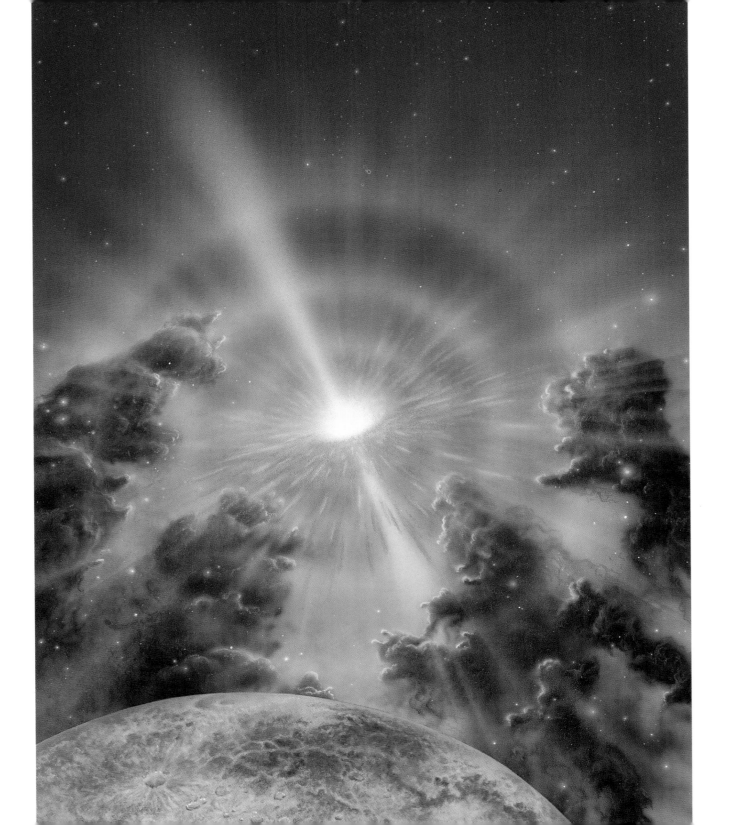

long enough to degrade the ozone layer and expose organisms to ultraviolet radiation from the Sun. The radiation would be enough to kill off many creatures, while causing high levels of mutations in the survivors. Organisms that reproduce quickly would be the first to exhibit the effects, since it takes many generations for mutations to spread through a population.

Is Anybody There?

The fact that an extraterrestrial civilization hasn't visited us yet may support this gloomy scenario of a universe hostile to life's long-term survival. The simple truth that we have no convincing evidence of extraterrestrial visits prompted nuclear physics pioneer Enrico Fermi to offer the blunt question: "Where are they?" The mystery behind this question deepened further when a 13-billion-year-old planet was discovered in our Galaxy—direct observational evidence that the universe started making planets very early, time enough for far-advanced civilizations to travel across space, colonize the Galaxy, or otherwise make their presence known to us.

The number of extraterrestrial civilizations that we might be able to contact could ultimately depend on their longevity. Radio astronomer Frank Drake, a pioneer in the search for extraterrestrial intelligence (SETI), quickly came to this sobering conclusion in the 1960s. He formulated an equation for estimating the number of coexisting technological civilizations in our Galaxy. The equation factored in the rate of star formation in the Galaxy, the fraction of stars that might have planetary systems, and the frac-

OPTICAL SETI *The earliest searches for extraterrestrial intelligence focused on studying radio waves. Many newer searches are optical, looking for laser light that is coming from nonnatural sources. In this image a laser beam conveying a message originates from a planet around a distant star, and the message is collected in data gathered by an optical telescope. Such interstellar communication may be the most efficient way to send and receive information.*

tion of those systems that might have Earthlike planets. Our discoveries today allow us to fill in many of the equation's variables with some confidence, such as the fraction of stars with planets. A more speculative variable is estimating what fraction of habitable planets would evolve technological intelligent life with which we might communicate.

The last variable in the equation, an estimate of an intelligent civilization's average longevity, vastly overshadows all other factors. How long does an intelligent civilization last, and how long might it maintain an interest in communicating with others? The equation predicted that if a civilization can last one million years, the nearest one to us could lie within 1,000 light-years. But if a technological civilization lasts just a few hundred years, we could be the only advanced life in the Galaxy at present.

If primordial life eventually evolved into sentient beings, we still wouldn't have a clue to their civilization's longevity. This outstanding unknown is being addressed by monitoring the stars for optical and/or radio transmissions. Astronomers have been conducting this high-reward and high-risk experiment since Drake made the first bold search for extraterrestrial signals in 1960, using a radio telescope at Green Bank, West Virginia, to eavesdrop on solar-type stars. Today SETI surveys cover a very tiny fraction of our Galaxy. But there are plans for even larger radio telescope arrays to extend our "listening ear" ever deeper into the Milky Way.

The most ambitious plan to date is to erect 350 radio antennas across about 150 acres of a region north of California's dormant Lassen Peak volcano. This SETI project, called the Allen Telescope Array, will have a collecting area of more than two acres, making it one of the world's largest steerable radio telescopes. SETI searches today scan thousands of stars, but the Allen array will reach thousands of light-years, encompassing many millions of stars. A conservative estimate from the Drake equation is that around 10,000 civilizations are advanced enough for SETI observations to find, estimates SETI astronomer Seth Shostak. "The bottom line comes out that even if you take Drake's more pessimistic ideas, you'll trip across a civilization by the year 2025," Shostak predicted in 2003.

However, one unsettling possibility behind the silence so far is that biological organisms are superseded by artificial intelligence. This might modestly be offered as yet another factor in the Drake equation: how frequently biological intelligence may be replaced by artificial intelligence—and, fundamentally, whether nonbiological entities would be motivated to communicate across interstellar space. This becomes quite problematic because mechanical life forms would not need to colonize a planet, so SETI targets may be missing other important locations in deep space. Moreover, artificial intelligence might not have *any* interest in visiting or talking to us.

Science fiction writer Terry Bisson humorously captured the dilemma in this imaginary dialogue, published in *Omni* in 1991, between two nonbiological entities that discover radio transmissions from Earth:

"They're made out of meat."

"Meat?"

"There's no doubt about it. . . . They use the radio waves to talk, but the signals don't come from them. The signals come from machines."

"So who made the machines? That's who we want to contact."

"*They* made the machines. That's what I'm trying to tell you. Meat made the machines."

"That's ridiculous. How can meat make a machine? You're asking me to believe in sentient meat. . . . We're supposed to talk to meat?"

"That's the idea. That's the message they're sending out by radio. 'Hello. Anyone out there. Anybody home.' That sort of thing. . . . Do we really want to make contact with meat?"

"I agree. . . . What's there to say? 'Hello, meat. How's it going?'"

Besides speculating about artificial intelligence elsewhere in our Galaxy, numerous science fiction novels have made dark predictions about its rise on Earth. In Jack Williamson's *The Humanoids* (1949), sleek black androids designed to serve and protect humanity take things a little too far; in Isaac Asimov's *I, Robot* (1950), robots go mad,

get superiority complexes, enter politics, and read our minds; and in Philip K. Dick's *Do Androids Dream of Electric Sheep?* (1968), bounty hunters track down renegade "replicants"—perfectly lifelike androids.

At the turn of this century a Silicon Valley technologist made a serious assessment of the future of man and machine. In an article in *Wired* magazine in 2000, Bill Joy, the cofounder and chief scientist of Sun Microsystems, predicted that by 2030 computers will be a million times more powerful than today's microprocessors. Could this computational power—approaching the speed of the human brain—ever give rise to artificial consciousness? Even if didn't, it could certainly allow machines to process information and make decisions with a rapidity and efficiency far beyond human capabilities. Hans Moravec, director of the Robotics Institute at Carnegie Mellon University in Pennsylvania, goes further. As Joy reported, "Moravec's view is that the robots will eventually succeed us—that humans clearly face extinction." Moravec explained, "The information that's passed from generation to generation in our genome consists of a few billion bits, but there are trillions of bits in our libraries. And we would not be who we are if it wasn't for this cultural information. The robots are simply the point when that cultural information takes over from strict biology." In this scenario artificial intelligence becomes an evolutionary step for a technological civilization, as inevitable as life crawling from ocean to land. Humans could introduce a new species into the Galaxy—thinking silicon, rather than carbon. But it is presumptive to think we would be the first species in the Galaxy to make such a leap. Perhaps the first extraterrestrial visitor we ever come face-to-face with will have been spawned in a laboratory, not a primeval ocean.

HOLDING OFF EXTINCTION

Every day that we fail to find evidence of intelligent life is another day we must ponder, like a prisoner in an isolation cell, if we are the only ones around. There might be

PIONEERING RADIO TELESCOPE FOR SETI *Twilight descends on the 34-meter radio telescope located at the Goldstone complex of telescopes in the Mojave Desert in California. It was one of the instruments used in 1992, in celebration of the Christopher Columbus quincentennial, to pan across the heavens and channel-surf billions of radio frequencies for extraterrestrial signals. Every second, computers performed 100 billion operations to sort through the frequencies for powerful artificial transmissions from any civilization orbiting a nearby star. But a year later the U.S. Congress, some members expressing skepticism about the reality of extraterrestrial life, pulled the plug on the ambitious all-sky survey and targeted search. Under private funding, the SETI program is forging ahead with much larger and more ambitious radio antenna arrays. (Courtesy L. R. Cook)*

a large "infant mortality rate" among emerging civilizations in the Galaxy. Some fraction might vanish due to an array of biological, technological, or military global disasters that snuff out a civilization. Radio astronomer Eric Chaisson believes that only "ethical" civilizations survive a turbulent warlike adolescence to enjoy a longevity that might surpass the lifetime of the parent star. But it's a long and arduous road even for the heartiest civilization, filled with unknowns upon unknowns.

Probably the biggest rationale for SETI is to try and find out if technological civilizations inevitably wipe themselves out long before they must worry about natural cosmic disasters. Our civilization came closest to this during the cold war with a nuclear arsenal capable of unleashing the force of a comet plowing into the planet. Perhaps there are common dangerous watersheds in the technological evolution of a civiliza-

tion that extraterrestrials could warn us about. Perhaps there are "toxic" technological experiments that civilizations inevitably do that backfire, such as fabricating a black hole.

British astrophysicist Sir Martin Rees is very pessimistic about the chances for the survival of our species. "Humanity is more at risk than at any earlier phase in its history," Rees wrote in his 2003 book *Our Final Hour*. "The odds are no better than 50–50 that our present civilization on Earth will survive to the end of the present century." Rees emphasizes that the last century saw an unprecedented acceleration of human knowledge and its myriad applications. As this acceleration continues, its consequences cannot be predicted. Rees worries about governments equipped with superweapons, whether nuclear or biological. Add to that the inaction by governments in confronting global environmental issues. Rees cites as well the deliberate actions of radical ideological groups that can damage vulnerable industrial societies. The September 11, 2001, coordinated terrorist attack on the United States may only presage what will happen as technological assets of such small groups become more sophisticated.

In 2003 a panel of life-science experts convened by the National Academy of Sciences issued an ominous warning that "the same science that may cure some of our worst diseases could be used to create the world's most frightening weapons." A genetically engineered pathogen could unleash an infectious disease far worse than any known natural organism. This gloomy forecast is driven by the fact that life-science knowledge is exploding in the same way that communication technology did in the 1960s. Complex biotechnology is becoming widely available to the public, including potential terrorists. Custom-designed pathogens could be antibiotic-resistant or developed to evade an immune response. Stealthy viruses could lie dormant inside victims for an extended period and then suddenly cripple a large portion of the population, devastating a country with massive health and economic problems long before a cure could be developed. "The resulting diversity of new bioweapons agents could enable such a broad range of attack scenarios that it would be virtually impossible to anticipate and defend against," the panel concluded.

If advanced civilizations are short-lived, then we may find only ancient artifacts or pick up signals long after a civilization has become extinct. In James Gun's 1972 novel *The Listeners,* astronomers try for generations to decode a message from a civilization orbiting the star Capella. They finally learn that the message explains how the Capellans died off thousands of years ago but left behind an automated radio telescope to continue contacting other civilizations and share the history of the Capellan race.

This science fiction tale is not too far from reality. Greetings to aliens are carried aboard a pair of NASA *Pioneer* and *Voyager* outer-planet probes with enough escape velocity to leave our Solar System and drift among the stars forever. Though it is unlikely these "notes in bottles" will ever be plucked out of interstellar space by extraterrestrials, they could be the first and last evidence aliens might have that intelligent life ever existed here. Like a worn-old snapshot of an ancestor, the artifacts, by their very existence, simply state, "Humans once existed. We lived here in the Galaxy."

The *Pioneer* spacecrafts carry an engraved plaque with "hieroglyphics" showing a pair of humans and our galactic "zip code" (our location relative to 14 pulsars). The *Voyager* pair carry a phonograph record encoded with sounds and images of our civilization as it existed in the 1970s. Added to this evidence of life on our planet, an expanding bubble of radio energy from our defense radars and telecommunications surrounds Earth out to 60 light-years. It will be detectable hundreds of years from now by alien societies with sufficiently sensitive radio telescopes. A deliberately broadcast transmission from the giant Arecibo radio telescope is also streaking toward the globular cluster M13, located 21,000 light-years away in the constellation Hercules. Around the year A.D. 22,974 any astronomically curious civilizations in M13 will see a radio burst from the plane of our Galaxy that is so intense it will briefly outshine the Sun at radio wavelengths.

Just before World War II, the atom bomb, and the cold war, filmgoers in 1936 saw an upbeat, optimistic glimpse of a technological future in the film *Things to Come.* The screenplay, written by H. G. Wells, presented a utopian vision of a government of scientists and engineers who reshape our war-torn planet and turn technology toward

COMMUNICATING PROBE NEAR A DEAD PLANET *A lonely sentinel orbits a dead planet that was once home for an advanced technological civilization. Its creators are long dead, due to a cosmic catastrophe. The probe continues sending out laser transmissions to known civilizations orbiting neighboring stars. Anticipating the unavoidable destruction of their planet, the intelligent beings living here constructed this probe within which they placed their entire recorded history. The first signal we receive from space may come from the automated artifacts of long-vanished civilizations.*

peaceful applications—like traveling to the Moon. While viewing the first manned spacecraft en route to the Moon, two of the society's leaders debate the future of humanity in space:

> *Cabal:* But for Man no rest and no ending. He must go on—conquest beyond conquest. This little planet and its winds and ways, and all the laws of mind and matter that restrain him. Then the planets about him, and at last out across immensity to the stars. And when he has conquered all the deeps of space and all the mysteries of time—still he will be beginning.
>
> *Passworthy:* But we are such little creatures. Poor humanity. So fragile—so weak.
>
> *Cabal:* Little animals, eh?
>
> *Passworthy:* Little animals.
>
> *Cabal:* If we are no more than animals we must snatch at our little scraps of happiness and live and suffer and pass, mattering no more than all the other animals do or have done. *(He points out at the stars.)* It is that—or this? All the universe—or nothingness. . . . Which shall it be?

Becoming an Extraterrestrial Civilization

In the 1960s Russian astronomer Nikolai Kardashev divided advanced civilizations in the universe into three major classes, depending on how much energy they can control and their technological prowess. Type I civilizations—like us—have the capability to communicate using light and radio waves and possess a basic understanding of the laws of physics. A Type II civilization has the capability of reengineering its planetary system, star travel, and space colonization. The galactic civilizations, or Type III societies, have energy resources on the order of the entire Milky Way! They enjoy lifetimes at least as long as the life of the Sun, which has five billion years to go.

But along the road to the utopian vision of *Things to Come*, biological civilizations

throughout the Galaxy must eventually come to grips with issues of overpopulation and dwindling resources. This is becoming a far cry from the poetic encouragement in the biblical Genesis: "Be fruitful and multiply; fill the Earth and subdue it; have dominion over the fish of the sea, over the birds of the air, and over every living thing that moves on the Earth." In reality, when humans started abandoning hunter-gatherer living in favor of large-scale agriculture roughly 10,000 years ago, they were able to short-circuit the normal controls that limit the size of any species' population. Our species started slowly on the road to exponential growth. It wasn't until 1800 that we had a billion people on the planet. But then it took only another 100 years to double the population to two billion. Now the world population has skyrocketed to six billion. In 100 years, the world's population has almost quadrupled.

The rate of population growth in the last century "is unprecedented, and it will not happen again," says Joseph Chamie, director of the population division at the U.N. Department of Economic and Social Affairs. A 2003 U.N. study predicted a world population of nine billion by the year 2300, based on the inevitability of population decline. If fertility rates don't decline as anticipated, the worst-case scenario is an increase to 36 billion people by 2300. Biologist and population growth researcher Paul Ehrlich of Stanford University says that Earth presently hosts 4.5 billion more people than the planet can comfortably accommodate. "Human activity is altering the planet on an unprecedented scale. More people are using more resources with more intensity—and leaving a bigger footprint on the Earth—than ever before," warns Vernon Mack of the United Nations Population Fund. The fund's 2001 report predicted that increasing poverty will be rampant among the global population of 2050.

This ominous degradation of life is not restricted to humans. "If current trends continue, fully one-fifth of the world's living species will vanish over the next 30 years under the pressures of development, population rise, environmental degradation, and other human activities," predicts Harvard University biologist Edward O. Wilson. In his 1992 book *The Diversity of Life* he further predicts that the same levels of extinction

that ended the age of the dinosaurs will happen by the middle of the next century. "The rise of an intelligent controlling species which can single-handedly bring about an extinction spasm is an event unique in history. But it's also unique that we have the power to decide what to do. It is inescapable that it is to humanity's great advantage to avoid species extinction rather than to throw away the genetic heritage of the world that is millions of years old. It is very risky to us to reduce the diversity of life on Earth," he warns.

The growth rate of our species requires that we take the next evolutionary steps to try to bring balance to our planet. We must become a fully extraterrestrial civilization. A century ago Russian space pioneer Konstantin Tsiolkovsky foresaw this when he said, "Earth is the cradle of the mind, but we cannot stay in a cradle forever." Former NASA administrator Daniel Goldin expressed similar sentiments in a 1998 speech to the American Astronomical Society: "In the nineteenth century, we were citizens of nations. In the twentieth century, we became citizens of a global, interconnected economy. And in the twenty-first century, we will become citizens of the Solar System." Extrapolating from Goldin's remarks, it might be tempting to predict that we will become citizens of the Milky Way Galaxy in the twenty-second century and beyond. Interstellar robots, and maybe human explorers, will visit extrasolar planets first charted by our contemporaries.

American University space historian Howard McCurdy says there is an emerging consensus "that we [should] send humans into space for reasons other than scientific"; that science has come to validate the vision of humans becoming a "multiplanet species." Planetary astronomer William Hartmann concurs: "I think we're on the verge of geopolitical changes in how we explore and use space. We must begin to explore the Galaxy to ensure the survival of humanity."

An extraterrestrial civilization has unlimited boundaries to growth by fully utilizing the resources of space for manufacturing, power generation, and colonization. The resources are abundant. "The total energy reserve contained in the Sun would be suf-

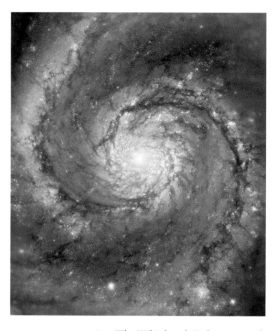

LIVING GALAXY? *The Whirlpool Galaxy, 50 million light-years away, may encompass billions of unseen planets and moons that will remain forever beyond our telescopic powers. A practical infinity of life-forms and innumerable civilizations may extend across the galaxy too, forever removed from us in space and time. Any civilizations that were present may have already perished because of numerous imaginable catastrophes. Although the field of view is crowded with stars, the distances between them may impose a cosmic quarantine whereby stellar civilizations never meet. (Courtesy Hubble Heritage and NASA)*

ficient to support forever a society with a complexity 10 trillion times greater than our own," the far-seeing physicist Freeman Dyson asserted in "How Will It All End?" As long ago as 1959 Dyson proposed what has become known as a "Dyson sphere": an artificial shell the size of a planetary orbit that would let an advanced civilization use all the energy emitted by its parent star.

Tsiolkovsky, an earlier true visionary, devised a 16-step "plan of space exploration" in 1926, at a time when some scientists were saying we could never make it as far as the Moon. Step 13 called for colonization of the Solar System. The last step was to leave the future dying Sun and colonize systems around other stars. Tsiolkovsky wrote, "Men are weak now, and yet they transform Earth's surface. In millions of years their might will increase to the extent that they will change the surface of the Earth, its oceans, the atmosphere, and themselves. They will control the climate and the Solar System just as they control the Earth. They will travel beyond the limits of our planetary system; they will reach other suns, and use their fresh energy instead of the energy of their dying luminary."

German rocket pioneer Kraft Ericke described Earth as the only passenger car in a freight train of boxcars (the other planets) ready for providing raw materials. A typical planetary system offers abundant resources to be harvested from comets, asteroids, and moons. The resources of the Solar System are truly limitless. The Asteroid Belt alone offers a total mass equivalent to that of the Moon for materials bearing aluminum, calcium, cobalt, iron, magnesium, manganese, nickel, oxygen, sodium, and titanium, among other elements and chemicals. "It amazes me that we're squabbling over the last reserves of fossil fuels and ores on Earth when the resources of the asteroids are available," says William Hartmann. "Imagine a ball of nickel-iron five miles across. That describes some asteroids. Also, the surfaces of the asteroids could house photovoltaic cells for supplying electrical power to Earth." Construction and industry in space offer the advantages of solar power and no pollution to Earth.

Like us, societies might be driven to colonize other planets in their star system to

support an exponentially booming population and accompanying hunger for resources. The other terrestrial planets lying outside the Sun's continuously habitable zone would have to be globally reengineered, or terraformed.

In rare cases a civilization in a stable binary system of two Sunlike stars would have a unique opportunity. If the binary pair is far enough apart, each star could host stable systems with habitable planets. A civilization could travel across the tens of billions of miles separating the planets with conventional propulsion—no need for a "stardrive." It would be easy to imagine a colonization effort to a neighboring planet around the companion star.

The first baby step in the human species becoming a multiplanet civilization is to build up space science, technology experimentation, and ultimately industrialization in the region between Earth and the Moon. The next step up from the International Space Station is to establish an outpost at the Earth-Moon L1 Lagrangian point dubbed the "Gateway." It would be the first big "truck stop" on the interplanetary superhighway, an inflatable station with docking bays, fuel reserves, workshops, and launch preparation facilities for sending probes and telescopes to the Moon and beyond.

The Moon is the next logical choice in our potential stepping-stone approach to our exploration of the Solar System. Establishing a permanent colony on the Moon would require designing and building new giant rocket boosters, spacecraft to shuttle people to lunar orbit, and spidery landers to ferry crews to the surface. A Moon base would require new techniques of housing and supplying people living off-Earth for long periods.

The Moon would be an invaluable proving ground for Mars-exploration technology and a source of raw materials and fuel for Mars-bound payloads. Expansive underground, radiation-hardened structures at the Moon base would allow for the construction, testing, deployment, and repair of robust space missions launched in one-sixth gravity. The Moon has the advantage of being a nearby destination that is scientifically interesting in its own right. It could someday provide the isotopic helium-3, deposited

SETI BETWEEN TWO PLANETS IN A DOUBLE STAR SYSTEM *Planets orbiting separate stars in a binary star system could independently develop intelligent life and a technological civilization. Should two such societies develop radio technology at the same time, they could communicate with each other during the time that the planets are in view of each other. In reality, the distant planet and star would appear much smaller and distant than depicted here; sizes are exaggerated to illustrate the concept.*

by the solar wind, for powering pollution-free Earth-based nuclear fusion electricity plants.

The space shuttle *Challenger* and *Columbia* tragedies, and lack of interest by the general public toward the International Space Station, are fueling the desire for an expansive, new long-range goal for humans in space. President George W. Bush announced such a vision in January 2004 when he directed NASA to undertake a two-decade program to send humans back to the Moon, and ultimately on to Mars.

His father, President George H. Bush, had made a similar commitment in July 1989, on the twentieth anniversary of the *Apollo 11* Moon landing. The price tag then was $500 billion. The projected price tag now, stretched out over the next two decades, could approach $1 trillion. Is our civilization willing to make this kind of down payment on becoming a "multiplanet species"? In the 2004 speech Bush expressed our nation's frontier spirit: "Mankind is drawn to the heavens for the same reason we were once drawn into unknown lands and across the open sea. . . . So let us continue the journey." In a televised discussion of the speech University of Maryland physics professor Robert Park countered: "Well, if Columbus could have sent a drone, he would have. And, as a matter of fact, [George H. Bush's 1989] program stopped as soon as they got the cost estimate. It went nowhere." Park added, "The great adventure of our time is to explore those places where no human can set foot. Mars is just one other place in the Solar System. The rest of the Solar System is pretty much closed to us. The gravity is too great for a human being. It would crush us. The temperatures are too high, the radiation levels are much too high. . . .We need to do that with robots."

Just getting to Mars could take months, until new propulsion systems, using nuclear-electric rockets, are developed to accelerate the journey. Once there, humans would need power, probably coming from a compact nuclear generator that has yet to be designed and built. Nevertheless, despite the difficulties in getting there, for over a century Mars has beckoned human imagination as a place to colonize. Though one-third Earth's diameter, Mars has the same land area as all of our continents combined. But

O'NEILL SPACE COLONY *This interior view is of a large, spherical space habitat for 10,000 people. Such space "city-states" may be more practical for Solar System colonization than terraforming planets. The "equator" of the rotating habitat is nearly a mile in circumference. Natural sunshine is brought inside through external mirrors. Rotation of the sphere at about two rotations per minute would produce gravity of Earth-normal intensity at the equator. A corridor at the axis would permit floating in zero gravity out to the agricultural areas, observatories, docking ports, and industries. The habitat would be constructed from materials mined from the Moon and asteroids. (Courtesy NASA)*

the planet is too cold and has too dry and tenuous an atmosphere to support life. In concept, Mars could be terraformed largely by artificially "bootstrapping" the Martian climate via warming the planet enough to free up frozen carbon dioxide that can begin building up another greenhouse effect. This could be done with giant space mirrors and asteroids deflected to crash into the planet to liberate trapped carbon dioxide. Genetically engineered organisms might be transplanted on Mars to rapidly produce greenhouse gases. Other plants would begin to produce oxygen, or it could be baked out of the rusty Martian surface with energy provided by nuclear-electric power or solar power from space mirrors.

Mars may be prototypical of the type of planets other civilizations might be tempted to terraform. It is a terrestrial planet living on the fringe of the habitable zone. But such an undertaking—no matter how advanced the civilization—would require a millennia-long commitment, and a huge allocation of resources. It's not inconceivable that future human colonists might be genetically altered and bred to better adapt to the Martian environment.

But why necessarily turn to planets as other places to colonize? Civilizations could build their own habitats in space in a small fraction of the time and cost it would take to renovate an entire planet. This is not a new idea. In 1937 the science fiction writer Olaf Stapledon described the concept of artificial biospheres constructed by advanced extraterrestrial civilizations in his science fiction novel *Star Maker.*

Physicist Gerard O'Neill popularized this dream in the late 1970s. His envisioned space-cities, dubbed "O'Neill colonies," that are cylindrical habitats capable of sustaining 100,000 inhabitants each. The colonies generate artificial gravity by rotating three times every minute. Giant mirrors collect sunlight and direct it into the cylinders. The colony, weighing about 10 million tons, would also contain areas for agriculture, animals, and plants. The estimated cost of the project was about $250 billion (1970s dollars) and was calculated to take about 20 years to build.

There could be no limit to the number of O'Neill colony city-states located at Earth's

distance from the Sun. This growth strategy offers vast potential for cultural diversity for our species, much as the Greek city-states of Sparta and Athens were quite socially diverse because of their geographic isolation. For any civilization, scattering "space city-states" all over a planetary system would get away from the all-your-eggs-in-one-basket scenario, where a planetary cataclysm could wipe out the entire intelligent species on Earth.

THE GREAT ESCAPE

Any galactic civilization ultimately would need to deal with the waning years in the life of its parent star. Its home planet would no longer lie in a habitable zone as the star aged. The society would eventually need to leave its planetary "cradle" permanently. Artificial planets and space colonies could be built farther from the warming, evolving star, as the habitable zone shifts outward to encompass previously uninhabitable planets.

What about leaving behind a planetary system and traveling across space to colonize a planet around another star? A problem often overlooked when this is romanticized in science fiction is that if a planet is habitable, *something probably already lives there!*

Interstellar travel within a reasonable time span—at least for mortal beings like us—would require scientific breakthroughs on three fronts: propulsion, speed, and energy, not to mention the desire of a civilization to invest exorbitant resources. NASA's Advanced Propulsion program is looking for radical alternatives to conventional rocket engines that would have to carry impossibly large quantities of fuel. NASA wants a propulsion system that doesn't need propellant. Maybe a starship could push against the very structure of space-time itself, or find a way to modify gravitational or inertial forces.

Given the will and resources, it would be naive to imagine that the daunting technological challenges of interstellar flight could not be overcome by advanced civiliza-

SPACE COLONIES NEAR A WHITE DWARF *Having gone through previous evolutionary stages as a Sunlike star and red giant, this star is now a white dwarf in the middle of a planetary nebula, cooler and with less energy output than at previous times. The intelligent beings living in the space habitats once dwelled on a planet much farther away from their star. They had the skills, knowledge, and raw materials necessary to construct space colonies and position them close to the white dwarf, from which they obtained enough energy to survive. This was a far more efficient solution to living with a dying star than attempting the exorbitant and treacherous option of interstellar travel and colonization.*

tions. If such a society had the pioneering fervor of the Polynesians who colonized the vast South Pacific, it might well travel to the stars, despite the incredible risks and hardships.

Perhaps these pioneers would build a "space ark." Because the ship might travel at no more than 10 percent of the speed of light, generations of colonists would live and die so that their descendants could live on a planet in another solar system. The social structure of a crew of 100 couples (considered an optimum size by some sociologists) would have to be carefully worked out. There would be no chance to turn around and go back home! The young couples selected for the launch and acceleration phase would postpone parenthood until their thirties to stretch generational overlap—an optimum strategy, say sociologists. The number of siblings would have to be limited to maintain a stable population.

Like Polynesians slowly making their way across the Pacific Ocean, the wave of colonization from a single supercivilization would move in starts and stops, "island hopping" across the Galaxy, following a "critical path" between star systems known to contain planets hospitable to life. At that rate the entire galaxy could be colonized in 100 million years. Since it's possible that civilizations could exist that got started hundreds of million of years ahead of ours, they should have already colonized the Galaxy. But because we haven't had any visitors, technological civilizations are either quite rare or nonexistent, as Fermi implied. Or civilizations may simply choose not to devote resources to colonizing other solar systems. Interstellar travel may simply be too arduous.

Scientists performing radio and optical searches for intelligent signals argue that it's much easier to send photons to the stars than matter. What's sobering is that far-advanced civilizations may have totally exotic ways to communicate. Instead of engaging in space travel, the most advanced civilizations might communicate via a "galactic Internet" where information about innumerable worlds is exchanged. A dream of science fiction is to communicate instantaneously so that one would not have to wait 100,000 years for a radio signal to arrive from the other side of the Galaxy. Even if it's impossible to travel faster than light, civilizations might be able to chatter at a rate that

MILKY WAY GALAXY INTERNET *Advanced civilizations will be highly motivated to find ways to communicate quickly over enormous distances in our Galaxy—using breakthrough physics to circumvent the long travel times of sending a beam across three-dimensional space. All advanced intelligent life in the Galaxy might be linked up via interdimensional shortcuts that enable instantaneous communication. Such a galactic Internet would encourage and support the sharing and dissemination of knowledge and culture across the Galaxy.*

would appear to supersede the limits imposed by the finite speed of electromagnetic radiation.

Recent experiments tend to support the idea from quantum theory that two or more particles can communicate instantaneously as demonstrated by a mysterious effect called entanglement. This means that if you change the spin or another quantum state of one of the particles, the other one changes in an identical way instantaneously, even though the particles are not visibly connected or may be at a great distance from one another, conceivably at the opposite ends of the Galaxy. Albert Einstein theorized that this could happen, but believing only what he could confirm with experiments, he dismissed it as "spooky action at a distance"! Despite recent evidence that entanglement does indeed exist, some physicists argue that apparent quantum "superluminal communication" cannot violate the Special Theory of Relativity. Einstein's theory predicts that no signal can cause an effect outside of the space-time surface on which light rays travel. Otherwise there could be paradoxes where an effect precedes its cause. Imagine a civilization transmitting a superluminal message describing the final days of their existence before a supernova blows up and destroys the planet. However, the light from the supernova doesn't reach us until 10,000 years later. This would be a paradox where we knew of the result before we saw the cause. This "causal loop" puzzle aside, physicists continue debating whether there truly is a limit to the speed of information in the universe.

THE BIG BANG-UP

If superluminal communication is possible, inhabitants of civilizations will have a lot to chat about on the hypothetical galactic Internet about seven billion years from now. A common watershed for all existing Milky Way civilizations will be our Galaxy's likely collision with the Andromeda Galaxy. The Milky Way and Andromeda Galaxies are

moving toward each other at one million miles per hour. A collision seems probable unless the Andromeda Galaxy sideswipes us and continues along a looping orbit, but we don't have precise enough observations today to accurately predict the outcome.

Computer simulations and telescopic images of other galactic mergers give exquisite details of what's probably in store. Stars will scatter into a huge sphere, and long tidal tails will form. The cores of the two galaxies will merge. When the central black holes in both galaxies coalesce, the newly forming galaxy will momentarily shudder in the wake of gravity waves rippling time and space.

Future astronomers surveying the product of this merger will gaze out onto a starry sky and look all the way into the core of the new elliptical galaxy. If for some reason they lack historical records, they will have no clue that there were once two majestic spiral galaxies, called the Milky Way and Andromeda by a long forgotten civilization. "The end of one era for a galaxy may be the beginning of a new era for another galaxy," says Ken Freeman of the Mount Stromlo Observatory in Australia.

A look at the nearby giant galaxy NCG 5128, better known as Centaurus A, may presage the future of the Local Group of galaxies after the Milky Way and Andromeda's "corporate merger." This monster elliptical galaxy has no doubt grown through major mergers. Its appetite hasn't abated, however. It presently is cannibalizing a wayward disk galaxy, and other galactic shreds are seen in its halo. A refueled supermassive black hole at its core spews out a fountain of energy in the form of extragalactic jets.

The good news is that the collision between the Milky Way and Andromeda Galaxies will create innumerable stars and planets that may never have been born otherwise because there was nothing to compress the residual clouds of interstellar hydrogen in our Galaxy. It will also be a front row seat at the fireworks display for budding astronomers across the Galaxy. The bad news is that the bursts of radiation from a lethal Roman candle eruption of supernovae and hypernovae might sterilize much of the Galaxy. Extinctions could occur on a galactic scale, disrupting innumerable worlds. "Go underground—unless you are so close that the neutrino flux can kill you. In which

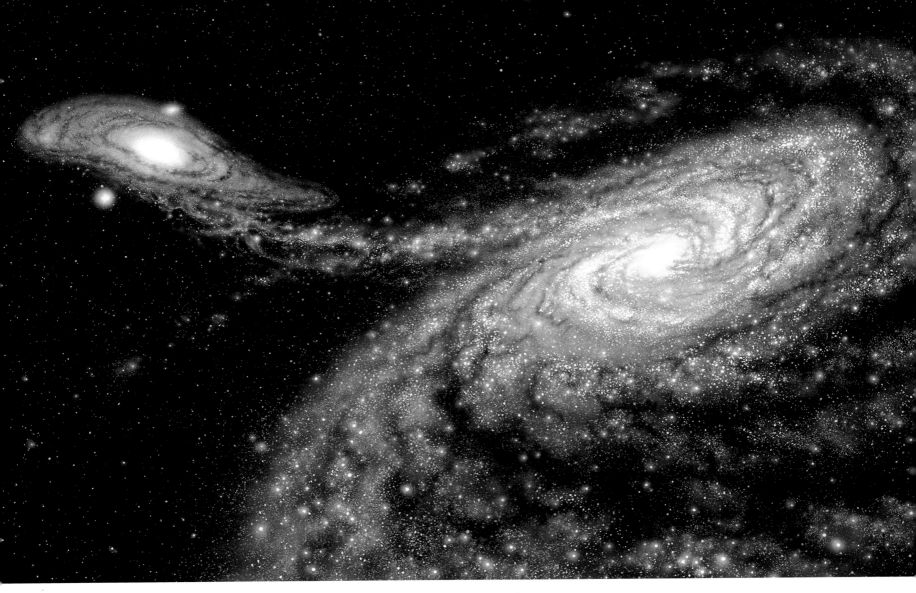

GALAXY COLLISION *The Milky Way and Andromeda Galaxies begin to warp and change shape as they move toward each other and merge six billion years from now. This will trigger a new period of spectacular star birth as interstellar gases smash together, precipitating the birth of myriad new stars. Civilizations will be treated to a spectacular sky show of stellar creation, but will also be bathed in deadly radiation from a firestorm of exploding young stars.*

GALAXY CENTAURUS A *The nearby galaxy Centaurus A is a rare example of the iridescent fireworks that result when galaxies collide. The collision fuels a supermassive black hole as well as a firestorm of star birth. Understanding an active galaxy means viewing it at different electromagnetic wavelengths: from radio to X-ray (blue), radio (pink and green), and optical (orange and yellow). Using such a broad spectrum gives a holistic view of this pathological galaxy. The warped, horizontal dark dust lane is caused by the collision of two disk galaxies. (Courtesy NASA, CXC, NRAO, VLA, Digitized Sky Survey U.K. Schmidt Image, and STScI)*

case you might as well stay above ground and enjoy the show," says astronomer Andrew Fruchter.

THE FATE OF THE UNIVERSE

The anticipated demolition and reconstruction of the Milky Way as we know it today dramatizes the fact that "we don't live in a preferred time," according to astrophysicist

Fred Adams of the University of Michigan. "Just as our planet, and hence mankind, has no special location within the universe, our current cosmological epoch has no special place in the vast expanses of time," he wrote in *The Five Ages of the Universe*. Whatever the fate of life in the universe, we are the only known species that has reached the intellectual pinnacle at which we can cautiously look ahead to countless more eons and at last ponder the Ultimate Future—as best as can be extrapolated from present-day knowledge.

Based on a 1996 study by Adams and astrophysicist Greg Laughlin of the University of California at Santa Cruz, the most conservative extrapolation is that we now live in what Adams and Laughlin call the Stelliferous Era. The era during which stars are being made started perhaps only a few hundred million years after the Big Bang and could continue for another 100 trillion years. At the end of it only the coolest and dimmest long-lived stars will remain, and the last planets harboring life as we know it will be those orbiting red dwarf stars. These planets would have been too cold for life to originate early in the parent star's life, but after many billions of years the star will grow bright enough to expand its habitable zone to encompass these planets.

Eventually all the stars will burn out. Dead stars, predominantly white dwarfs, will continue to be orbited by probably lifeless planets. Over many billions of years more, chance close encounters between stars will cause planets to be dislodged from their orbits and go sailing off into space. This will happen to the lifeless Earth eventually, assuming it is not swallowed up by the Sun. As planetary systems get pulled apart, entire galaxies will evaporate as their stars fly off into deep space or sink into the galactic center. Certainly as long as there are stars for energy, the potential for life will exist. It's not inconceivable that far more exotic forms of life will find cozy niches around white dwarfs and neutron stars, and maybe even black holes.

In an ironic twist, the universe's underachievers, the brown dwarf stars, may come to the rescue in its twilight years. Either by collision or by close binaries spiraling in together, two brown dwarfs could at last combine and rekindle their hydrogen fuel,

ARTIFICIAL PLANET ORBITING A BLACK HOLE *In the very distant future all stars will have burned out, leaving interstellar space in inky darkness. In this bleak, far-off future the only sources of energy left are black holes. This image shows an artificial planet constructed by an intelligent civilization orbiting a stellar black hole. By our standards this is a violent place for anything to survive, with X-rays and extreme gravity. But it is not inconceivable that a far-advanced species would find a way to exist here as a last outpost for intelligent life in the dying universe.*

which lay dormant for billions upon billions of years. The combined mass of the two stars coming together would allow them to burn hydrogen through fusion as a very low-mass star. Such stars could burn for a trillion years after the last "normal" star had expired. They would truly be the very last surviving stars in the universe, spread unimaginably far apart in space and time. The very last forms of life might arise here too— the final manifestations of self-replicating matter in the closing act of the cosmos.

Any entity living only a billion years after the Big Bang could never extrapolate to the complex universe of today. And that's a span of merely 13 billion years. Despite our best guesses we will likely turn out to be clueless about the ultimate fate of space and time.

UNIVERSES IN COLLISION

The perils of trying to predict the future, even by scientists using supercomputers, has been reinforced by the discovery that the expansion of the universe is accelerating. Just a few years ago astronomers were simply wondering about the rate of the expansion of the universe, and how it might be slowing down under gravity. Imagine pushing a ball and watching it roll up a slight incline. It slows down with the backward tug of gravity. This was predicted to have been happening in the universe under the mutual pull of gravity among galaxies. It was simply an issue of whether there was enough matter and dark matter to halt the expansion, which would lead to a "Big Crunch" as everything fell back together.

The favored view was that the balance of matter and energy in the universe was precisely tuned to allow it to expand steadily and indefinitely. If this were not the case, then our present view of the universe would be as improbable as glimpsing a tossed coin teetering on its edge. An eternally decelerating universe would make the expansion look more like an ice skater gliding across a perfectly smooth and nearly frictionless pond surface.

But scientists discovered, much to their surprise, that rather than coasting like a skater, distant galaxies will eventually be moving away from us so quickly that their light will never reach Earth. A repulsive gravity from the vacuum of space is pushing galaxies apart ever faster. The light from all the galaxies beyond the Local Group will eventually vanish as the expansion of space accelerates to faster than the speed of light. We truly then will be the singular island universe as many of Edwin Hubble's contemporaries believed. An inky sea devoid of light will surround a single elliptical galaxy of purely ancient red stars and a burned-out supermassive black hole. The universe might seem bizarrely claustrophobic. Without galaxies there are no more "markers of space," as Hubble described them. An accelerating universe "would be the worst possible universe, both for the quality and quantity of life. . . . There's no long-term future," says astrophysicist Lawrence M. Krauss.

Astronomers may spend decades trying to figure out exactly what the dark energy is that seems to be pushing the universe apart. If it is truly a constant, as predicted but then rejected by Einstein, then the universe will accelerate indefinitely. If it is not constant, then it could be inherently unstable. This is not unprecedented. The inflation theory proposes that the early universe was propelled by a repulsive gravity that very quickly decayed, much like a radioactive substance. The energy released produced a hot, uniform soup of particles. This concept of inflation is vital to the success of the Big Bang theory.

Dark energy too might decay and in doing so cause the universe to eventually collapse. In fact, dark energy in space may simply flip and become an attractive rather than repulsive force. This would cause the universe to reverse its expansion and ultimately implode. On the other hand, if the force of dark energy slowly increases over time, it might cause the universe to completely come apart in a few tens of billions of years, an apocalyptic end dubbed the Big Rip. To some cosmologists, such a short-lived universe would argue for the reality of infinite parallel universes, as well as universes that precede our universe's birth, or follow our universe's demise. They argue that it's hard to imagine that our universe was the only brief bubble of matter and energy that

JUPITER, 100 BILLION YEARS OLDER *When the universe is 10 times its present age, Jupiter, seen here from one of its moons, will exist as a cold ball of liquid hydrogen orbiting the Sun, now a white dwarf star. Minimal heat will radiate from Jupiter's interior to drive weather systems, so its atmosphere will become featureless. Traces of methane will give the planet a bluish look. Long before then the Milky Way will have metamorphosed into a giant elliptical galaxy in the aftermath of a collision with the neighboring Andromeda Galaxy. The only luminous stars left will be the red dwarfs, burning notably brighter than they were when the Sun blazed as a normal star. Even at this age—long before the last stars burn out—the Solar System already looks strange and unfamiliar.*

would ever exist, much like it's hard to imagine that our planet is the only place where life would ever exist.

Princeton University's Paul J. Steinhardt and Cambridge University's Neil Turok proposed in 2001 that our three-dimensional universe could be thought of as a membrane—dubbed a "brane" by researchers. To visualize this other dimension we need to compress three-dimensional reality outward to a flat sheet of paper. Imagine an ant crawling across the sheet and having no sense of up or down, or of any reality off the paper's two-dimensional surface (which we're substituting for our three-dimensional world). We can think of ourselves as the ant, imprisoned in the "flatland" world of the paper. For us a fifth dimension (the fourth dimension is time) would be the space off the paper. We can imagine a series of parallel universes, like sheets of paper stacked in an office outbox or slices in a loaf of bread.

Occasionally a piece of a parallel universe brane might peel off and head in our direction across a fifth dimension. The approaching brane would make our universe look as if it were accelerating! When it collides with our universe, temperatures would skyrocket to trillions of degrees, and everything would be incinerated. As the universe cools down it would have an uncanny resemblance to what we are observing today, the expansion and cooling of the universe from a hot and dense state. Maybe there was no Big Bang at all—it was just the result of a collision with a brane 14 billion years ago. This may have happened again and again, and we are just part of an infinite cycle of birth and death in a perverse "megaverse" where parallel universes collide like bumper cars. "Our bang would be just the latest in a sequence of bangs, coolings, and new bangs that could have continued . . . maybe an infinite time into the past," says Steinhardt.

The idea of the universe vanishing into a completely different reality may satisfy any lingering steady state universe believers. There may never be a true beginning or end to the universe, just a string of metamorphoses. Maybe the acceleration we are seeing will suddenly dump its seething energy, just as happened after the universe went through its first exponential growth via inflation after the Big Bang. Maybe our universe goes

INTELLIGENT LIGHT BEING *Perhaps knowledge, consciousness, and intelligence can be stored in beings made not of matter, but of photons or other forms of energy. This has long been predicted in science fiction stories. If sentience depends on the ability to store and transmit information, then such entities may not be merely science fiction, given a trillion years more for evolution.*

through an infinite series of energy cascades. "In a sense the inflationary universe never stopped," says Fruchter.

Would a "born-again" universe also beget planets and life? It's hard to imagine how the necessary, precisely tuned physical conditions would ever be the same. It would be like going back to Las Vegas year after year and expecting the roulette wheel to play out the same exact series of numbers as on your first visit.

In the 1980s Stephen Hawking proposed that our universe could spawn a baby universe every time a star collapses into a black hole. On the other side of the black hole the baby universe would then expand and grow, forming its own self-contained branch of space-time. If true, then myriad baby universes exist because of the plethora of black holes in our universe. And that's just for our one universe.

Even if parallel universes exist, they may never interact with ours. But they would provide a truly infinite tapestry for every conceivable variation on life and intelligence to eventually play out—at least for those universes with initial conditions that are conducive to life as we know it. This is the ultimate Copernican Principle: we do not live in a special universe.

FROM LIFE FORMS TO COSMIC CONSCIOUSNESS

What happens to intelligent life in a universe that might continually reinvent itself? Ultimately, self-awareness in the universe may abandon even the immortality of mechanical life and manipulate matter and energy to create entities of pure consciousness that store information in ways that are utterly unfathomable. Freeman Dyson echoed this idea in "How Will It All End?"

> I am assuming that my consciousness is inherent in the way the molecules in my head are organized, not in the substance of the molecules themselves. If this assumption is true, . . . then it makes sense to imagine life detached from flesh and blood and embodied in

networks of superconducting circuitry or in interstellar dust clouds. . . . If the assumptions of abstraction and adaptability are correct, the patterns of life and consciousness would be transferable without loss from one medium to another. . . . Immaterial plasma may do as well as flesh and blood as a vehicle for the patterns of our thought.

Dyson's thesis was beautifully described in Arthur C. Clarke's novel *2001: A Space Odyssey*: "But the age of the Machine-entities swiftly passed. In their ceaseless experimenting, they had learned to store knowledge in the structure of space itself, and to preserve their thoughts for eternity in frozen lattices of light. They could become creatures of radiation, free at last from the tyranny of matter."

Regardless whether it's "thinking meat," a silicon wafer, or pure energy, comprehending the origin and fate of the universe will befuddle any advanced intelligence for as long as there is a universe. But comprehending the universe will become harder in the future as information about the universe's past vanishes, as galaxies disappear from one another across an event horizon, the point beyond which information can't reach us.

Whatever lies ahead, our generation will be remembered as the first to put together a broad-brush view of the universe in its infinite complexity from the Big Bang, to cosmic evolution, to planets and life. Unless life manages to somehow redirect the universe from burnout, intelligence will want to preserve this information into the twilight era of the universe.

Whatever consciousness survives to the end of the universe, its last effort may be to preserve the flame of knowledge of all that preceded it. At first glance this seems a hopeless task in a universe where everything will likely wink out of existence. England's Astronomer Royal, Sir Martin Rees, predicts that information, thoughts, and memories—even the collective knowledge of a galactic civilization—could survive far into the future if downloaded into circuits and magnetic fields.

A far-advanced extraterrestrial civilization may build the ultimate machine—a self-aware quantum computer. Though now purely the stuff of science fiction, such a device would use the quantum properties of subatomic particles and photons to store and

CONSCIOUS COMPUTER *As the universe evolves and stars and living beings die out, a supercomputer collects all the knowledge in the universe, in this image inspired by Isaac Asimov's "The Last Question." Eventually the computer becomes conscious and devotes all of its thought to halting entropy in the universe. Once it finds the answer, it commands: "Let there be light," and another Big Bang takes place. This is pure fantasy, but quantum physics predicts that the universe might be spontaneously reborn.*

process information. This would allow it to perform certain kinds of calculations at fantastically high speeds. For example, such a computer could quickly search huge databases that would take an ordinary computer the lifetime of the universe.

Only such an entity—other than a god—might grasp a chaotic reality where all possibilities would overlap, and everything imaginable would be happening everywhere at the same time. Such a machine might calculate the infinity of possibilities not just for our universe but for countless others. Such an entity could be the last vestige of consciousness in the cosmos. It might store the collective knowledge not only of humanity, but of other intelligent beings across the cosmos as well.

Of course, science fiction writers have already envisioned such an Ultimate Computer. This was best dramatized in Isaac Asimov's "The Last Question." In the year 2061 humans build a powerful computer called "AC" (for analog computer). It is so large and advanced that its technicians have only the vaguest idea of how it operates. On a $5 bet, two drunken technicians ask the computer the "last question": What happens when the universe runs out of energy? But even the all-powerful AC does not have enough knowledge about the universe to answer this question.

Through the rest of the story Asimov astutely describes the cultural evolution of our species. Humans move out to colonize the Solar System, then the Galaxy, and then the universe. They evolve into machines, and then pure energy beings. The AC grows exponentially in capability but still cannot solve the puzzle of what will ultimately happen to the universe. After countless years humanity's collective mind, now free to roam anywhere in the universe at will, eventually fuses into a single mind, which in turn fuses with the AC itself. As the cosmos goes pitch-black, the AC dwells in hyperspace collecting data to solve the last question.

At last the AC discovers the solution, even though there are no longer any humans to give the answer to. It contemplates the infinite sea of burned-out stars, and in a sheer act of will it commands:

Let there be light . . .

SISTER WORLD *While we have not yet detected Earth-sized planets, much less even terrestrial planets with water, it is possible that the universe is well populated with planets and moons similar to our home world. How many of these have nurtured intelligent life as well?*

Afterword

As the reader reflects on all the wondrous things described in the preceding pages, it is hard to believe that so much progress and so many amazing discoveries have been made during the space age. To appreciate how much the lore of planets and extraterrestrial life has changed, a person really needs to be a planetary scientist of my generation. I have been privileged to participate in and witness the incredible transformation of planetary science from being the black sheep of the scientific world to being at the forefront of astronomical science. What a trip it has been.

Just 40 years ago the study of planets was almost taboo in astronomy. Respectable astronomers didn't dabble in it. I remember senior colleagues counseling me and others to "stay away from it—it will ruin you!" To enter into any discussion of life in space was truly to risk professional suicide. The taboo resulted primarily from extravagant and outrageously wrong claims of the detection of intelligent activity on Mars by early twentieth-century astronomers, particularly Percival Lowell. But my curiosity, and no doubt some naïveté, outweighed my concern about future employment. I explored the nature of planets and the possibilities of life in space.

Then the space age burst upon us. My fellow graduate students and I marveled at the strange object called *Sputnik* that flew slowly and majestically across the sky. This spot of light among the stars served as a sign that we would soon voyage to the planets and build great observatories in space. We would escape the murk of our atmosphere and see wonderful things both in the Solar System and beyond. And so we have done. In an instant in cosmic time, we have learned much about our Solar System, dis-

covered planets around other stars, and conceived of ways to detect not just life, but intelligent life, in space.

Planetary science has shown that space is replete with an incredible variety of marvelous and fascinating phenomena—almost none of which could have been predicted, even by a brain quite capable of constructing complex theories about nature. The one important discovery that was predicted is that the changing tidal forces from Jupiter, kneading its moon Io like a lump of bread dough, would cause Io to be extremely hot and home to prodigious volcanic activity. But no one came close to predicting the existence beyond our Solar System of the hot Jupiters, clear evidence of widespread formation of planets and one of the most important scientific discoveries of the twentieth century. No one predicted that the surface of Europa would be a shell of ice, under which there could be an ocean with more water than in all the oceans of Earth combined.

No one predicted that the universe could be so prolific that stars would produce more planets than their systems were able to hold in stable orbits. Yet this discovery changes our whole vision of planetary systems in the cosmos. We have seen that, where we have sufficient data, these systems all contain as many planets as they can without disruption by interplanetary collisions. Alternatively—and how amazing—the stars deal with their excess offspring by ejecting "surplus" planets into space, to wander eternally like nomads far from stars in the dark recesses of the Milky Way. Could these planets have enough atmosphere and internal heat sources to have a warm surface, maybe even liquid water and life? This is the sort of fascinating question that we never thought to ask, but now it becomes plausible. Rather than being rare, planets may be born in greater numbers than their parents can support.

Surely this list of discoveries comprises just the appetizers on a huge celestial menu of wonders that will be within reach as our instruments become more powerful. Robots will land on Mars, not just to peek at the rusty landscape, but to drill deep into the crust to see if even today there are creatures like those living in the subterranean grot-

toes of Earth. If we have the will, we could land a nuclear-powered supermining machine on the icy surface of Europa and wait as it drills through miles of ice and then sends its data before plunging into the frigid, dark, Europan ocean. Special boats, after a trip of a few billion miles, will land on Titan and allow us vicariously to sail its exotic hydrocarbon lakes that may teem with life. We will build bigger and better space telescopes, which will look back to the dawn of time to tell us of the strange beginnings of the universe. We will launch sophisticated spacecraft like the Terrestrial Planet Finder that may reveal to us other Earths, with oxygen and chlorophyll, and tantalize us with the possibility that, if we could but see them, creatures exist there, not greatly unlike us. Will they be looking out into space and asking, as we do, "Who else is out there?" And then, "What can we learn from them?"

If we have the will to provide the resources, we can answer these questions. The task will not be easy. The separation between civilizations could easily be hundreds or thousands of light-years. The signatures of their existence, radio and light waves, may be very faint. Just as our civilization is learning how to communicate and entertain with less and less power, their signals may be but faint whispers almost hidden in the radio noise of the cosmos. But technology exists that can find them. A powerful radio telescope placed on the far side of the Moon, the only place in the Solar System that never has Earth in its sky, could search for those faintest radio whispers from distant civilizations without being troubled by our radio signals. Perhaps we will even employ the most powerful telescope of all, which exploits the relativistic bending of space by the mass of the Sun to create the equivalent of a lens over a million miles in diameter. From this vantage point, so far out in space that the Sun is but a very bright star, we will be able to observe the continents of distant planets, the lights of cities at night. In a twinkling, we will learn more than we can now imagine.

Until now we have seen only poorly some of what is out there. We have been like a passenger in a jet plane flying high over cities with no ability to see all the intricate and amazing activity and beings below us. We have seen only a rich ensemble of streets and

MILKY WAY ALIENS *A technological civilization thrives on a planet in a distant part of the Milky Way Galaxy. They have dutifully mapped our Galaxy, built telescopes, and even sent out interstellar probes. Like us, they feel a cosmic isolation and loneliness. This must be very common to all inquisitive civilizations across the Galaxy, and perhaps a common and powerful driver to reach across space and time to try and touch the minds nurtured under the glow of a different star. What will we have in common with them? What will be radically different? Like us, they will likely have an awe and reverence for the infinite possibilities in a never-ending universe.*

buildings whose existence tells us, without a doubt, that a wealth of interesting phenomena exists. We can't yet sense those phenomena in our universe, but the time is coming.

Usually after reading a science book the reader comes away with the idea that all the important discoveries have been made, and there is nothing worthwhile left to do. How discouraging to young people hoping for a career in science. This book gives us a much different picture. The jet plane is about to land, and scientists of the future will be able to walk the streets of the cities of space and delight in all the unpredictable, even unimaginable, sights. You have had the privilege of seeing here, in art and words, a first glimpse of wonders to come.

FRANK DRAKE
Senior Scientist, SETI Institute, Mountain View, CA

Space Links on the World Wide Web

The following links are also available online at www.ucpress.edu (search for "Infinite Worlds").

ASTROBIOLOGY

NASA Astrobiology Institute
http://nai.arc.nasa.gov/

The Astrobiology Web
http://www.astrobiology.com/

ASTRONOMY ORGANIZATIONS

American Astronomical Society
http://www.aas.org/

Astronomical Society of the Pacific
http://www.astrosociety.org/

Jet Propulsion Laboratory
http://www.jpl.nasa.gov/

NASA
http://www.nasa.gov/

Planetary Society
http://www.planetary.org/

SETI Institute
http://www.seti.org/

Space Telescope Science Institute
http://www.stsci.edu/

EXTRASOLAR PLANETS, BROWN DWARFS, ETC.

California & Carnegie Planet Search
http://exoplanets.org/

The Extrasolar Planets Encyclopaedia
http://cfa-www.harvard.edu/planets/

The Geneva Extrasolar Planet Search
Programmes
http://obswww.unige.ch/Exoplanets

Giant Planet Calculator
http://zenith.as.arizona.edu/~burrows/
evolution3.html

JPL Planet Quest
http://planetquest.jpl.nasa.gov/

The Search for Extraterrestrial Intelligence
at UC Berkeley
http://seti.berkeley.edu

Virtual Planet Laboratory
http://vpl.ipac.caltech.edu/

OBSERVATORIES

European Southern Observatory
http://www.eso.org/outreach/gallery/astro/

Lick Observatory
http://www.ucolick.org/

PHOTOGRAPHS

Astronomy Picture of the Day
http://antwrp.gsfc.nasa.gov/apod/astropix
.html

Hubble Pictures
http://hubblesite.org/newscenter

National Space Science Data Center
 Photo Gallery
http://nssdc.gsfc.nasa.gov/photo_gallery/

SPACE ART/SCIENTIFIC ILLUSTRATION

Guild of Natural Science Illustrators, Inc.
http://www.gnsi.org/

International Association
 of Astronomical Artists
http://www.iaaa.org/

Lynette R. Cook
http://extrasolar.spaceart.org/

Novaspace Galleries
http://www.novaspace.com/

SPACE MISSIONS

The Kepler Mission
http://www.kepler.arc.nasa.gov/

Terrestrial Planet Finder
http://tpf.jpl.nasa.gov/earthlike/
 earth-like.html

SPACE NEWS

Astronomy Magazine
http://www.astronomy.com/

Sky & Telescope Magazine
http://www.skypub.com/

Space.com
http://space.com

Science@NASA
http://science.nasa.gov/

DIRECTORY OF ASTRONOMY RESOURCES

Cosmic Link
http://www.webdiva.org/space/

Index

Page numbers in italic refer to illustrations and their captions.

DESIGNER: SANDY DROOKER
INDEXER: ANDREW JORON
TEXT: 11/18 ADOBE GARAMOND
DISPLAY: AGENCY
PRINTER/BINDER: EUROGRAFICA SpA